STUDIES IN EARLY IMPRESSIONISM

Yale Publications in the History of Art, 22
Vincent Scully, Editor

Studies in Early Impressionism

Kermit Swiler Champa

New Haven and London, Yale University Press

1973

Copyright © 1973 by Yale University.
All rights reserved. This book may not be
reproduced, in whole or in part, in any form
(except by reviewers for the public press),
without written permission from the publishers.
Library of Congress catalog card number: 70-151569
International standard book number: 0-300-01285-3

Designed by John O. C. McCrillis
and set in Monophoto Bembo
Printed in the United States of America by
The Murray Printing Company,
Forge Village, Mass.

Published in Great Britain, Europe, and Africa by
Yale University Press, Ltd., London.
Distributed in Canada by McGill-Queen's University
Press, Montreal; in Latin America by Kaiman & Polon,
Inc., New York City; in Australasia and Southeast
Asia by John Wiley & Sons Australasia Pty. Ltd.,
Sydney; in India by UBS Publishers' Distributors Pvt.,
Ltd., Delhi; in Japan by John Weatherhill, Inc., Tokyo.

For Russell and Anthony

Contents

Illustrations

Color plates *(after page 30)*

Preface

John Rewald's *History of Impressionism* is the most ambitious and useful study of impressionist painting. First published over twenty years ago, it remains virtually alone in a field of scholarship which is overburdened by a century of myth and repetitive commentary. Rewald's greatest accomplishment lies in having set straight the record of artistic and social history for French painting from 1860 to 1880. His narrative reweaves in a truly comprehensive fashion the fabric of artistic and non-artistic events, and it does so wherever possible on the basis of primary documents.

The particular sort of historical objectivity which Rewald introduced into impressionist scholarship does not, unfortunately, tell the whole story. While claiming to study a group of painters whose historical importance rests primarily on the paintings they produced, his book never focuses on questions of painting itself. His readers are never called upon to respond to the artistic qualities of the paintings that pass before their eyes. In all fairness, however, one must grant that the ideal of Rewald's presentation is a kind of objectivity which many would consider absolutely valid. This is the objectivity of pure chronicle—the unadorned record of events.

It is significant that Rewald quoted the theoretical assumptions of the great French historian, Fustel de Coulanges, in the introduction to his book:

> History is not an art, it is a pure science. It does not consist of telling a pleasant story or in pure philosophizing. Like all science, it consists in stating the facts, in analyzing them, in drawing them together and in bringing out their connections. The historian's skill should consist in deducing from the documents all that is in them and in adding nothing they do not contain.

On the surface at least, Rewald seems to have followed out these assumptions to the letter. But in reality he has done almost the opposite. Since he intended to write art history, the questions of historical connection, deduction, and analysis should certainly have begun with matters of art per se, rather than with questions of artistic biography, art politics, and the sociology of art.

What one misses most above all in Rewald's presentation is a clear statement of the facts, or better, a sure sense of what the important facts are and how they relate to less important facts. This is alarming to say the least, since it is obvious that the history of impressionism is a history of impressionist paintings, considered as facts in themselves. However, in Rewald's hands, the facts of paintings themselves and the facts which relate paintings to other historical phenomena run together without established priority and without critical distinction.

The scholarship of impressionism has however gained immensely from Rewald's example. The past twenty years have contained a wealth of serious and well-planned exhibitions of paintings by individual impressionist painters. Important monographic studies, articles, and oeuvre catalogues have appeared at regular intervals. It would be misleading to attribute all recent scholarship in the field of impressionism to Rewald's example, but it is nevertheless clear that his work provided the basic reintroduction of impressionism to the realm of systematic investigation. With the work of people like Daulte, Cooper, Seitz, Isaacson and Mount[1] individual questions of style and documentation have progressed considerably, but Rewald's *History* remains the only comprehensive discussion of impressionism in general.

The following studies of early impressionism focus on some of the basic artistic issues that Rewald and most other recent scholars of impressionism have chosen to ignore. These issues are, for the most part, visual in the sense that they derive from an examination of paintings as paintings. Methodologically speaking, this may sound more like art criticism than art history, but for this writer at least, art history must always start with critical judgments and proceed to link these judgments through an analysis of sequence and development. Whenever art history proceeds without benefit of critical judgments it evades its intellectual responsibilities. Its emphasis is shifted from artistic form to materialistic function.

Impressionism, more than any prior moment in the history of art, rejects functional analysis out of hand. Its iconology is uninteresting, its sociohistorical role unimportant. The greatness and the depth of impressionist painting lies, so to speak, on its surface—a surface which year after year expands its importance as an object of purely visual interest. The history of impressionism traces a process of liberation within which the art of painting achieves for the first time an ideal of sensuous autonomy. Like the art of music, impressionist painting requires the spectator to accept the sensuous importance of the art form itself.

It is difficult from a distance of over a century to recapture completely the impact that impressionist pictures had on the art public of the 1860s. While cries of "ugly," "incompetent," "immoral" have greeted virtually every revolution in Western art, these were certainly louder and probably uttered with more justification in the 1860s than ever before. Painting had never appeared so willful, so self-indulgent, so completely gratuitous as it did during that decade. Beginning with Manet's coarse paraphrases of the old masters, and continuing with Monet's bold complexes of color and brushwork in the form of landscape scenes, painting seemed about to disintegrate. Few critics and fewer members of the art public in general could see any sign of hope at all. Words of support came from young critics like Zola, Duret, and Duranty.[2] Knowing and sharing the public's positivist leanings, these critics first stressed relationships between the science of vision and the unorthodox

1. François Daulte, *Frédéric Bazille et son temps*, 1952; and *Alfred Sisley*, 1959. Douglas Cooper, "Renoir, Lise, and the Le Coeur Family—A study of Renoir's Early Development," *Burlington Magazine*, no. 674 (May 1959), 163–71, and no. 676 (Sept.-Oct. 1959), 322–28; and D. Cooper and John Richardson, "Claude Monet," in *Edinburgh Festival and Tate Gallery*, 1957. William Seitz, *Monet*, 1961 and *Claude Monet—Seasons and Moments*, 1960. J. Isaacson, "Monet's Views of Paris," *Oberlin College Bulletin*, 24, 1 (1967), 4–22. Charles Merrill Mount, *Monet*, 1966, and "New Materials on Claude Monet: The Discovery of a Heroine," *Art Quarterly*, 25, 4 (Winter 1962), 315–33.

2. Emile Zola, *Salons*, ed. F. W. J. Hemmings and Robert J. Niess, 1959. Theodore Duret, *Manet and the French Impressionists*, trans. J. E. Crawford Fitch, 1910. Edmond Duranty, *La Nouvelle Peinture*, ed. Marcel Guérin, 1946.

appearance of impressionist paintings. However, these explanations were never wholly convincing and it remained for critics of the early 1880s, namely Mallarmé and Laforgue,[3] to assert openly that impressionist painting derived its qualities from sensuous novelty rather than the scientific descriptiveness of its surface configurations of color and brushstrokes. The knowledge that this sort of painting conveyed was seen to be aesthetic.

As one looks back upon impressionist criticism as it evolved from Zola to Laforgue, it is tempting to look for signs of progress in interpretation and understanding. In doing so, however, it becomes apparent that the initial critical conflict accurately represents what was and is so revolutionary about this painting. Artists like Edouard Manet, Claude Monet, Pierre-Auguste Renoir, Camille Pissarro, Alfred Sisley, Frédéric Bazille, Edgar Degas, and Paul Cézanne stood at a crossroads in the history of painting. They sought a new and fundamentally abstract identity for the art form they practiced, but they relied upon visual data from the world of everyday reality in order to extract this identity. By opposing the world which they saw with the successive images they devised to record it, the impressionist painters pursued two kinds of knowledge simultaneously. They became aware, almost obsessed, with the complexity of natural appearance but, equally, they discovered through the process of opposition the complementary complexities of their own art form. Each painter remained committed throughout his career to this process of discovery through opposition, and this personal commitment provides the basis for apparently contradictory interpretations of impressionism's artistic program. The question whether impressionist painting probes more deeply into problems of science or of art remains, therefore, suspended for all time.

A fascinating parallel to the interpretative dilemma provoked by impressionist painting appears in the respective writings of the two most important art theorists of the 1860s and 1870s. Neither Taine (in France) nor Fiedler[4] (in Germany) was specifically concerned with impressionism, but their attempts to define theoretically the nature of artistic quality come into conflict over the same issues that impressionist painting represented in concrete form at the same historical moment. For Taine, a Comtian positivist, artistic quality resided in selective, scientific imitation of reality: great painting singled out for salient emphasis the essence of the social and historical milieu out of which it grew, and it did so with all the scientific accuracy at its command. For Fiedler, a Kantian idealist, the quality of artistic form became a universal category, manifested and understood perceptually. Art stood in opposition to science in Fiedler's mind, as the product of a mode of understanding that refused to become conceptual, hence scientific. In Tainian terms, impressionism is an agent of visual and sociological truth. In Fiedlerian terms, it is a new formulation of perceptual experience, presented with greater abstract purity than ever before. Although somewhat broader in emphasis, these terms restate once again the dichotomy of contemporary impressionist criticism as it developed from Zola and Laforgue.

The most important twentieth-century critics of impressionism have maintained this dichotomy between positivism and formalism—a fact that emphasizes again the reality of the critical dilemma.

3. Stéphane Mallarmé, *Oeuvres Complètes*, ed. H. Mondor and G. Jean-Aubry, 1945; see: "Le Jury de Peinture pour 1874 et M. Manet," pp. 695–700; "Le Ten O'Clock de Whistler," pp. 569–86; "Proses Diverses," pp. 666–884. Jules Laforgue, *Selected Writings of Jules Laforgue*, trans. and ed. William Jay Smith, 1956; see "Impressionism," pp. 190–97.

4. H[ippolyte] Taine, *The Ideal in Art*, trans. J. Durand, 1869. Conrad Fiedler, *On Judging Works of Visual Art*, trans. and ed. Henry Schaefer-Simmern and Fulmer Mood, 1949.

On the Tainian side Meyer Shapiro has argued that:

> In its unconventional, unregulated vision, in its discovery of a constantly changing phenomenal outdoor world in which the shapes depend on the momentary position of the casual or mobile spectator, there was an implicit criticism of symbolic social and domestic formalities, or at least a norm opposed to these. It is remarkable how many pictures we have in early impressionism of informal and spontaneous sociability, of breakfasts, picnics, promenades, boating trips, holidays and vacation travel.[5]

On the Fiedlerian side we have Clement Greenberg, speaking first of all about the nineteenth century in general and then specifically about Manet and Monet:

> Each art had to determine through operations peculiar to itself, the effects peculiar and exclusive to itself. By doing this, each art would, to be sure, narrow its area of competence but at the same time it would make its possession of this area all the more secure... Each art would be rendered "pure" and in its "purity" find the guarantee of its standards of quality as well as of its independence. "Purity" meant self-definition and the enterprise of self-criticism in the arts became one of self-definition with a vengeance.
>
> ... Manet's paintings became the first *modernist* ones by virtue of the frankness with which they declared the surfaces on which they were painted.[6]
>
> What [Monet] found in the end was... not so much a new as a comprehensive principle; and it lay not in nature, as he thought, but in the essence of art itself, in art's abstractness.[7]

The several studies which constitute the text of this book attempt to select and examine historically the artistic issues that emerge during impressionism's first decade—that of the 1860s. These issues are formulated in terms which characterize as clearly as possible the visual qualities of artistic form. By proceeding historically and by analyzing several artists comparatively, questions of interpretation arise at a particular moment and within a particular context. As a result of their appearance in a historical sequence, these questions emerge in a more exacting perspective than that provided by purely critical discussions.

The painters considered here are seen to direct by the uniqueness of their work the passage of art through a period of history, in contrast to the usual view that the simple unfolding of time spawns and explains artistic events as a matter of course. My thesis is also in opposition to the orthodox positivist assumption that impressionist painting consisted of many efforts directed toward a single goal—the goal of truth to the momentary appearances of nature—an assumption that tends to suppress the identity of individual artistic efforts and to view these efforts as impersonal variations on a preestablished theme.

This book stresses the differences that existed between one artist and another. It presents the artists in the process of reaction and response, both to one another and to sources which they all shared. By isolating the character of each artist's development, impressionism appears less tied to the artistic, social, and historical polemics of the 1860s and seems involved instead with the centuries-old effort to make new and important contributions to the art of painting.

5. Meyer Shapiro, "The Nature of Abstract Art," *Marxist Quarterly*, 1, 1 (Jan.-March 1937), 83.

6. Clement Greenberg, "Modernist Painting," *The New Art*, ed. Gregory Battcock, 1966, pp. 102–03.

7. Clement Greenberg, *Art and Culture*, 1961, p. 41.

Each artist discussed here had his own ideas of how to go about making such contributions. These ideas are implicit in the form which his particular development takes. Monet, for example, worked analytically. Generally speaking his painting seems to develop from point to point. Each achievement contains some factors that will subsequently be rejected and others that will be examined further. Renoir on the other hand worked more synthetically, adding regularly to his arsenal of available interests and techniques, and rarely giving up anything for very long. Both artists were able to produce a succession of important realist paintings, but the qualities and aims of their respective works were by no means identical.

In presenting a study of this sort one must anticipate the question: How precisely can qualities and aims be determined in the absence of painting-by-painting commentaries by the artists themselves? There is no simple answer to this. By looking long and hard at the pictures, certain important factors become apparent; the difficulty comes in describing these factors and characterizing their importance.

It must be emphasized again that the factors which seem most important in projecting the aims and qualities of impressionist painting are for the most part visual or, more precisely, formal in essence. In other words they have to do with the various ways in which the artists put their pictures together. Subject matter seems in most instances to be a pretext rather than an essential factor in determining the final appearance of a given picture. Since all the painters studied here were realists of one sort or another, the choice of subject matter was relatively open. Each could choose what to paint on the basis of how he intended to proceed with his interests of the moment.

Terminology invariably becomes problematic in a discussion that tries to paraphrase fundamentally visual aims and qualities of artistic achievement. In order to anticipate at least a few of the terminological difficulties in the discussion which follows, some definitions should be introduced in advance. First of all with regard to color, tonal (tonality) and optical (opticality) are used as opposite terms. Tonal color features a single, dominant color sensation in which elements of contrast are suppressed. Optical color stresses contrasts of both hue and color value, so that individual accents retain their importance as separate visual units in the context of a painting as a whole. Second, with regard to pictorial design, composition and organization are used in opposition. Composition implies structure in three dimensions, organization, in two. It is hoped that the remainder of the terms used are self-explanatory.

Assuming the revolutionary art of Manet as a point of reference, this book proceeds with individual studies of Monet, Renoir, Pissarro, Sisley, and Bazille. These painters, taken together, eventually form a loosely related group, sharing certain interests and attitudes. Degas and Cézanne are not considered directly, since their work, particularly in the 1860s, stands apart from that of the other artists. Monet and Renoir receive the most detailed treatment. Their works establish the extremes of the discussion, and at the same time demonstrate through their gestures of mutual respect and interest whatever ties bind the group together. Pissarro appears as an independent figure who merges with the group when his own interests bring him to a point of coincidence with those of Monet and, to a lesser extent, Renoir. Sisley and Bazille appear as amateurs, related in their dependence upon Monet and Renoir but distinct in the particular qualities of their individual achievements.

As each painter is brought forward for discussion, it is necessary to decide first of all which paintings seem to embody the greatest degree of interest and importance. In making such decisions several criteria are helpful. First of all, "Salon" paintings, prepared for yearly official exhibitions, consumed a great deal of time and effort for every artist of the period. Such paintings tend to be demonstration

pieces and, as such, frequently attempt to provide a sort of summary for each year's work. By examining successive Salon pictures the broad rhythms of individual development become apparent. Second, each artist tends to repeat certain types of pictures at more or less frequent intervals. In these repetitions one finds a secondary and generally more subtle rhythm of change. Finally, in letters and other personal documents, a third criterion appears—the criterion of the *desired achievement* or the *direction sought*. This last can ideally bring into focus efforts which in themselves appear inconclusive or directionless.

While these criteria are helpful in singling out the main thrust of each artist's efforts, they do not in themselves guarantee the qualitative importance of individual paintings. Successes, relative successes, and failures appear throughout the work of every artist. Developmental aims and qualitative achievements do not invariably coincide. The presence or absence of this coincidence is a vital concern of the art historical record. These studies attempt at every point to articulate this concern.

Within the limits of this writer's sensibilities, qualitative achievements are underlined irrespective of context or magnitude. Within the limits of this writer's skill as a historian of art, the complex patterns of artistic development are isolated, traced, analyzed, and connected. Ideally, one hopes that the paintings under consideration benefit from the analysis to which they are subjected. At the very least, a spotlight is cast on several of mankind's highest achievements in the art form of painting, and for the duration of the narrative the reader, as well as the author, is compelled and privileged to confront these achievements.

Finally as a point of style, the narrative which follows relies heavily upon the present tense for analyzing individual paintings. It does so in order to imply simple factual description. In such situations the past tense seems, to this writer at least, to attribute an unwanted sense of intention.

The making of any book requires an expenditure of time and effort by many people besides the author. Prof. Frederick Deknatel of Harvard University and Mr. Clement Greenberg were preeminent in inspiring almost a decade ago the studies which led to this book. For editorial advice and substantive suggestions while the book was in progress thanks are due to Prof. Mark Roskill (University of Massachusetts, Amherst), Prof. George Heard Hamilton (Sterling and Francine Clark Art Institute, Williamstown, Massachusetts), Prof. Vincent Scully and Prof. Robert Herbert of Yale University. For patient guidance of the book through the mire of final assembly and publication Mrs. Anne Wilde of the Yale University Press deserves a degree of gratitude that can hardly be measured. For being there as a friend for so many years to consult and to respect for his own transcendent achievements, Prof. Michael Fried of Harvard University merits a special form of thanks, as does my wife Kate Hodges Champa, who mustered my confidence with her own industry in the final stages of the book's preparations. My mother, Mrs. V. A. Champa, typed several successive versions of the manuscript over a four-year period without even questioning that most thankless task. To the Department of History of Art at Yale University and to its chairman Prof. Egbert Haverkamp-Begemann are extended thanks for the financial subsidies which finally launched this book into print.

K.S.C.

Providence, Rhode Island
1971

1. Monet—The Early Figure Paintings

Two artists, Edouard Manet and Claude Monet, were the pivotal figures in French painting during the decade of the 1860s. Their separate works, while differing in many essentials, established the composite foundation for much of what we know as modern painting.

For purposes of general classification, the term impressionism has been used to characterize the overall fabric of style that developed in this period. However, the most superficial examination of works by Manet and Monet, or by Degas and Renoir, demonstrates that this so-called impressionism contained a diversity of aims which was often so extreme as to render a general stylistic category almost meaningless.

Realism, or the commitment to defining pictorially effects directly visible in nature, is the single unifying current in the period. But realism had, in the broadest sense, also directed the work of Constable, Corot, Ingres, and Courbet, so it is hardly unique to the 1860s. What is unique to this decade is the way in which realism was accepted as an established fact by every artist of major importance.

This general acceptance of realism carried with it certain limitations—limitations which have affected realist painting during each of its periodic appearances in the history of Western art. Realism inevitably emphasizes the visual importance of the image itself and isolates it from whatever literary values it may hope to convey. Realism ruptures the balance between formal and literary intention that stands as the highest ideal in Western painting from Giotto to Delacroix.

Prior to the 1860s, realist developments—those of Van Eyck, Caravaggio, Watteau and others—dissolved gradually into the main flow of classical and baroque painting. These developments revitalized, and finally supported, the traditional desire for formal and iconographical unity. But in the 1860s the force and conviction of realism became so strong that such dissolution would never again be possible.

Realist form and traditional content stand in firm and final opposition in Manet's great paintings of the early 1860s, the *Déjeuner sur l'herbe* (Plate 3) and the *Olympia* (Fig. 1). As a painter of the human figure, Manet seems driven to continue traditional themes, those of Venus and the fête champêtre; but as a realist, Manet is driven by his own vision, and he commits himself to an increasingly direct and unconventional representation of natural appearance. The phenomenological tension produced by these conflicting drives is intense, and Manet makes no attempt to resolve them. His thematic

gestures to Giorgione and Titian are unsupported by moral or aesthetic connections that might serve to make these gestures comprehensible.

The *Déjeuner* and the *Olympia* stand for all time as cognitive puzzles. They are at once traditional subjects and atraditional objects. Our levels of comprehension are kept clearly separate, and no painting of the last century and a half has managed to force these levels together again without sacrificing its quality as art.

The degree of cognitive tension that issues from Manet's pictures results to a large degree from the fact that he was primarily a painter of the human figure. As such he was confronted by traditions of imagery which were much stronger than those facing his younger contemporaries like Monet, who worked for the most part with landscape subjects.

As a landscapist Monet fell heir to dominantly antitraditional elements of earlier nineteenth-century art, elements first stated in the works of Constable and continued through the Barbizon painters, Courbet, Boudin, and Jongkind. Nineteenth-century landscape after Constable had demonstrated more successfully than any other branch of painting a growing independence of subject matter from the literary issues of traditional Western imagery. Questions of content increasingly restricted themselves to the associations which the viewer rather than the artist brought to bear upon the landscape subjects represented. By selecting natural motifs such as sunsets, rustic glades, or seasonal occupations of the peasant classes, landscape painters determined the responses which their viewers would have within certain broad limits, but they did not provide a consistent vocabulary of subjects and associated values to substitute for the imagery of traditional painting which their work, being landscape, rejected out of hand.

This meant that landscape was able to develop as pictorial art with greater freedom and less self-consciousness than figure painting in the same period. If one views the work of Delacroix as contemporary with the development of landscape paintings from Constable to Jongkind, it becomes clear that much of Delacroix's talent is spent in the substitution of literary values from romantic narratives for the inherited imagery of traditional religious and historical subjects. Comparatively little effort is directed toward basic questions of pictorial innovation. Innovations as they do occur seem as often to derive from a desire to give sensuous elaboration rather than to probe fundamental questions of form.[1]

As a figure painter Manet was pulled in two directions. He was certainly aware of formal and technical innovations in nineteenth-century landscapes. At the same time, he was academically trained and an admirer of Delacroix, so that traditions of imagery involving the human figure were firmly established in his mind. His initial efforts to bring these two directions in his artistic personality together in the *Déjeuner sur l'herbe* and the *Olympia* produced the cognitive ambiguities noted previously. It is not my purpose here to follow Manet's own development outward from the ambiguities of the *Olympia* and the *Déjeuner* but to look instead at a group of figure paintings by Monet that respond more or less directly to Manet's example and finally to determine the significance of this response. As we proceed we must keep in mind the fact that Monet came to figure painting from a youthful career as a landscape and seascape painter. His involvement with figure painting does not stem from any new interest in the art of the past but rather from a sincere respect for the works of Manet viewed from the vantage point of the moment when they were first exhibited. Manet's paint-

1. I am developing this point further in a forthcoming article, "Delacroix, Naturalism, and Clarification."

ings appeared to Monet as highly important contributions to realist painting. Manet treated the human figure with an optical directness that Monet had previously found only in landscape painting.

Questions of contentual ambiguity may or may not have been understood by Monet as he viewed the *Olympia*, the *Déjeuner*, and other of Manet's pictures. But whatever the case, Monet's chief fascination as he studied these works was the abrupt treatment of form which Manet had developed to establish a sense of optical immediacy in his figures. Without Manet's example, Monet might never have seen figure painting as a viable extension of his own work in landscape.

Once Monet recognized the importance of Manet's achievements, he accepted them as a challenge. In attempting to answer this challenge in his work of 1865 and 1866, Monet succeeded in marking out a totally new direction for his own painting and for realist painting in general. This new direction emerges gradually, as Manet-like figure subjects begin to appear alongside Monet's landscapes of late 1864 and early 1865. It appears in full force as he concentrates almost exclusively on large-scale figure paintings from mid-1865 through mid-1866.

The essentials of Monet's early landscape style as it appeared at the time he became interested in Manet are best seen in *Fishing Boats* (Plate 4) of mid-1865. In paintings like this Monet conceived of his motif in the broadest possible terms. Relying on precedents recently discovered in Japanese prints, he juxtaposed flat areas of color and tone to evoke a particular character of light and atmosphere and to define the specifics of the subject as well. Monet relies on oppositions of both graded and contrasting colors to generate the particular pictorial impact he desires. In this way he departs from the more tonal orientation of contemporary works by Manet, with their emphasis on contrasts of paint texture and color value. However, both painters shared a concern for generating images which are extremely active optically and radically simplified in their transcription of visual fact. The basis for mutual interest is therefore apparent.

It is difficult to say precisely when Monet first became interested in Manet's art. We know from published letters that in 1863 Monet's friend Bazille had begun a careful study of Manet's paintings and presumably had communicated some enthusiasm to Monet.[2] Prior to this date Monet could undoubtedly have seen Manet's works at the Salons from 1861 onward, in the Salon des Refusés in 1863, or in private showings. However, the two artists did not actually meet until 1867, and Monet's letters never refer to Manet directly until that date.[3]

Visual evidence seems to indicate that 1864 was in fact the crucial date for Monet's awareness of Manet. During the summer of that year Monet did two portraits—one of a certain Dr. Leclenche (Fig. 2) and another of the etcher Jules Jacquemart (Fig. 3).[4] These portraits were probably done on commission while Monet was working at the famous artists' and writers' resort, the Ferme St.-Siméon, on the Norman coast near Honfleur. Faced with figure-painting commissions, Monet seems to have drawn from his knowledge of Manet's work for a way of dealing with the projects at hand—projects for which there were no immediate precedents in his own painting.

The two portraits show a much more sensuous approach to the handling of oil paint than is normal for Monet's works of this period. Modeling is abrupt, with highlight and shadow values contrasting sharply in a fashion distinctly recalling Manet. In the seated portrait of Dr. Leclenche the figure

2. Gaston Poulain, *Bazille et ses Amis*, 1932, p. 36.

3. Claude Monet, *An Interview, 1900*, reprint of an article by Thiébaut-Sisson in *Le Temps*, Nov. 27, 1900.

4. Louis Gonse, *L'Oeuvre de Jules Jacquemart*, 1876, p. 31.

dressed in black and white is isolated against a neutral background with no elaboration of pictorial space, a factor again suggesting Manet and such paintings as *Mlle. V. in the Costume of an Espada* (Fig. 4) of 1862. The *Portrait of Jacquemart* represents an outdoor setting, but the relation of the figure to the path and the umbrella suggests a basic conception closely related to the Leclenche portrait which is elaborated by a background of prefabricated foliage. The disjointure between Jacquemart's figure and the setting is nearly as marked as that in Manet's *Mlle. V.*, but the fact that Monet chooses an outdoor background at all anticipates interests to come. In his next campaign of figure painting the following summer, Monet will attempt to integrate figures more closely into landscape motifs in an effort to combine his own landscape interests with figures conceived after the example of Manet.

Monet's two early portraits show departures from Manet which are, however, nearly as striking as the relationships. As a young man at school in Le Havre, Monet had been an accomplished amateur caricaturist, and his conception of the figure in the Leclenche and Jacquemart portraits is still colored by the graphic qualities of caricature drawing.[5] In contrast to Manet's pictures, the silhouettes and contours of Monet's figures are vigorous and almost brittle in character, so that there is a very nervous interaction of the elements of drawing and modeling. This essentially graphic conception of the figure also continues into Monet's work of the following summer.

From April 1865 to April 1866 Monet gave his efforts almost completely to projects of figure painting, beginning with his own *Déjeuner sur l'herbe* (Fig. 5) and ending with *Women in a Garden* (Plate 2). We are fortunate in having more or less complete documentary reports of Monet's activities during this important campaign. A group of letters to his friend Bazille and several eyewitness reports make it possible to follow the specifics of Monet's work with considerable precision.[6]

We know first of all that Monet left Paris shortly before the opening of the official Salon in April 1865. Accompanied by his mistress, Camille, he moved to Chailly in the Forest of Fontainebleau. Prior to his departure from Paris he had discussed his plans for a large group figure painting with Bazille, and the latter had apparently agreed to travel to Fontainebleau to pose whenever Monet needed him. In other words Monet had decided considerably in advance of his own departure that his efforts for the summer were to focus on a figure composition, presumably to be entered in the Salon of 1866, and he moved to Fontainebleau with the specific purpose of painting this picture. This sort of preplanning represents a major contradiction to the popular image of Monet—painting, so to speak, as the birds sing.

For better or worse Monet had committed himself to a difficult project—one for which he was totally unprepared either by training or by precedents in his own art. He would eventually project a canvas on the life-size scale of Courbet's great *Burial at Ornans* (Fig. 6) but conceived in terms of the subject of Manet's *Déjeuner sur l'herbe*. Late in his life Monet described the way he developed his project:

> I made it [the *Déjeuner sur l'herbe*] after Manet's; I proceeded after the fashion of the day, with some small sketches after nature [which were later] composed in my atelier. I worked very hard on the picture which is so unfinished and wrecked...[7]

5. John Rewald, *The History of Impressionism*, 1961, p. 39.

6. Poulain, pp. 50–72. G. Jean-Aubry, *Eugène Boudin, d'après des documents inédits*, 1922, p. 62. Le Duc de Trévise, "Le Pèlerinage de Giverny," *Revue de l'Art Ancien et Moderne*, 30ᵉ Année, 51, no. 283 (Feb. 1927), 116–34.

7. De Trévise, pp, 121, 122.

While alluding to Manet's picture, Monet's development of his own project was dramatically opposed in its handling of the subject and in its definition of realism in figure painting. First, Monet began by developing a landscape setting. For three months he tried to accustom himself to the landscape of the Fontainebleau Forest and to determine an ideal background for his picture. A group of landscape paintings remains to document his survey of the forest. Three of these paintings (Figs. 7–9), which have heretofore been considered landscape pictures pure and simple, are, on one level at least, preliminary investigations of background elements for Monet's projected figure painting.[8]

Two of the paintings are off-axis views of a road through the forest. They provide a broad foreground space and define this space with a large tree trunk at the right side. A seasonal variation in the foliage differentiates the two paintings—the first is from late spring with trees budding and autumn leaves remaining on the ground, and the second from early summer, showing the foliage as a rich, uniform green. Monet had in the two paintings comparative reference documents for his eventual choice of a setting. His decision would revolve around the flat and rather abrupt two-dimensional color contrasts of the second picture and the softer, more varied color structure of the first.

A third landscape study offers yet another factor. Its motif is more intimate, less a panorama of the forest than a record of a small pocket of space in the very heart of the wilderness. This study offers very little in the way of foreground space and instead deals with interactions of light which are sometimes direct but more often filtered and reflected by the complicated network of vegetation. Here Monet revels in the resonant interactions of color and shadow involved in what we may call "forest light." He pushes colors to intensities which the scene itself would only have suggested. He manages, in fact, to approach complementary color contrasts in two instances—crimson and dark green, and chartreuse and blue. Monet seems primarily interested in adapting the broad technical fabric of his early style to the coloristic turbulence of the motif at hand. By pushing the intensity of his colors somewhat harder than actual observation demanded, he is able to avoid the finicky, somewhat petty quality that invades earlier nineteenth-century treatments of similar motifs.

These three landscape studies, as well as others which were probably lost or destroyed, demonstrate Monet's process of adjustment to the setting of the Forest of Fontainebleau. After their completion he was ready to begin studying figures in context. At this point he began agitating for Bazille to join him and pose along with Camille. "Dear Bazille, The countryside is marvelous, come and see it" (April 9). Then on April 28: "I wish you were around to advise on the choice of landscape for the figure."[9]

By May 4, Monet began to apply pressure, indicating that he was rapidly approaching a point where figure studies should begin:

> You've simply got to come and pose for some figures. If you don't, I'm afraid I'll ruin the whole business. I beg of you my friend, don't let me sit in this embarrassing state. I think only of my picture, if that is ruined, I think I'll go mad.[10]

By August 16, Monet had begun to exhibit a measure of anger regarding the situation:

8. Rewald, pp. 118, 119. Mount, *Monet*, p. 89.
9. Poulain, *Bazille*, p. 50.
10. Ibid.

Bazille, if you don't answer me by return mail, I must assume by your refusal that you intend to offer no assistance at all. I'm desperate and I'm actually beginning to believe you want me to ruin my picture. This is incomprehensible to me since you agreed in advance to come and pose. If you're stuck for money, write and tell me, and I'll send you what I have.[11]

This final letter drew the desired response and on August 16 Bazille left for Chailly, and Monet was able to begin figure studies. One of these studies of Bazille and Camille remains (Fig. 11), but others, of which there must have been many, are lost. It is possible, however, to see on the basis of the remaining sketch exactly how Monet proceeded. He posed Bazille and Camille standing in the shade, dressed in elegant urban fashion. Besides establishing the poses, Monet looked for ways to relate his figures to the forest setting. This search was complicated by the irregular, indirect, and often reflective light source he seemed to desire, but general solutions sufficed for purposes of the preliminary sketch.

After carefully placing the few highlight accents necessary to snap the black-clad figure of Bazille from silhouette into three dimensions, Monet concentrated on drawing the areas of blue shadow which define the fall of Camille's white dress. Broad zones of shadow give pictorial space to the setting and rough, shingle-like strokes of pure pigment state highlights in the foliage in a fashion determined earlier in landscape studies.

Monet's technique in this sketch is skeletal to say the least. The drawn ornament of Camille's dress and the patterns of shadow interact in a way that makes both elements highly unstable three-dimensionally. Similarly, the bold highlight accents on the figure of Bazille and in the surrounding foliage, by virtue of their scale and abruptness, seem on the verge of separating from the forms they describe. Nevertheless it is by virtue of such cross-readings and separational effects that the sketch conveys the striking visual presence of his subject, existing in a moment of light. Even though essentials of setting are only suggested by Monet's sketch, they are a distinct part of the same vision that comprehends the figures. Here Monet's realism becomes unequivocal, as all elements, human or landscape, assume their reality through the action of the light which defines them.

Shortly after the completion of this sketch, Monet's efforts to synthesize his large painting were frustrated by a freak accident. He sprained his leg and was bedridden for several weeks.[12] While in bed and nursed by a water-dripping device fabricated by Bazille (a former medical student), he posed for Bazille's canvas entitled *Improvised Ambulance* (Fig. 10). Subsequently Bazille left Monet in the care of Camille and returned to vacation with his family at their summer home near Montpellier.

Monet was in sufficiently good shape both physically and financially to depart for Paris at some point in mid-September. Writing to Bazille from Paris on October 11, Monet's temper flared from the disappointments of the previous months, but his ambition to complete the large *Déjeuner* continued.

On all sides I'm subjected as never before to people who persist in guarding their silence. Just let me get my hands on you when you get back [to Paris], and [in the meantime] try not to do anything else to make me angry. It's a good thing you're finished vacationing. Send me 125

11. Ibid., p. 51.
12. Ibid., p. 56.

6

francs on account right away. I'm back in shape but I don't have my share of the rent, since I had a lot of trouble getting out of Chailly. [Now] I must get to work on my picture, everything is ready.[13]

To judge from this letter Monet had apparently been able to complete enough studies of figures and landscape motifs to proceed without further delays toward the final version of his big picture. However, his old adviser and friend Boudin visited Paris in late December of 1865 and in a letter to his brother implies that, as of December 20, Monet had still not begun the final version. "I have seen Courbet and some others who are working on large pictures, lucky people. Young Monet has one to cover which is about 20 feet wide."[14]

On the basis of Boudin's report Monet seems to have had his large canvas stretched and ready to go. He had not, however, begun to work on it directly. Instead he had probably spent his time preparing a smaller version (Fig. 5) of the composition as a whole. This version, dated 1866, involves the direct transfer of elements from the sketches of 1865 with virtually no change of scale. Working in this way Monet would have been able to solve whatever compositional problems occurred without at the same time calculating the enlargement of the whole to suit the dimensions of the large canvas.

The completion date of the small version is impossible to establish with any precision. A letter from Bazille to his parents, probably written in early February, suggests that Monet had by that time moved to the large canvas: "Monet is back at work after some delay; his picture is very advanced and solid."[15]

Although there is no documentary evidence to clarify the progress of Monet's work in this phase, the existence of the completed small version and fragments of the incomplete large version (Plate 1 and Fig. 12) make it possible to assume that Monet was, during the midwinter of 1866, enlarging directly from the small version. He was proceeding with this enlargement without traditional academic devices of squaring for measurement. This is evident from the fact that even the most un- finished sections of the large version indicate nothing in the way of guide lines or transfer measure- ments. In other words Monet was for the most part relying on the skill of eye and hand to make this difficult final step.

One can easily speculate on the magnitude of the problems encountered—difficulties which caused ultimate frustration and eventual abandonment of the project. Monet's lack of academic background and his total reliance on personal devices of style and technique spelled out a dead end. Never having worked on a canvas of the scale projected for the *Déjeuner*, Monet could not antici- pate the trouble he would run into.

Looking first at the small finished version of the *Déjeuner* (Fig. 5), one is impressed by the ease with which the young Monet handles a complicated figure composition. Around the central picnic cloth, he places figures in a variety of seated and standing poses. The compositional focus on the central group is strong, but Monet manages as well to spread his figures outward to the very edges of the canvas. Pictorial space is shallow and uncomplicated. Strong foreshortenings are avoided, so that problems involved in transferring figures from studies of the previous summer into this version of

13. Ibid., p. 58.
14. Jean-Aubry, p. 62.
15. Poulain, p. 61.

the *Déjeuner* were relatively simple. The various parts of the outdoor setting are freely derived from earlier landscape studies and move somewhat rigidly through and behind the frieze-like placement of the figures.

The character of Monet's composition as a whole is clearly geometrical in emphasis, relying considerably on echoes of the horizontal and vertical axes of the rectangular canvas. In this small version the flat, compressing quality of the geometry is not pronounced, but along with other factors it would cause difficulties in the larger version of the picture. The most problematic of the other factors is the abruptness of Monet's figure modeling. When enlarged, the resulting flatness of figural definition would prove highly troublesome. Further, the vibrant highlight and color accents of red, chartreuse, and violet would inevitably become more independent and isolated. But in this small version all these factors sustain the raw, unyielding toughness that gives the image its unprecedented quality of visual presence.

The difficulties which Monet experienced in extending the scale of his composition become apparent in the fragment from the left side of the large *Déjeuner* (Plate 1). Here one is impressed, even overwhelmed, by the boldness of Monet's effort. But one is equally aware of the disaster. The painting, or rather this fragment of it, is irrevocably two-dimensional. Brilliant accents of color push and pull violently as Monet attempts to bring his life-size figures into the round and to give them space in which to move. He modifies their positions, pulling them away from the lower edges of the canvas; he intensifies and complicates the modeling, but failure was inevitable. The boldly simplifying tendencies of Monet's art, when enlarged to this scale, could not be forced to render a consistent third dimension without sacrificing luminosity and color intensity.

The image presented by this large fragment is one of conflict and frustration. The element of conflict derives from the demands which the figures make for some sort of plastic realization and from the assertive flatness of Monet's technique which is optically opposed to these demands. Compared to Monet's, the figures in Manet's *Déjeuner* seem very three-dimensional despite their equally unconventional modeling. Aware of the fact that a more complicated system of modeling, which featured either a softer treatment of shadow and coloration or a denser impasto, would break down the optical presence attained in the small *Déjeuner*, Monet became discouraged and abandoned the project altogether.

Although he was frustrated in the final stage of his project, he had nevertheless accomplished a great deal. In the small version he succeeded in producing a sort of tribute-challenge to Manet. He revised Manet's subject along thoroughly realist lines. His picnic is a picnic pure and simple. An integrated sense of visual presence in which the subject assumes a wholly passive role is Monet's counter to the unsettling gestures to tradition cultivated by Manet.

The extent to which Monet was conscious of his dialogue with Manet as the *Déjeuner* project unfolded can be seen in the second fragment which remains from the unfinished final version. This fragment (Fig. 12) is cut from the center of the large canvas. In the group of figures clustered around the picnic cloth, Monet changed the pose of one figure—the man at the upper left center. This revised pose represents an obvious quote from Manet's *Déjeuner* introduced to link the two pictures once and for all.

Having worked on his large version of the *Déjeuner* until some point in mid or late February (1866), Monet had only a short time left in which to prepare an important painting for the official

Salon that would open in April. *Camille* (Plate 8), Monet's most direct tribute to Manet, is the result of this last-minute preparation.

Camille, which was immediately successful with critics and public alike, offers a real puzzle to the student of Monet's style. It constitutes a partial abandonment of the technical boldness and the vigorous optical effects which had directed the artist up to 1866 and features instead a concern for the precise evocation of fine textures. It seems almost inconceivable that Monet, the same painter who only a few weeks before had attacked the broad expanse of the large *Déjeuner* with such freedom and directness, should in *Camille* so meticulously, albeit brilliantly, define the satin skirts and fur trim of his subject's costume.

One should not, however, be deceived by Monet's behavior in *Camille*. The picture was born from the frustration of the *Déjeuner*, and the atypical qualities of *Camille* can be explained as a broad reaction to the former project. With the exception of the three-fourths rear pose of the figure, which derives from early studies for the *Déjeuner*, *Camille* is conceived in nearly antithetical terms.

First of all, the outdoor setting is rejected and with it the problems of projecting the figure from a coloristically complicated background. Instead, the neutral background favored by Manet in his single figure paintings has been adopted once again. Against this the figure is developed in terms of strong, Manet-like oppositions of light and dark, oppositions which, however, remain firmly tied to the description of textures.

Granted the transcriptive, not to say materialistic, qualities of Monet's picture, it still conveys an "object sense" which is radical in comparison with similar works by Manet, such as the latter's *Fifer* (Fig. 13) of the same year. By object sense is meant the way in which the pictorial qualities of the picture assert themselves in a fashion that is independent of any psychological or narrative characterization of the subject. The dehumanizing aspect of Monet's pose is partly responsible for this, but equally important is the extreme emphasis given to coloristic and tactile effects in Camille's costume. Monet's decision to construct a figure painting that prohibits psychological access to the figure itself and to concentrate instead on the visual spectacle offered by the costume establishes an essentially scenic preoccupation in the painting of the human figure.

Monet's scenic approach to *Camille* is consistent with his straightforward development of the earlier project for the *Déjeuner*. In each instance he tried to maintain a sense of distance from his figural subjects, so that they, like the pictures themselves, would demand to be looked at rather than thought about. His success in presenting *Camille* as a bit of purely visual reality is remarkable, particularly since the precision of his technique tends to suppress the revolutionary character of the image. Unlike certain figure paintings from seventeenth-century Holland—those of De Hooch or Vermeer which are obvious precedents for *Camille*—this picture is thoroughly impersonal and uninformative. As a portrait it is unsatisfying; it tells nothing about the subject. It does not even offer a particularly recognizable view of her face. What one sees is costume and gesture, which together establish the visual content of the picture, and no other consideration is permitted to intrude.

Compared to *Camille*, Manet's single figures, *The Fifer*, for example, possess what Venturi has called the quality of icons.[16] These figures are presented as compacted visual and psychological units

16. Lionello Venturi, *Impressionists and Symbolists, Modern Painters*, 2, 1950, p. 18.

which literally force themselves into the viewer's presence. Usually these figures appear frontally and are large in relation to the overall surface of the picture. Because of this and because of the crispness of their coloration, they dominate the viewer's field of vision in a fashion analogous to the figures in Byzantine mosaics. The effect which these figures produce is diametrically opposed to that of the *Camille* which, psychologically speaking, withdraws from the spectator's presence in order to focus attention on an incident of pure vision.

When Monet moved to the small town of Ville d'Avray, near Paris, for the summer of 1866, he was certainly encouraged by the success of *Camille*. But the unfinished project for the *Déjeuner* still haunted him, and the challenge of setting a large-scale figure subject out-of-doors remained. In response to this challenge he planned and executed the *Women in a Garden* (Plate 2). This painting benefits from a much simpler program than that of the earlier *Déjeuner*. Responding to the relative ease and rapidity that had marked the production of *Camille*, Monet now proceeded with greater directness than he had in his work of the previous summer.

First, he abandoned the complicated procedure of preparatory studies that he had followed in the *Déjeuner* project. Instead he began and finished his picture on a single large canvas. Problems of scale and composition were confronted directly in conjunction with the basic effort to evoke the vigorous interactions of light and color that would give definition both to figures and setting.

In order to ensure that his picture sustain a consistent mode of vision throughout, Monet worked in his garden. His large canvas was placed in full view of the garden setting. Camille, changing from one costume to another, posed at several points within the setting, and Monet varied her pose so as to construct a group of figures. During the creation of the picture he had at all times a direct reference to each element involved in the scene. In other words, he transferred the controlled conditions of studio figure painting to the outdoors.

In choosing to work out-of-doors there was, of course, one problematic factor—the weather. Monet's picture studies a scene under intense and quite direct afternoon light. We know from his own statements regarding the picture that he painted only when light conditions were suitable. Courbet, who visited him while the painting was in progress, was somewhat amused at the un-conventional rigor that marked Monet's procedure. Monet's description of *Women in a Garden* and of Courbet's visit offers an excellent statement of the uniqueness of Monet's methods.

> This picture I painted completely on the spot and after nature, without retouching it after-wards. I dug a trench in the ground, a sort of pit, to lower the canvas progressively in order to get at the top. I worked at Ville d'Avray where I was advised periodically by Courbet, who came to visit me. One day he asked me "Why aren't you working my young friend." I ans-wered him: you can see that there's no sunlight. That meant nothing to him since he thought you could always work on the landscape sections. [But] there was a bit of a smile when he said this, and it is possible he was just speaking in irony.[17]

The possible irony to which Monet refers concerns the whole question of relative truth and representational convention in realist painting. In his early landscapes and in the *Déjeuner* project Monet had worked synthetically, assembling large compositions on the basis of multiple sketches from nature. Under Manet's influence he had attempted to incorporate the visual directness of

17. De Trévise, "Le Pèlerinage," pp. 121–22.

sketches from nature into a complicated figure painting conceived in the studio. His failure in this project turned his efforts toward the creation of the *Camille*, a studio painting of a studio subject. Then, moving back to the problem of painting outdoor subjects during the summer of 1866, he took the logical next step. He worked from beginning to end out-of-doors, selecting his conventions of composition and of visual representation with direct reference to the subject as he viewed it. In his subsequent development Monet's methods, and those of Pissarro and Sisley as well, proceed from this point.

There are two strands of Monet's development as a painter which come into focus in *Women in a Garden*. The first concerns the removal of the pictured human figure from the framework of traditional imagery. Beginning with the *Camille*, the human figure was isolated as a scenic rather than a humanistic fact, and the tension of Manet's figure subjects was released. This is continued and developed in the *Women*. The second strand involves the final rejection of predetermined conventions of representation and composition in favor of conventions derived from an examination of the possibilities which the motif might itself suggest. Granted this characterization of the role which *Women in a Garden* plays in the development of Monet's approach to painting, a discussion of his first campaign of figure painting should certainly conclude with a brief examination of this picture.

An important clue to Monet's way of working exists in an unfinished trial run of *Women in a Garden* (Fig. 14) which today lies partly concealed beneath an equally unfinished work by Bazille. In the lower half of Bazille's *Nude Boy on the Grass* one can still make out the loosely sketched figure of a seated woman in a white dress holding a fan. This figure bears a definite resemblance to the foreground figure in *Women in a Garden* and suggests that Monet worked directly on an unprimed canvas without any sort of preparation. The lightly sketched figure was apparently abandoned when Monet decided to work a larger canvas with more figures. He then turned the slightly used canvas over to Bazille.

After this, Monet seems to have moved directly to *Women in a Garden*, probably roughing in elements of figures and setting in the same broad and direct manner suggested by the unfinished sketch. His basic method was to establish the primary contours and the intervening tones of positive color and semishadow, the latter tending as they had in the earlier *Déjeuner* to assume a blue rather than gray cast. Over this base of contours and tones Monet placed intense and strongly patterned planes of color, representing areas of costume and foliage which were directly lighted. Finally he drew in a sharp, rather graphic manner, costume details and accents of contour.

The completed picture stands as a brilliant demonstration of the flattening rather than the modeling quality of intense natural light as it defines forms of various sorts. It is this quality which Monet chooses to develop in the absence of volume and space definition. Shifts in the scale of figures mark Monet's only real concession to the definition of space. The arbitrary and uninformative way in which he arranges his figures indicates an obvious departure from his methods in the *Déjeuner*. The poses which the figures assume, and the acts which they seem to perform, appear to be wholly random and dictated by Monet's efforts to achieve a powerful surface effect. The colors and shapes of the figures are poised at points around the central tree, indicating the most forceful arrangement that Monet was able to discover in his examination of the motif. The motif itself, offering both figural and landscape components, provides visual raw material rather than subject matter. Nature is no longer Delacroix's "dictionary" of exact definitions. To Monet it has become a vast unformed

language, whose meanings must be expressed aesthetically.

As it stands, the *Women in a Garden* concludes Monet's first campaign of figure painting most impressively. Its brilliance, originality, and willfulness seem in retrospect to have assured its rejection by the jury for the Salon of 1867. The picture leaves unresolved a whole range of issues concerning the articulation of pictorial space, the modeling of individual figures, and the scale of figures relative to one another. But by leaving these issues unresolved Monet is able to generate an unprecedented sense of lightness and optical movement. The painting seems to translate rather than simply transcribe a piece of nature. Within the limitations of the medium of painting, *Women* seeks to formulate a purely optical kind of metaphor, which is comparable in terms of sheer visual energy to the scene it so splendidly evokes.

To conclude, then, we have followed Monet's work for roughly two years. In a group of figure paintings we have seen him work with and against the example of Manet in order to advance tendencies already implicit in his work as a landscape painter. From these experiments with figure painting, many of the fundamental issues of realist painting emerged as problems of one sort or another, and he attempted to deal with them on his own particular terms. His terms decisively rejected traditional imagery, narrative of any kind and, finally, any question that did not stem directly from the process of opposing real and painted appearance.

2. Monet in 1867—The City and the Shore

Monet's *Women in a Garden* concluded a two-year cycle of work which had concentrated on images of the human figure. Having worked out questions first posed by the Jacquemart portrait commission, Monet returned in the autumn of 1866 to landscape painting. Elements reflecting his accomplishments and attitudes as a figure painter first appear in a landscape context in several small works from Ville d'Avray, but more importantly they form the basis for one of Monet's largest and most important landscapes from the 1860s, *The Terrace at Le Havre* (Plate 5), done in the late summer of 1866.

For this picture Monet rephrased the basic motif of the *Women in a Garden* in such a way as to give the broad panorama of the seaside setting an uncontested dominance over the figures which move through it. In so doing, he was working systematically from the implications of the *Women* by further emphasizing the scenic qualities of figures through a reduction of their scale and importance. Reinforcing this scenic conception, the figures are either faced away from the viewer or seen at a distance in profile. In one instance (the figure in the center foreground) a parasol is so held that the head of the figure is hidden from view. To an even greater degree than in the *Women in a Garden*, the figures on the terrace seem incidental—they are characteristic scenic facts with no projected identity. Visually they are part of a counterpoint of flat shapes and brilliant colors that Monet uses to construct his picture. As subject elements, the figures are no more or less important than the beds of flowers or the flags waving overhead.

Although Monet's treatment of the figures does recall the *Women in a Garden*, several new interests appear in the *Terrace*—interests that will form a governing part of his work the following summer. The most obvious of these is structural in character. Monet selects a rigid, geometrical sort of pictorial organization.[1] The picture is formed in terms of a broad grid of interlocked horizontal and vertical elements. These elements certainly derive from the interaction of the terrace, the sea, and the flagpoles in the scene as he viewed it, but his use of this interaction is both arbitrary and calculated. He employs it, along with a rather steep overhead view, to flatten out the space of the picture as a whole and to divide various zones of the picture laterally.

The development of intense flat colors derives from his midafternoon view of the scene in the

1. See chap. 7, p. 69.

same way that the bright, nearly uniform value structure of the *Women in a Garden* recorded Monet's first response to painting out-of-doors in full sunlight. In both instances Monet accepted the fact that movement and space were deemphasized—even lost—in the emphasis given to the direct evocation of light-struck surfaces. Rather than backing away from these inevitable losses, he attempted to capitalize on his gains and to search for ways of organizing them. He did not have too far to look, since many of his own early landscape works had been organized around abrupt and rather geometrical divisions of the canvas surface, which were derived from roads or paths receding in perspective or from silhouettes of landscape elements seen against a distant sky. Where these structural effects had often appeared clumsy in Monet's earlier landscapes, they now attain consider-able force in their application to the particular interest in bright sunlight effects and abrupt color contrasts in the *Terrace*.

Monet's *Terrace* represents a process of trial and correction, the two components being inseparable in the final product. It carries the commitment to brilliant sunlight effects from the figural context of *Women in a Garden* into a motif of pure landscape where the remaining figural component receives no humanistic emphasis whatsoever. The *Terrace* corrects *Women* by replacing the some-what amorphous design of the latter with an emphatic development of geometric conventions which, in the new context, gain in pictorial importance through the reinforcement they offer to Monet's interest in laterally spaced accents of flat color.

Monet's two major groups of works from the following summer (1867)—the cityscapes of Paris and the seaside paintings from Ste.-Adresse—move along a basically similar path to that marked out in *Terrace*. However, this path was refined and extended in a variety of unexpected ways.

Interim paintings from the fall and winter of 1866–67 prepare Monet for his achievements during the following summer, but they do not figure as precedents in the same way as the *Terrace*. Views of *Honfleur* (Fig. 16) and *Fécamp* (Fig. 15) indicate a revived interest in low-keyed tonal color, inspired partly by the approach of autumn but most important as an alternative to the sharp, almost brittle character of his color in the *Women* and the *Terrace*. Similarly, these autumn works show Monet concentrating on refinements of brushwork which convey subtle intervals of coloration without sacrificing either breadth or directness.

Several snowscapes (Fig. 17–19) are particularly important in this search for optical and technical refinements.[2] With their basic white, brown, and blue tonality these pictures are a challenge to Monet's powers of transcription and organization. Obviously calling for lighter and more delicate technical effects, these pictures relax structurally into soft but clear massings of landscape elements around space-defining roads. They define the subtleties of local and reflective coloration on the generally white snow cover and oppose these subtleties to contrasting areas of winter foliage and sky. In these snowscapes Monet holds in balance an unprecedented delicacy of coloristic transcrip-tion and an opposite tendency to play broader masses of single tones against one another two-dimensionally. His success in achieving this balance will stand as a constant challenge to Pissarro and Sisley in their snow scenes of the next decade.

2. The dating for landscapes from the fall and winter of 1866–67 in Rewald, *History of Impressionism*, pp. 179–80, seems satisfactory. It is reinforced by a letter from the painter, A. Dubourg, to Boudin. See Jean-Aubry, *Boudin*, p. 64.

For Monet the snowscapes marked the passage of winter, as the views of Fécamp and Honfleur had marked the previous autumn. In all these paintings he seems to bask in the joy of discovery. Working without apparent program, he sets out to master each seasonal nuance and to press it into effective pictorial form. His technique appears to be simple, but it encompasses some of the most complex passages of color and color value ever painted. As a group these pictures confirm the importance of Monet's earlier decision to work outdoors, and they stand as an encouragement for even more ambitious efforts the following spring and summer.

A very important procedure appears in Monet's work during the winter. He begins to work on groups of paintings of the same or similar subjects—not groups derived from a common body of sketches in the manner of his earliest landscapes but "series" of pictures working within a more or less stated frame of reference. The snowscapes are the first of Monet's series paintings, and this precedent would strongly affect his forthcoming work in Paris and Ste.-Adresse. Besides generating the idea of series work, the snowscapes as well as the views of Fécamp and Honfleur demonstrated to Monet the value of alternating in his painting between brilliant, high-contrast color and close-valued tonal color. Each would provide a test or buffer to control the effects of the other, and throughout his career Monet would use this alternation to great advantage.

Monet moved to Paris in April of 1867 to work on several views of the city. He had with him a firm base of style and procedure, derived from the *Terrace* and works of the winter just passed. This base was sufficiently strong in its own right to make it possible for him to approach the subject of the cityscape with a fresh outlook, and one that rejected precedents in similar subjects by Corot, Jongkind, Lépine, and Vollon. Significantly, Renoir, who was working on his own cityscapes of Paris at the same time, continued very much within a basically Corotesque tradition.[3]

The tradition, which Monet rejected and Renoir followed, derived from Corot's epochal views of the *Harbour of La Rochelle* (Fig. 20) from 1851. This tradition saw the city as a picturesque arrangement of architectural and topographical elements (rivers and streets) which were viewed in a softly diagonal fashion from ground level. The "tourist-eye" view of vistas opening and closing as one moves through the city formed a perfect urban corollary to the lyrical landscape views of Corot and his friends, the Barbizon painters.

Renoir's view of the *Pont des Arts* (Fig. 21) declares its allegiance to this tradition through the quayside view, which follows the diagonal axis of the river, opposing well-known architectural monuments on both sides. The bright and rather flat color of Renoir's picture draws it into Monet's technical orbit without in any way concealing its debt to the tradition of Corot.

Monet's paintings (Figs. 22–24) are, on the other hand, not only apart from this tradition but completely opposed to it, recalling instead eighteenth-century cityscapes such as those of Canaletto. The ground-level viewpoint, which identifies the artist's view with that of the wandering tourist, is completely rejected. The steep overhead viewpoint used in *Terrace* (probably reinforced in Monet's mind by precedents in the urban photographs of Nadar and others) suggested a completely different sort of vantage point—one that would revise the whole relationship between the viewer and the scene and would at the same time permit anti-picturesque modes of composition. Monet found his new vantage point on the balcony of the Louvre Palace. Significantly, his use of the

3. Poulain, *Bazille*, p. 81. See also parallel discussion of Monet's cityscapes in J. Isaacson, "Monet's Views of Paris."

balcony of the Louvre had been anticipated by at least one topographical photographer, Guervin, who photographed the square of St.-Germain l'Auxerrois from the balcony of the east facade at some point in the early 1860s.[4]

From his strategic location on the balcony, Monet confronted the city visually, at the same time remaining detached from its physical life and its characteristic vistas. The choice of angles and positions from which to view any segment of the city was virtually limitless. His eventual selection of motifs seems to have revolved around the discovery of three distinct types of view which, taken together, would best summarize the range of possibilities available. Each motif offered a specific sort of emphasis, or, better, a way in which a particular sequence of elements could be seen to provide the most concise statement in the form of a picture. Predictably, Monet would not attempt to offer new ranges of narrative meaning in the choice of his motifs and viewpoints but, rather, he would simply accept the visual raw material of the city and use it for fundamentally pictorial purposes. This is not to say that meanings and associations on a personal level did not exist as an important factor in Monet's painting, but such considerations were held in check in the process of visualizing pictures. Monet was by 1867 firmly committed to a scenic conception of subject matter. As an artist and a maker of pictures, his decisions regarding how and what to paint involved considerations of pictorial relevance and visual impact.

In his works of this period Monet's vision of nature provided a wide range of isolated scenic facts that could be seized upon and organized. His "series" painting at this point is a sequence of these facts. In his later works, from the late 1870s onward, such facts become harder and harder to isolate. Facts become momentary to such a degree that the painting of a single moment or a sequence of moments stands as an intensely arbitrary abstraction, even when the ostensible motif remains constant. The fundamental difference between Monet's series of views of Paris and his much later series of the facade of Rouen cathedral lies in his expanded awareness of the abstract conventionality of realist painting and his increasing recognition of the artist's synthetic role in the isolation and fabrication of the pictured image.

The three isolated views of the city of Paris which Monet chose to paint also demonstrate the role that photography played in his conception of painting at this historical moment. He conceives of the format of his canvas in terms which parallel the photographer's conception of the photographic plate. Both are surfaces of unequal horizontal and vertical dimensions, and in either the canvas or the photographic plate there are two directional possibilities: the rectangle can be positioned with its long axis horizontal or vertical. The position selected will have an impact both on the limit of the view and on the emphasis given to the spacing of individual elements in two and three dimensions.

For the three cityscapes of Paris Monet experimented with both scale and directionality in his choice of formats. For the first picture in the group, the *St.-Germain l'Auxerrois* (Fig. 23), he used a conventional horizontal format, slightly wider than high. For the second two pictures, the *Princess Garden* (Fig. 24) and the *Quay of the Louvre* (Fig. 22), he used proportionally similar formats—one dimension nearly double that of the other—but he transposed the longer dimension in the second version. Since the Paris cityscapes mark the only instance in Monet's career when such obvious

4. There are prints of the Guervin view of St.-Germain l'Auxerrois in the Bibliothèque National, Paris.

transposition occurs in a brief but major campaign of work, it seems likely that he was experimenting on the basis of leads offered by contemporary photography.

The obvious question that results from the above discussion is one of priority. Did Monet's selection of motifs predicate the shifts in format, or did the decision to experiment with different formats determine the selection of views? Such a question is impossible to answer satisfactorily, and it is likely that the decisions about motif and format were very much interrelated in Monet's mind and that both remained subservient to the basic desire to present the motifs with the greatest conciseness and directness.

There are several reasons for suggesting that *St.-Germain l'Auxerrois* (Fig. 23) represents the first of the sequence of cityscapes. It is clearly the simplest and most conventional of the three paintings in the series. It carries a date of 1866, but this date is obviously a later addition and certainly incorrect—a fact provable on the basis of both style and documents.[5]

For his view of the church and the shaded square which separates it from the Louvre itself, Monet focused his attention on the facade of the church with its spreading buttresses and transepts and its large rose window. He used the geometry inherent in the structure of the facade to organize his design through a careful alignment of horizontal and vertical members with the axes of the picture plane. This alignment in combination with the overhead view tends to draw all elements, whatever their actual spatial position, forward to the picture plane. The result is a flattened, lateral arrangement of elements, similar in type to that developed in the *Terrace* of the previous summer. Monet's geometrical network spreads downward into the square beneath the facade, where the trees are interlaced with regular shadow lines running horizontally across the square. A certain awkwardness or indecision enters the picture on the right side where Monet includes the diagonal recession of a small street. The perspective slant of the buildings which line this street congest and confuse the simplicity and directness of the image as a whole. Monet relies on the flat uniformity of his brushwork and the bland evenness of his registration of color and color value to unify the motif, but a certain tentativeness remains. This tentativeness and in fact all the problematic elements in the picture derive from Monet's attempt to retain at this point an element of the picturesque. He seems to have felt a need in this first of the cityscapes to relieve the geometrical stiffness imposed by his focus on the church, so he opposes this stiffness with the suggestion of a freer, more open vista to the right.

In his two subsequent cityscapes, Monet achieved a greater structural variety and dynamism, not through such picturesque contrasts but through adjustments in his angles of vision. These adjustments are less disruptive and at the same time less limiting in their projection of the broad panorama of the city which was offered to Monet from his unusual vantage point. Also, it is for these subsequent views that experimentation with horizontal and vertical positions of the canvas format becomes a major consideration.

Princess Garden (Fig. 24) is the most capricious and willful of Monet's three cityscapes. The panorama of the city is viewed in such a way that the steep vertical format positively squeezes the motif, so much so that the visual compression lends considerable momentum to the vertical directionality already established by the format. By focusing this momentum on the dome of the distant Pantheon

5. Isaacson agrees that this date is incorrect.

and by halting the horizon roughly two-thirds of the way up on the vertical axis, Monet capitalizes on this verticality without granting it license to control the whole of his picture surface. Although compressed at the sides and relatively flat spatially (the picture lacks the conventional foreground of the earlier *Terrace*) Monet's view gives the essentials of topographical detail and position quite convincingly. The view provides these essentials without forcing the artist to make his brushwork overly descriptive. The brushwork remains quite abrupt, flat, and relatively unfused over the whole of the picture, becoming particularly rugged in its descriptions of the overcast sky.

The limited tonality of the picture (limited for the most part to greens, blues, black, and white) softens the impact of the brushwork somewhat and permits an even registration of the shifts in color value demanded by atmospheric perspective. Were it not for Monet's success in handling these shifts, the painting would collapse spatially. In the bottom of the picture Monet rejected the possibility of any assistance from linear perspective by permitting the perspective-implying diagonals of the garden to reverse themselves at the lower left corner. Having done this the garden becomes a truncated diamond shape—clearly two-dimensional in nature. Above this shape, areas of foliage and architecture intermingle in a soft symmetry that emphasizes the two-dimensional link between the upper tip of the diamond and the distant silhouette of the Pantheon.

Although the actual processes of Monet's design of the *Princess Garden* convey a sort of abstract logic of their own, they are clearly part of his attempt to project the momentum of visual movement across the great vistas of space that were provided by his elevated vantage point. In projecting this movement through his choice of format and through his abrupt linkages of near and distant elements, he again rejected the traditional devices of panoramic landscape painting—in this case devices of so-called classical landscape deriving from the works of Poussin and Claude.

The employment of high vantage points in "classical landscape" resulted from a desire for maximum control in the selection and organisation of pictured elements. These vantage points made possible the free manipulation of landscape, architectural, and figural parts so that ideal placements and effects could be readily secured. In the quest for an ideal order in the disposition of elements and in the dramatic use of local color and general tone, classical landscape sought to rival the grandeur and simplicity of classical poetry.

For that kind of poetry Monet pursued a more immediate and sensuous kind of excitement, the purely visual excitement of unconventional and disorienting views. It is evident that Monet was fully conscious of the available means for organizing and intensifying this excitement. In the *Princess Garden* Monet's adjustment of formal means to expressive ends operates to perfection. The sense of tentativeness and indecision noted in *St.-Germain l'Auxerrois* had passed completely.

For the third of his cityscapes of Paris, the *Quay of the Louvre* (Fig. 22), which could have been completed either before or after the *Princess Garden*, Monet used the long horizontal dimension of his format to give primary emphasis to the lateral dynamics of his view. His location and his focus on the dome of the Pantheon remains constant in this picture and in *Princess Garden*, but the force of this focus is here considerably reduced, as the dome becomes but one of a series of accents which shape the distant horizon. The actual line of the horizon produces a wedge-like separation between the city and the sky, reintroducing a preference already traced back to some of Monet's earliest landscapes. In the present context this separation acts as a foil to the general horizontality of Monet's picture, but equally it maintains the emphasis on spatially superimposed near and distant elements, an emphasis that has developed as a constant factor throughout the series of cityscapes.

Of the three cityscapes, *Quay* seems most sensitive to topographical variety. Separate areas—the quay, the river, the Ile de la Cité, and the distant left bank—are all recorded with an eye to their independent visual character, although once again the flat uniformity of Monet's brushwork and the space-reducing qualities of his viewpoint ensure a continuation of his surface-oriented conception of painting. The autumnal coloration of quayside trees (a factor arguing for a somewhat later date in the year for this picture) is equally important in generating pictorial variety. This coloration provides the warm tones which had been excluded from Monet's palette in the other two cityscapes and parallels the somewhat richer palette of forthcoming work from Ste.-Adresse.

Having relaxed in the *Quay* some of the abstract formality of the *Princess Garden*, Monet was more willing than at any other point in the cityscapes to introduce a sense of character into the figures who passed through his scene. Now sure in his control of the painting as an object, Monet opened his eyes to the complex of figural activity and social intercourse that took place on the quay beneath him. The result is that the figures are transformed from the rather anonymous black dots of the other two cityscapes and become defined entities in their own right. Without making a point of it, Monet grants that the magnificent spectacle of the city is incomplete without at least a passing record of the lives of the people around whom and for whom it is built.

Monet's new sensitivity to the life-role of figures in the scenic contexts he paints would lead him to some unusual developments in his works from Ste.-Adresse during the same summer, 1867. Although such sensitivity may appear to contradict the ahumanistic tendencies in his work of the previous year, this sensitivity remains purely visual in essence. The obsessive need to reject figural character now appears pointless since such character is, as a matter of visual fact, part of the segments of nature Monet chooses to paint. If the record of this character can be accommodated in strictly visual terms, it constitutes a perfectly acceptable part of Monet's style. Monet was never to emphasize figural character, but he would, for a time at least, permit it to emerge.

In his two views of the *Beach at Ste.-Adresse* (Figs. 25, 26), done at some point after his departure from Paris in the early autumn of 1867, Monet uses the varied character of his figures to distinguish two related paintings of the same scene. For one picture he introduces in the left foreground native Norman fishermen conversing around their small boats which rest on the beach. In this picture the bay is filled with other fishing boats heading out to sea. Except for two vacationers, seated somewhat back along the coast, the moment of Monet's view stresses the everyday nature of the place. For the second picture the moment shifts abruptly. The bay is filled with pleasure boats, participating in a regatta, and the shore is crowded with finely dressed urban types, grouped to view the spectacle.

Unlike the cityscapes of Paris, these two Ste.-Adresse pictures represent changes in the character of an identical location, brought about by the variety of uses to which men put this location. It is the presence of people acting in the place for different reasons that provides the change in the appearance of that place. Monet's view is, in contrast to that of the Paris pictures, relatively submissive. He does not force his viewpoint, nor does he appear to construct the scene arbitrarily. Instead he accepts the two distinct moments which the scene itself provides as a basis for two distinct pictures. This is not to say that the pictures are identical except for the shifts of character. Monet's viewpoint does shift somewhat from one to another.

For the first Ste.-Adresse picture (Fig. 25) he is situated quite close to the level of the beach. From this position the broad shapes of the various boats tend to dominate the view, and areas of beach,

sea, and the distant shoreline move around the boats in an easy unforced way, making spatial posi-
tions relatively simple to establish. Monet's brushwork is more varied than it had been for the Paris
pictures, and as a result the flattening qualities of his style are less evident. Brushwork and color
in this picture seem at every point adequate and just to the effect being transcribed. For the moment
Monet's style calls almost no attention to itself, but serves instead a somewhat neutral role.

Most of the same observations hold for the second picture (Fig. 26), except for the fact that a
slightly higher viewpoint emphasizes the broad pattern of water in the bay. In conjunction with
this Monet directs a great deal of attention to coloristic variations in the water itself. Responding to
a more brilliant sunlight than that indicated in the previous picture, he plays shifting tones of green
and blue against the more consistent coloration of the shore. The result is a recollection of the
Terrace of the previous year, but a recollection which is modified by a more subtle approach to color.

With these seaside scenes, Monet reentered a range of subjects which were at the time very nearly
autographic of his old friend and advisor Boudin. However, a comparison of their work in 1867
would indicate only the stylistic and conceptual distance which Monet had traveled on his own.
The genre quality in Boudin's beach scenes finds no echo in Monet who, no matter what conces-
sions he makes to figural character, remains firmly dedicated to giving breadth and force to his
picture as a total unit.

On one occasion in the Ste.-Adresse campaign Monet did very nearly trap himself by giving too
much attention to genre events. This happened in a large picture, the *Jetty at Le Havre* (Fig. 27),
which he intended to submit to the Salon of 1868. The actual scale makes it an important item in
Monet's work of this period, but it is in no sense a completely successful picture. More than anything
else, it demonstrates exactly what Monet's style cannot realize without sacrificing its basic tenets.

In order to see how Monet arrived at his decision to do such a picture as *Jetty*, it is necessary to
keep in mind the two beach scenes just discussed and to add to this background at least two other
contemporary seascapes which treat the open sea as an independent motif. The first of these, the
Fisherman's Hut, Ste.-Adresse (Fig. 28), still retains a certain typological tie with the beach scenes,
but the natural aspect of the scene has become much less civilized—the hut itself forming the last
vestige of human presence in what is otherwise a bald confrontation of barren cliffs and a choppy
sea. Having reduced his motif to a few major elements of sky, cliffs, and sea, Monet's technique
achieves an unprecedented boldness, as he struggles to give pictorial definition to the coloristic and
textural turbulence of the sky and the sea. In the second seascape (Fig. 29), this boldness is, if anything,
increased. Here Monet builds gnarled patches of pigment, often of a pure lead white, to evoke
waves breaking over the rocky shore and to lend weight to the cloud cover. The actual coloration
of the water moves from the graded tones of the beach scene to muddy greens and browns which
work over and through the white foam crests of the waves.

The boldness of Monet's execution in these seascapes is as uniform and unifying in its own way
as was the flat evenness of his brushwork in the Paris pictures or the more varied brushwork of the
beach scenes. As long as he maintains a basic uniformity within his technique for a given picture,
Monet seems able to handle an infinitely wide range of means and effects. When rejecting this
consistency, the results were less predictable, a fact which is made crystal clear in the *Jetty*, where
Monet began to think in narrative rather than pictorial terms.

The program of the *Jetty* continues directly from the two Ste.-Adresse beach scenes with their

accent on the way in which the presence and the aspect of human figures condition the appearance of various settings. In the particular instance of *Jetty*, the setting is a composite of the open sea, studied in the two seascapes, and the populated shore of the two beach scenes. The jetty, of course, functions as a walkway into the bay at Le Havre, connecting the shore with the lighthouse. It provides a location from which seaside visitors can confront the turbulence of the sea more directly than would be possible from the shore itself. From the jetty, spectators are surrounded by the sea on all sides, but they remain physically secure from it by the thin ribbon of masonry that stretches defiantly outward to the lighthouse.

Monet's painting shows the jetty at a moment just after a storm. The sea still moves violently, breaking against the jetty and the shore, but the sky has begun to clear, and a rainbow has appeared over the water at the right. In describing the scene Monet records substantive differences between the natural elements of the sky and the sea—which are rough, irregular, and rather threatening— and the stable geometrical masses of the jetty and the lighthouse. He expresses these differences through broad variations in brushwork and coloration. Against this pictorial turbulence appear the lightly drawn forms of the tourists and of the lamp fixtures, which together seem to scurry along the jetty. Having realized these components of the scene quite successfully, Monet confronts the problem of the rainbow. Needless to say, rainbows provide something of a challenge both coloristically and substantively, and this challenge is finally too much for Monet in the present context. The pictorial activity of the sky and sea force a strong and rather hard rendition of the coloration of the rainbow—a factor which completely obviates the balance of drawing, texture, and coloration operating elsewhere in the picture.

Monet was willing in this instance to sacrifice the pictorial cohesion of his painting for reasons of comprehensiveness in the treatment of the subject. His willingness to do this is somewhat baffling considering the persistent striving for unifying pictorial effects that characterized his efforts during the previous three years. However, it is probable that Monet's return from urban Paris to the familiar beaches of the Seine estuary and finally to the sea itself suggested a sort of narrative of homecoming, and this the *Jetty* set out to realize. His personal involvement with the subject matter of *Jetty* forced all other issues aside, leaving him with a moving but pictorially unsuccessful image of confrontation between civilized man and the sea.

3. Monet in 1868

Prior to 1868 Monet's work proceeded without interruption. The official Salon welcomed him in 1865 and 1866. He seemed destined for gradual, if unspectacular, success and an eventual income from his work. But beginning with the rejection of *Women in a Garden* from the Salon of 1867, his fortune took a bad turn, both figuratively and literally.

Monet's finances had never been particularly secure, but he managed during the early and mid-1860s to get along on the periodic subsidies provided by his family. Unfortunately this assistance came to a halt as he insisted upon pursuing a career that stood increasingly apart from recognized academic practice. He began by refusing to submit to academic training. The brief period in early 1863 which he passed in the studio of Charles Gleyre was the closest he ever came to such training. Once that studio closed, Monet was on his own, once and for all. His parents' objections notwithstanding, he was determined to work independently.

A favorite aunt, for a time at least, assisted Monet as much as she could.[1] She, along with Bazille (who purchased *Women in a Garden* in 1867)[2] made it possible for Monet to subsist economically during the first years of his struggle to gain official recognition. But in spite of this help he found himself in increasingly desperate financial straits, and the sheer effort of supporting himself and his pregnant mistress from the autumn of 1867 through the spring of 1868 nearly brought a halt to his career as an artist.

Monet seems to have done no painting at all during this time, and for the Salon of 1868 he was forced to enter a work of 1866.[3] Along with the equally penniless Renoir, he stayed out the winter in Bazille's Paris atelier.[4] Camille, and Monet's newborn son, Jean, were apparently dependent on the generosity of Camille's family during this same period. Somehow, Monet succeeded in getting sufficient funds to move himself, Camille, and their son to Fécamp in the spring of 1868, but things went from bad to worse financially. Monet's only hope lay in the person of a wealthy art collector from nearby Le Havre, a certain Monsieur Gaudibert.

On June 29 Monet wrote to Bazille from Fécamp:

> I was obviously born under a bad star. I've just been thrown out of the hotel, as naked as a
> baby. I've found a few days lodging for Camille and my poor little Jean in the country. I'm

1. Mount, *Monet*, discusses Monet's finances on a virtual month-by-month basis. See especially pp. 158–80.
2. Poulain, *Bazille*, p. 72.
3. Rewald, *History of Impressionism*, p. 155.
4. Poulain, p. 114.

leaving this evening to see about doing some things for my "amateur" in Le Havre. My family won't do anything for me. At this point I don't even know where I'll be sleeping tomorrow.

Shortly after this letter, Monet confessed in another note to Bazille to having attempted suicide: "I was in such a mess here that I made the mistake of throwing myself into the water. Fortunately, nothing resulted from this."

Finally in late August or early September, Monet got the break he had been waiting for: "My patron in Le Havre has called on me to do a portrait of his wife"[5] (Plate 9). Monet's relief, in the face of this apparent good fortune, was understandably great, and a few weeks later he wrote to Bazille of his situation and of his plans for future work. This letter because of its importance is here quoted in its entirety.

I am surrounded here by everything that I love. I pass my time out of doors on the pier, when there is something going on, as when the boats head out for fishing; otherwise I go into the country, which is beautiful around here, [and] which I find more pleasant in winter than in summer; naturally, I'm working all the time, and I believe that I may yet do some serious things this year. After dinner, my dear friend, I find in my little cottage a good fire and a wonderful little family. If only you could see how cute your god-son is right now. My friend, it is fascinating to be able to see this tiny creature, and believe me I'm glad to have him. I'm going to paint him for the Salon surrounded by other figures as usual. I'm going to do this year two figure pictures: an interior with the baby and two women, and some sailors out of doors. I want to do this in a spectacular manner. Thank heaven for this gentleman from Le Havre who came to my aid; I am enjoying the most perfect tranquility. I would like to stay this way for good, in a corner of the world as tranquil as this. Consequently I don't envy your being in Paris. Don't you think that one is better off alone with nature? One is so completely pre-occupied with what one sees and hears in Paris, if one is to remain strong; what I do here will at least have the merit of not resembling anybody, because it is simply the expression of what I've experienced by myself. The more I go on, the more I regret how little I know. That's what makes me most uncomfortable. I hope that you are ambitious and that you are working hard. People who are well off like you should be producing marvels. Tell me what you will have [ready] for the Salon and whether you are content with it. I suggest that you send me all my works which you have [with you] there. I have lost so many that I cling to those which remain. Also, if you want to do me a favor, look in our closets for the white canvases that I left behind and also for any pictures where there are unfinished parts, like your standing portrait and another work from 1860 where I did some bad flowers. Look [around] and send me everything you find which I can use. Look through everything carefully, my friend [and] you will do me a great service, because I'm working so much that I've used nearly all the canvases I have, and [of course] there is Charpentier [a dealer in artist's supplies] who is going to stop my credit. He's making me pay cash, and you never know how much things may cost.[6]

Monet's letter outlines several factors that will affect his forthcoming painting, causing it to assume a somewhat different aspect from that of his last important campaign which had terminated almost a

5. Ibid., pp. 120, 129.
6. Ibid., p. 130.

year before in the autumn of 1867. The work he was about to begin at Fécamp would not continue directly any of the major interests of 1867. The intervening year had disrupted Monet's artistic development and radically changed the circumstances of his life. This disruption was to have a marked effect on his painting; it would be years before he could recapture the momentum evident in his work from mid-1866 through the fall of 1867.

Certain difficulties were inherent in Monet's commission for the portrait of Madame Gaudibert. It was obviously planned as a paraphrase of Monet's very successful *Camille* (Plate 8) of 1866. *Camille* had been a slightly atypical performance to begin with. It had emerged at a difficult moment in his career, served its purpose, and exercised very little direct influence on Monet's work immediately thereafter. Now, late in 1868, after two and a half years and following a long period of forced inactivity, Monet agreed in the face of dire financial circumstances to duplicate the style of the *Camille*. In effect, he agreed to reopen what was clearly a closed chapter in his development, in order to gain the financial security necessary for a return to other work that interested him directly.

The Gaudibert commission may at first have seemed a godsend to Monet and, never lacking confidence in his own abilities, he assumed quite reasonably that he could fulfill his obligation with a minimum of effort. As he was soon to discover, this was not the case, and in the spring (probably April) of 1869 Monet was still involved with the portrait, either completing or revising it, and he complained in a letter to Bazille: "My painting doesn't go, and I'm definitely discounting the idea of glory (for myself). I'm falling into the third rank."[7]

By the time this letter was written other matters were also conspiring to attack Monet's confidence, but the simple fact that this picture—the challenges it presented and the crises it provoked—stands as a constant factor linking Monet's optimism of 1868 and his depression of the following spring, singles it out as the key to relative success or failure in Monet's work during this period. The Gaudibert portrait, by its very demand for a reprise of effects from the *Camille*, was unable to give firm direction to Monet's work. Instead it demanded compromise. For an artist like Monet who performed well only when following the dictates of his own developing interests and when solving the problems to which these interests led, compromise predicated crisis and indecision.

Stylistically speaking, the crisis provoked by the Gaudibert portrait involved the question of reconciling the transcriptively precise illusionism of the *Camille* with the bolder, more varied pictorial effects that had appeared in Monet's work after the completion of *Camille*. In other words, Monet placed himself between two totally contradictory tendencies in his own art—tendencies that would never have required compromise had it not been for the demands of the Gaudibert commission.

An artist like Renoir, whose artistic frame of reference was composite, not to say eclectic, could easily have dealt with the sort of situation that Monet faced in this particular instance. However, Monet was not Renoir; he could not think of the *Camille* without at the same time being aware of what had transpired in his own work, both in response and in reaction to that painting. He could not force himself to make a replica, and some sort of stylistic compromise or reconciliation posed the only other alternative. The nature of his compromise affected not only the Gaudibert portrait but the

7. Ibid., p. 39.

remainder of his work from this period as well. Without bringing Monet's development to a complete standstill, the picture did precipitate a number of difficulties.

The only surviving indication of Monet's work in the period immediately prior to the Gaudibert project appears in a painting of Camille, probably done in the late summer of 1868. This painting, *The River* (Fig. 30), is clearly a continuation of technical and conceptual interests previously defined in Monet's work of 1866 and 1867. Like *Women in a Garden* and the beach scenes from Ste.–Adresse, *The River* is a figure piece set out-of-doors. The importance of the figural component lies somewhere between the extremes of works from 1866 and 1867. The figure is clearly dominated by the setting, but it is quite large in its actual scale relative to the scene as a whole. Characteristically, the figure is seated with her back to the viewer so that no psychological factors interfere with the presentation of view as a total scenic fact.

The motif is quite complicated. An overhead view acts, as it had in several previous pictures, to flatten out elements which, in the view itself, were displaced spatially. The tree at the left of the picture is cut off abruptly at the left and upper edge of the canvas so that its traditional space-defining function collapses in favor of a flat silhouette. This is consistent pictorially with the apparent flatness of the riverbank, the river surface, and the distant shore, all of which align themselves in two dimensions as a result of Monet's overhead view. The figure of Camille is described in a rugged, almost brutally impersonal fashion with broad, heavily loaded brushstrokes that give only the most basic description of position and substance. Modeling as such does not exist. Monet seems most interested in contrasting the surfaces of the figure as defined by indirect light with the fully sun-struck surfaces of the houses on the distant shore. The latter appear both as actual elements in Monet's view and as direct but inverted reflections in the smooth surface of the river beneath them. In the area around the figure of Camille, only the reflected image of these houses remains in view—the actual image being blocked by the foliage of the tree that spreads out over Camille's head.

Taken as a whole, *The River* stands as a perceptual commentary on the relativity of vision. The picture brings together elements which are by their very nature indirect in their presentation of appearance and substance. Silhouetting and appearance through reflection—both are frequent but ambiguous aspects of visual perception, and it is these aspects that Monet seizes upon as appropriate to the abrupt flatness of his technique and the strong two-dimensional impetus of his viewpoint. Circumstances brought about by the Gaudibert commission conspired to prevent Monet from developing the interests which appear in this picture. However, Monet's impressive campaign at Bougival in mid-1869 (carried on in the company of Renoir) does reflect precedents in *The River*, intensifying the focus on complicated aspects of natural appearance and widening the range of coloration far beyond the simple contrasts of the present picture.

It is impossible to determine on the basis of documents the exact chronology of Monet's work during the period of the Gaudibert portrait. The portrait itself is dated 1868 and was probably finished (although possibly reworked the following year) in the late fall or early winter. A large indoor *Déjeuner* (Plate 7), one of the projects that Monet outlined in his long letter to Bazille, is not dated. It seems reasonable to assume that this picture was begun at some point after Monet's completion of the commissioned portrait, but in time for presentation to the jury of the spring Salon in 1869. Besides these two major projects, there are several informal and generally small-scale paintings which remain from Monet's work of this period. Included among them are paintings of Camille (Fig. 31), Jean in his cradle (Figs. 32,33), still lifes (Figs. 34, 35), one outdoor view of boats in the harbor at Fécamp

(Fig. 36), and at least one drawing of a similar subject (Fig. 37), and finally two trial runs for the *Déjeuner* (Figs. 38, 39). The group of small pictures appears, for reasons discussed below, to bridge the period between the Gaudibert portrait and the beginning of work on the *Déjeuner*.

Before considering Monet's work in general for this period, it is essential to define very specifically the challenges and frustrations of the Gaudibert portrait itself. The problems which emerge in this picture are as vexing as they are numerous.

The basic changes that appeared in Monet's style during the interval of two and a half years that separates the completion of the *Camille* from the beginning of work on the *Mme. Gaudibert* have already been described. Exactly how Monet attempted to deal with the many conflicts which resulted from these changes remains to be demonstrated.

Monet's first step towards reconciling the old and the new in his style occurred in his selection of the background against which the figure of Madame Gaudibert was to be seen. Monet here rejected the ambiguous floor and dark drape of the *Camille* and chose instead a highly complicated setting which includes a patterned rug, a light background curtain, and a wood table holding a vase of brightly colored flowers. Against this Madame Gaudibert appears in a silver-gray satin dress, around which she holds a red wool shawl. Monet has removed all broad contrasts of color that might serve to project the figure from its setting. Instead, he has decided to work with related colors and color values which tend to draw the figure and the setting together. To intensify the situation, he has lighted the picture almost uniformly, as if relying on the even illumination from a broad skylight window. By so doing broad passages of shadow are eliminated, and with them another potential device for projecting the figure from its setting.[8]

Monet relies of necessity on his precise analysis of color values for the coherent projection of his subject and of the context in which it appears. Given the range of elements to be described, a relatively tight and descriptive technique would seem to be demanded in order to control narrow visual distinctions of texture and coloration. But here Monet walks a tightrope. He attempts to retain a uniform breadth and directness in his brushwork and simultaneously to use individual strokes to suggest subtle shifts in texture and coloration.

On the one hand Monet's behavior in the process of paraphrasing the *Camille* is consistent with the self-determination that seems always to have guided his action as an artist. On the other hand, this behavior is in the context of *Mme. Gaudibert* self-defeating and in many ways pointless. The picture, as it stands, is more a logical demonstration of problem-solving than a painting realized as painting. The picture totally lacks a sense of inevitable rightness in the discovery of technical conventions applicable to the motif at hand. Instead it seems to belabor its own procedural complexities.

The painting is not pointedly unsuccessful in resolving any of its various aims. However, the almost diagrammatic character of the brushwork, which the viewer is forced to follow in an endless path across identifiable but unloved surfaces, is boring if not actually repellent. Coloristically, Monet's efforts to evoke a uniform lightness produce a brittle and somewhat washed-out thinness which benefits neither the painting as a whole nor the individual parts.

8. The complicated costume and setting of the *Mme. Gaudibert* may indicate that Monet was challenging some of the effects common in the more fashionable realist portraiture of Alfred Stevens and Carolus-Duran. Mount makes a similar suggestion in relation to the *Camille* and to figures in the *Déjeuner sur l'herbe*, where he finds references to Winterhalter (*Monet*, pp. 90, 97, 116).

In his efforts to produce a viable revision of the *Camille*, Monet clearly lost more than he gained. A small portrait of Camille seated on a sofa (Fig. 31) in the family house at Fécamp provides a more successful realization of the same scheme. It is quite possible that this small picture, also an indoor portrait, represents some sort of trial run for the Gaudibert commission. Monet's palette is distinctly related in both works, although the smaller tends because of its size to stress stronger contrasts of color value for purposes of clarity. But most important is the similarity of brushwork as it appears in the two pictures. In both, rather textureless strokes define shapes, textures, and relative color values. Because of their uniformity and general lack of inflection, these brushstrokes tend to dissolve into a continuous web of evenly modulated paint. The smaller picture, again because of its size, presents a less demonstrative and diagrammatic surface, but its essential qualities are closely related to those of the *Mme. Gaudibert*, and it seems likely that Monet went to work on the larger picture after having arrived at a relatively satisfactory procedure in the context of the smaller.

Granted the plausibility of this speculation, there would be a clear parallel between the Gaudibert portrait and the project for a large-scale *Déjeuner sur l'herbe* in 1866—a parallel in the basic mode of operation. In both instances Monet worked from a framework of style which had been established in paintings of one size and attempted to transfer the essentials of this style to a much larger work conceived in a similar fashion. He may once again have miscalculated the effects of enlargement, but, whatever the case, his painting for the next several months would attempt to bring about a closer stylistic coherence in the effects obtainable in works of widely varying sizes. Viewed from the vantage point of his work of the 1870s, Monet's effort at this time to maintain an ability to produce pictures on canvases of a monumental Salon scale seems anachronistic, but it is important to remember that in the late 1860s Monet still hoped to receive official recognition. This, of course, necessitated the cultivation of a "monumental style" not only for portrait commissions such as the *Mme. Gaudibert* but also for Salon pictures.

The two large paintings which Monet had planned in his long letter to Bazille (an interior with the baby and two women, and some sailors out of doors) were certainly intended as the Salon side of his work for the winter of 1868–69. One of these, the large indoor *Déjeuner* (Plate 7), actually came to fruition, only to be rejected by the Salon of 1869. Predictably, this picture was anticipated by a group of smaller works which examine many of the elements eventually combined in the *Déjeuner* itself. Coming in the wake of the *Mme. Gaudibert*, this group of paintings is quite comprehensive in its selection of motifs and its exploration of technical effects. Being comprehensive, the group provided a broader working base than that offered by the small portrait of Camille which, as noted above, seems to have been a preliminary exercise for the *Mme. Gaudibert*.

Not all of Monet's smaller works from this period are done in direct anticipation of the large *Déjeuner* but, as a group, they establish a complex of style (both as an absolute and as applied to specific types of motif) that reacts against the rigidity of the *Mme. Gaudibert*. A small *plein air* study of boats in the harbor at Fécamp (Fig. 36) recalls works from the summer of 1867 as well as *The River* from 1868. But more important are two paintings of Monet's son Jean, asleep in his cradle. In these, as in two contemporary still lifes, Monet appears to be making a concentrated effort to couple the breadth and distinctiveness of his brushwork that had appeared in the *Mme. Gaudibert* with a more delicate sense of textures. It is evident in the *Still Life with Fish* (Fig. 34) that Monet's new interest in texture is not in any sense related to that direct equation of pigment and real texture which he had

tested in the *Camille* of 1866. Instead, the new interest seems to take as a point of departure *The River* and to work into the generally continuous fabric of brushwork which appears in that picture a greater flexibility in the transcription of textural effects. This flexibility is intended to correct the diagrammatic inflections of brushwork in the *Mme. Gaudibert*. This movement away from the style of *Mme. Gaudibert* is seen most clearly in Monet's subtle variation of the consistency of the paint itself. Such variations replace the dry, unyielding surface of the *Mme. Gaudibert* and enable Monet to project a subtler range of textures without compromising the breadth and consistency of his brushwork.

The success of Monet's more flexible approach to the painting of delicate textures is apparent in the *Still Life with Fish* (Fig. 34). Without resorting to glazes or any other sort of technical cliché, he is able to project a wide range of textural effects, easily encompassing the reflective surfaces of the fish and the heavy folds of cloth beneath. His actual brushwork is uniform in character without laboring its uniformity. Minute inflections in the brushwork and in the thickness of the paint record the unique way in which each element of texture responds to the available light.

The two paintings of Jean in his cradle (Figs. 32, 33) contain a wider variety of textures than the still life and add further problems of printed fabrics and painted dolls. These complications occur within a range of color which is nearly identical with the muted pinks, grays, and whites of the still life. Nevertheless, Monet manages to devise a sort of technical shorthand that is capable of generalizing these complications without sacrificing the identity of any individual element. His success is particularly apparent in the smaller of the two paintings (Fig. 33) where he is able to distinguish the painted face of the doll from that of his son by a simple adjustment in the pattern of his brushwork.

Comparing these three paintings with *Mme. Gaudibert* it is clear that Monet was unwilling to give up the bold, "painted" look of the portrait. What he did do was eliminate the system of regular intervals between individual brushstrokes and to make these intervals respond in a more sensitive fashion to the particular effects they describe. This change of procedure is more important than may at first appear. It amounts to a complete reversal of the relationship between the appearance of the painting and the motif which the painting presents. In *Mme. Gaudibert* the surface appearance of the painting has been determined, and pictorial unity results from a system that is formulated a priori. In these three subsequent pictures the quality of the painted surface is discovered while the work is in process, and unity occurs as a product of this discovery.

The technical experimentation that appears in Monet's working method at Fécamp does not achieve any final resolution. For the moment Monet remains committed to the open, exploratory position. As he continues to work through the winter and into the spring of 1869 his paintings test both the advantages and the disadvantages of his procedures. The advantages are most apparent in a painting of Camille, *Mme. Monet in a Red Cape* (Fig. 40).

The dating of this picture has never been securely fixed, but its color choices (which are closely related to the *Mme. Gaudibert*), its domestic subject matter, and the open quality of its technical effects all seem to suggest that it was painted at Fécamp at some point after *Mme. Gaudibert* and before the large indoor *Déjeuner*.

With the exception of the *Boat in the Harbor at Fécamp*, *Mme. Monet in a Red Cape* is the only picture from this period which seems to continue Monet's interest in outdoor subjects. Although not painted outdoors, the picture is conceived as a logical winter view of the out-of-doors. Monet here presents a

winter scene from the confines of his house—a view through a large French window of Camille passing in front of a blurred landscape of snow and winter foliage. The painting shares many of the positive qualities of the *Still Life with Fish*. However, forceful geometrical conventions of composition remove it from the general orbit of contemporary works and anticipate directly effects in the large indoor *Déjeuner*.

Monet uses the geometry of the *Mme. Monet in a Red Cape* in a way which recalls his periodic reliance on geometrical devices in earlier works. In the present instance the window casement is directly aligned with the axis of the picture plane to establish a broad, grid-like structure for the picture as a whole. The space-compressing qualities of this grid, in conjunction with the painting's generally monochromatic palette, provide obvious anticipations in this work for later Nabis painting, as that from the early career of Vuillard.

A second function of the window casement (and the geometrical emphasis it establishes) is to eliminate the foreground of the picture and to push the center of visual concentration back to the plane of the window. As a result the curtains which stand directly inside the window and the figure of Camille which stands directly outside it exist at virtually the same distance from the viewer. This distance validates a more summary treatment of details and textures than Monet could have permitted in any of the other Fécamp pictures. Monet's technique easily generalizes the basic elements of the view, simplifying many of them but never emphasizing this simplification. More than in any other picture from Fécamp, Monet is able here to derive all necessary description from modulations of color value and from narrow shifts of brushwork and paint density. He had arrived at a similar point stylistically in his landscapes of 1867, but *Mme. Monet in a Red Cape* seems in the context of work at Fécamp an important advance nevertheless.

Monet's plans for the indoor *Déjeuner* probably began to take shape shortly after his work on the *Mme. Monet in a Red Cape*. Two small paintings of the *Sisley Family at Dinner* (Figs. 38, 39) are directly preparatory for this *Déjeuner*, and they seem to operate within a framework of style that reflects the *Mme. Monet in a Red Cape*. At this point then, it is necessary to examine the project for the indoor *Déjeuner* in some detail.

Monet's decision to paint a large indoor scene of Jean surrounded by women had, as we have seen, been made at the very beginning of his stay at Fécamp. He mentioned it in an early letter to Bazille, and it seems clear that he intended the *Déjeuner* to stand alongside the *Mme. Gaudibert* as a major monument to his return to work. Had it been accepted by the Salon jury of 1869, the *Déjeuner* would have carried Monet's hopes for public recognition, and it might conceivably have reopened communication with his family.

The painting was clearly planned as a display piece—a complicated and large-scale figure composition. The subject for the picture, while an obvious document of Monet's momentarily blissful domestic life, may also have involved the influence of Manet, as some writers have hypothesized.[9] Manet's *Déjeuner à l'atelier* (Fig. 41) had been painted in mid-1868 and was to appear in the Salon of 1869. There are several general similarities between this picture and Monet's. Since the two artists were acquainted with each other at this time, it is quite conceivable that Monet could have seen Manet's picture before having decided on his own. It has even been suggested that Monet may have

9. Seitz, *Monet*, p. 80.

posed for one of Manet's figures before departing for Fécamp. Whatever the case, the two paintings have been considered together virtually from the time of their completion, a fact attested to by drawings after both paintings which exist on adjacent pages of Bazille's sketchbook of 1869.[10]

If Monet's and Manet's paintings are in fact related, they stand in the same relation to each other as do their respective *Déjeuners sur l'herbe* (Plate 3 and Fig. 5). That is to say, Monet's revises Manet's on the basis of a more directly realist method. The stiff studio poses and the highly arbitrary placement of Manet's figures would certainly have bothered Monet. Similarly, the narrative pretext of the luncheon still life coupled with the psychological vacuum existing between the various figures would have appeared to be disruptively artificial. Monet had by now adopted a more neutral and easygoing approach to figure subjects. Manet's way of suspending narrative coherence in order to project individual figures more forcefully was in basic opposition to Monet's increasing willingness to view almost any sort of situation with an attitude of scenic neutrality. A variance of attitude between the two had been implicit in 1866, and their confrontation in two works of similar conception in 1868–69 serves to underline this once again.

Neither artist was willing to permit narrative relationships between figures to undercut the formal aspects of his picture. However, Monet tried to accept these relationships and to work around them, while Manet chose to make such relationships highly ambiguous. Monet's highly impersonal approach to the *Camille* (Plate 8), the *Women in a Garden* (Plate 2), and to the figures in the *Terrace* (Plate 5) had served its purpose by enabling him to concentrate on formal and technical problems. Once these problems and their various solutions had developed a certain momentum and self-sufficiency in their own right, the danger of permitting narrative events to reappear was less acute. For Manet, on the other hand, the human figure had been, and would continue to be, a powerful icon, optically forceful and psychologically arresting as a unit. Complexes of figures consisted of several figure units, none of which could be permitted to interact with another in a simple narrative fashion without entailing some sacrifice in the impact of each figure on the viewer. Monet's indoor *Déjeuner*, on the other hand, deemphasizes individual figures in its presentation of a complex of figure and nonfigure elements which compete for visual primacy. As a background for Monet's acceptance and development of this mode of presentation, the two small paintings of the Sisley family at dinner (Figs. 38, 39, Plate 7) demand at least summary consideration.

These pictures offer first of all the cast of characters for the *Déjeuner* (Plate 7). Sisley and his wife appear to have been Monet's guests at Fécamp for a considerable period of time, during which Monet took advantage of their presence and used them as models.[11] Both versions of the Sisley family are painted indoors in artificial light, the first showing figures grouped around the dinner table and the second showing Sisley by the fireplace with women sewing around the table. A double source of light is provided by the lamp that hangs over the table and by the fireplace to the right. The light so produced is highly diffuse and irregular, giving a spotty illumination to the figures and setting as well. Bold patterns of shadow interweave with areas receiving more or less direct light, creating a

10. These drawings appear in an album now in the Drawings Department of the Louvre, Paris. The catalogue numbers in Daulte, *Bazille*, are D 38, fols. 4, 5.

11. The identification of the figure of Mrs. Sisley in the indoor *Déjeuner* is based on the resemblance of the female figure, seated next to Jean Monet, to Mrs. Sisley as she appears in Renoir's portrait of *Alfred Sisley and His Wife* (Fig. 76). See also John Rewald, "Notes sur Deux Tableaux de Claude Monet," *Gazette des Beaux Arts* (Oct. 1967), 245–48.

Plates

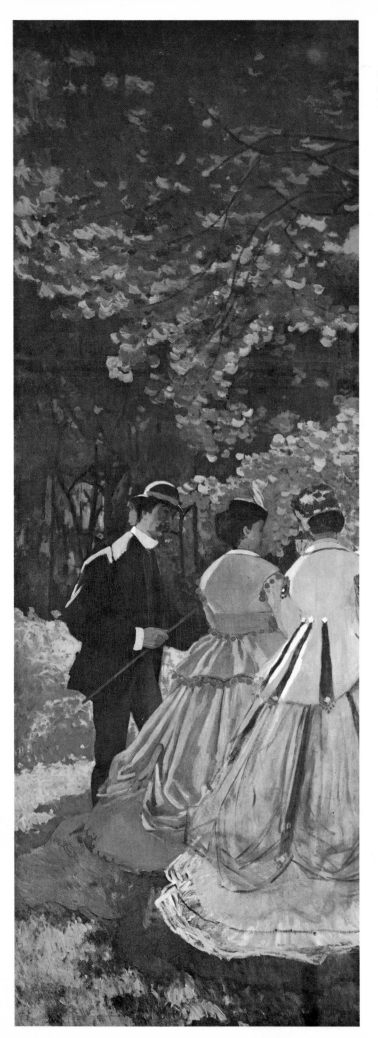

PLATE 1. Monet, *Déjeuner sur l'herbe* (fragment from left side of large version), unsigned, 165″ × 59″, Louvre, Paris. Photo: Cliché des Musées Nationaux.

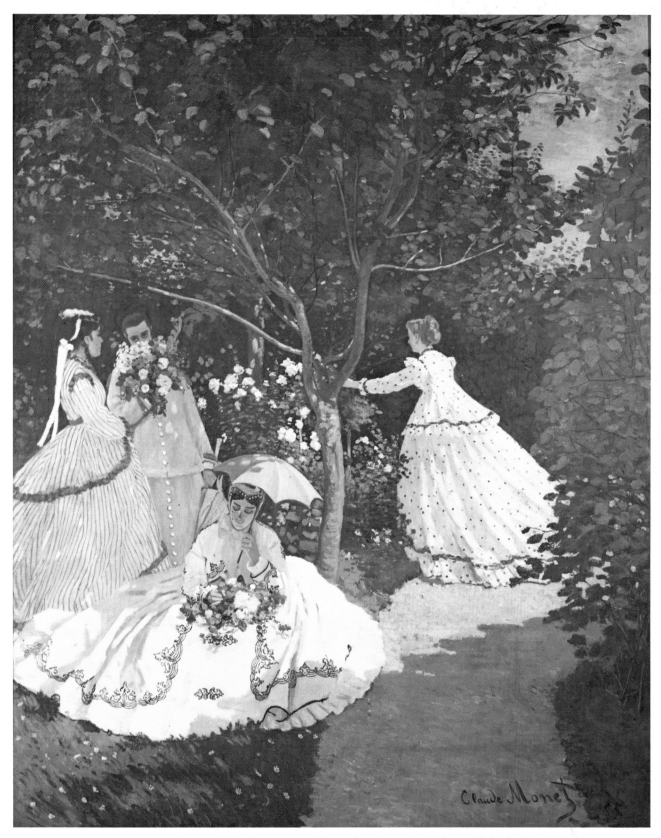

PLATE 2. Monet, *Women in a Garden*, signed Claude Monet, $100\frac{1}{4}'' \times 81\frac{3}{4}''$, Louvre, Paris. Photo: Cliché des Musées Nationaux.

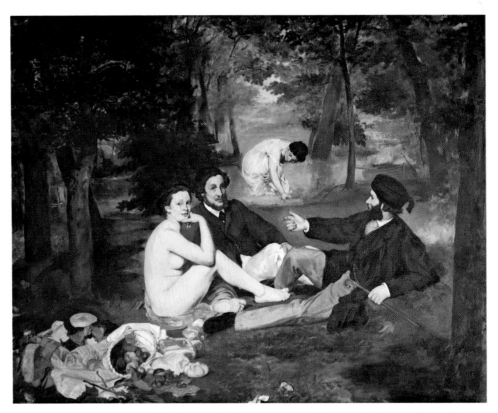

PLATE 3. Manet, *Déjeuner sur l'herbe*, signed Ed. Manet 1863, $84\frac{1}{4}''\times106\frac{1}{4}''$, Louvre, Paris. Photo: Cliché des Musées Nationaux.

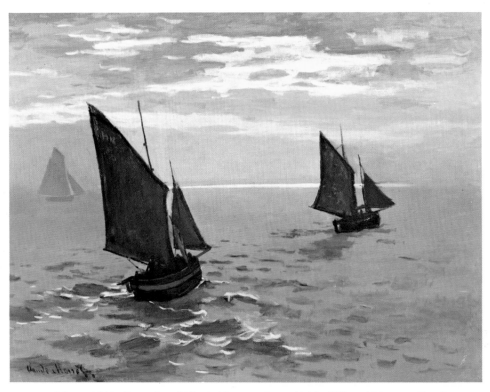

PLATE 4. Monet, *Fishing Boats*, signed Claude Monet, $37''\times50\frac{1}{2}''$, The Hillstead Museum, Farmington, Connecticut.

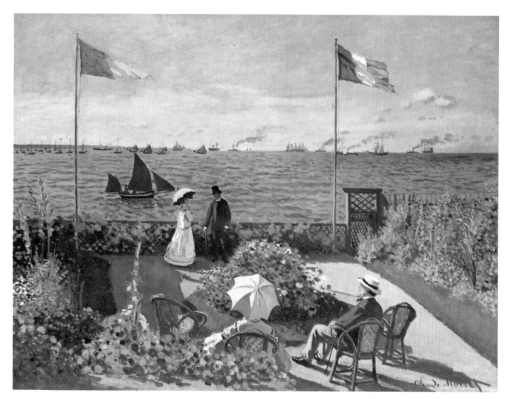

PLATE 5. Monet, *Terrace at Le Havre*, signed Claude Monet, $37\frac{7}{8}'' \times 50\frac{3}{8}''$, The Metropolitan Museum of Art, New York.

PLATE 6. Monet, *The Bridge at Bougival*, signed Claude Monet, $25'' \times 36''$, The Currier Gallery of Art, Manchester, New Hampshire.

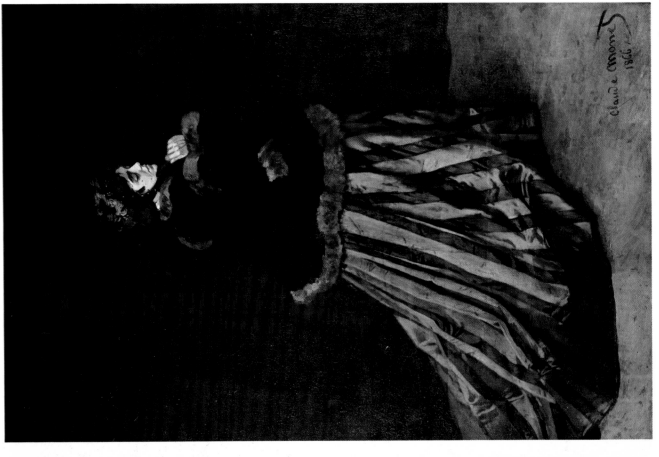

PLATE 8. Monet, *Camille (Woman in a Green Dress)*, signed Claude Monet 1866, 91¼" × 60", Kunsthalle, Bremen, West Germany.

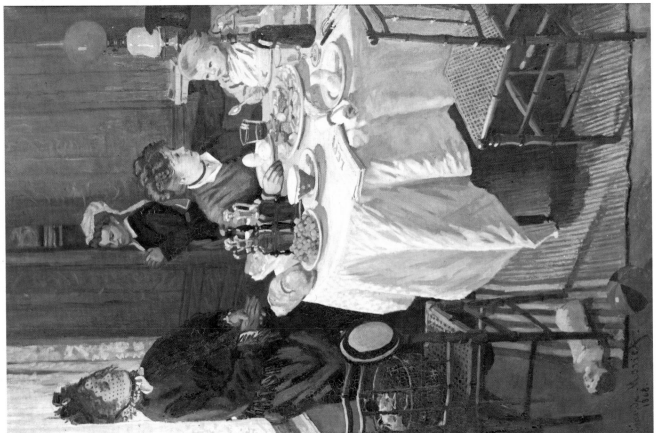

PLATE 7. Monet, *Déjeuner (Indoors)*, signed Claude Monet 68, 75⅜" × 49¼", Staedelsches Kunstinstitut, Frankfurt/Main, West Germany.

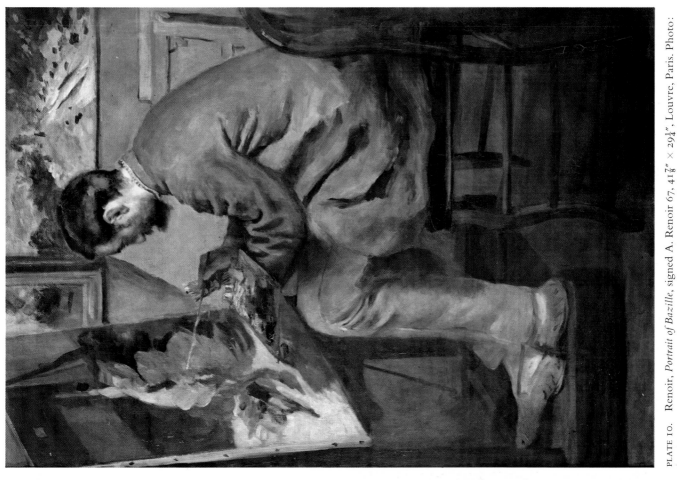

PLATE 10. Renoir, *Portrait of Bazille*, signed A. Renoir 67, $41\frac{7}{8}'' \times 29\frac{1}{4}''$, Louvre, Paris. Photo: Cliché des Musées Nationaux.

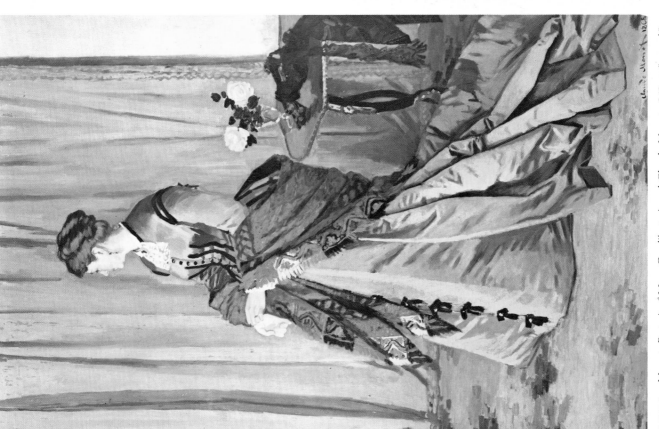

PLATE 9. Monet, *Portrait of Mme. Gaudibert*, signed Claude Monet 1868, $90'' \times 57\frac{1}{2}''$, Louvre, Paris. Photo: Cliché des Musées Nationaux.

PLATE II. Monet, *La Grenouillère*, signed Claude Monet, $29\frac{3}{8}'' \times 39\frac{1}{4}''$, The Metropolitan Museum of Art, New York.

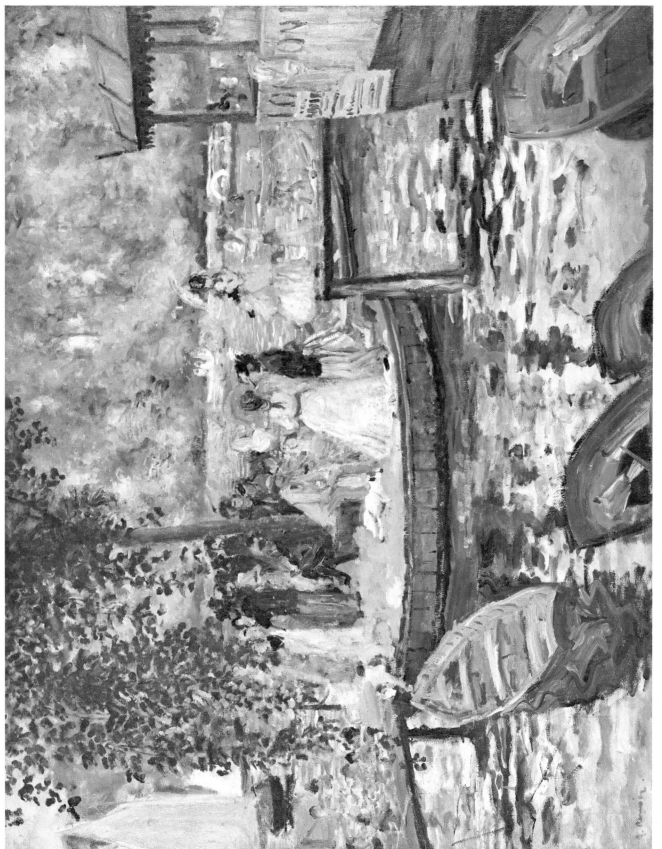

PLATE 12. Renoir, *La Grenouillère*, signed A. Renoir, 26″ × 31⅞″, National Museum, Stockholm.

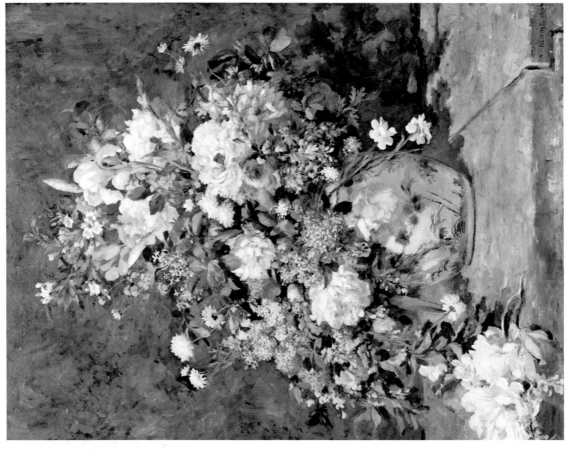

PLATE 14. Renoir, *Spring Bouquet*, signed A. Renoir 1866, 41″ × 31½″, Fogg Art Museum, Harvard University, Cambridge, Massachusetts. Bequest of Grenville L. Winthrop.

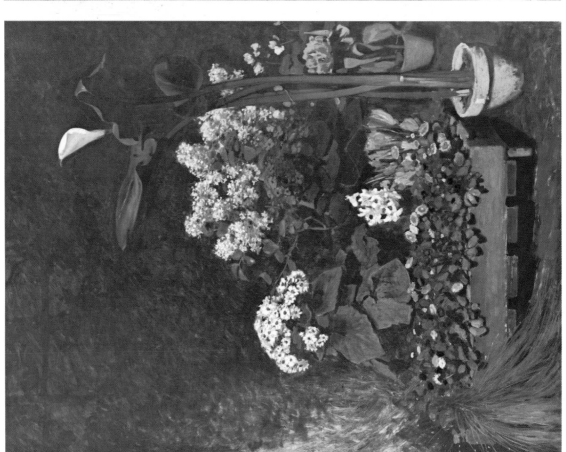

PLATE 13. Renoir, *Flower Still-Life*, signed Renoir, 51¼″ × 37¾″, Kunsthalle, Hamburg, West Germany.

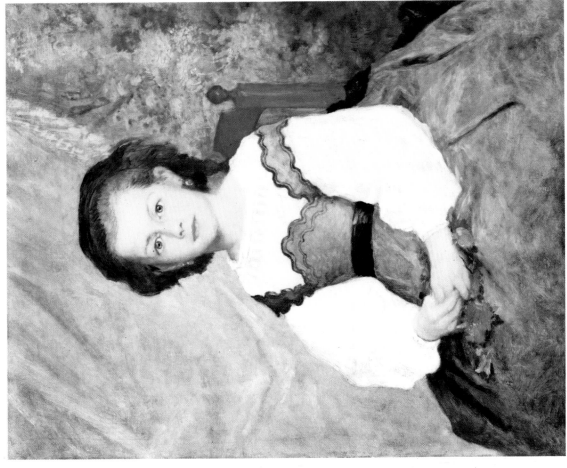

PLATE 16. Renoir, *Portrait of Mlle, Romaine Lacaux*, signed A. Renoir 64, 20″ × 26″, The Cleveland Museum of Art, Bequest of Leonard C. Hanna, Jr.

PLATE 15. Renoir, *Lise Holding a Parasol*, signed A. Renoir 67, 71½″ × 44½″, Folkwang Museum, Essen, West Germany.

PLATE 17. Renoir, *Mother Anthony's Inn*, signed Renoir 1866, 76″ × 51″, National Museum, Stockholm.

PLATE 18. Pissarro, *Still Life*, signed C. Pissarro 1867, 32″ × 39½″, The Toledo Museum of Art, Toledo, Ohio. Gift of Edward Drummond Libbey, 1949 (P. & V. 50).

PLATE 19. Pissarro, *The Banks of the Marne at Chennevières*, signed C. Pissarro, 37¼″ × 56¾″, National Gallery of Scotland, Edinburgh (P. & V. 46).

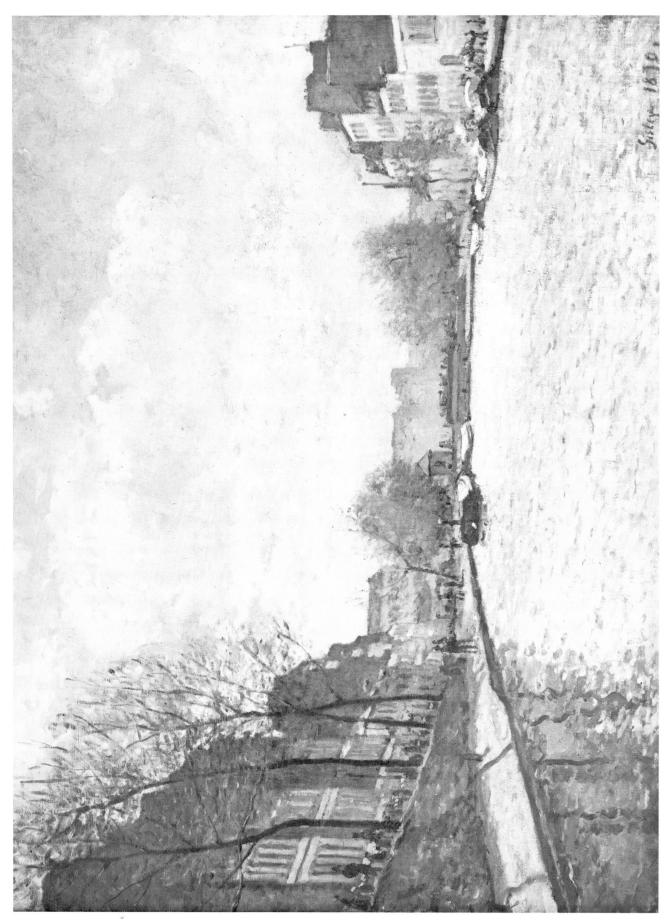

PLATE 20. Pissarro, *Banks of the Marne, Winter*, signed C. Pissarro 1866, $36\frac{1}{8}'' \times 59\frac{1}{8}''$, The Art Institute of Chicago, Mr. and Mrs. Lewis L. Coburn Fund (P. & V. 47). Photo: Courtesy Art Institute of Chicago.

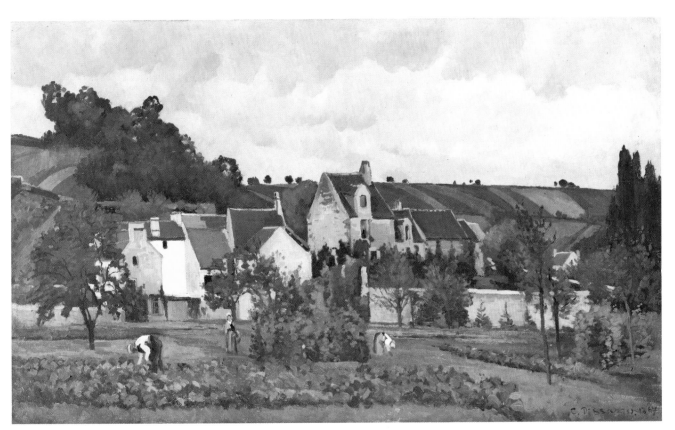

PLATE 21. Pissarro, *Hermitage at Pontoise*, signed C. Pissarro 1867, $37\frac{1}{2}'' \times 62\frac{1}{2}''$, Wallraf-Richartz Museum, Cologne, West Germany (P. & V. 56).

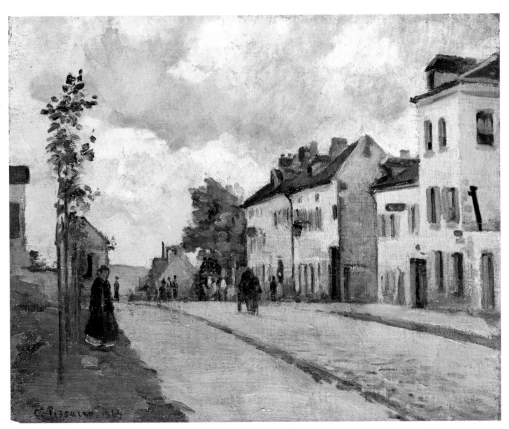

PLATE 22. Pissarro, *Road to Gisors*, *Pontoise*, signed C. Pissarro 1868, $15\frac{3}{4}'' \times 19\frac{1}{3}''$, Kunsthistorisches Museum, Vienna (P. & V. 63).

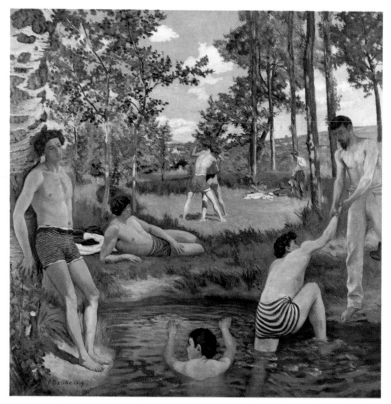

PLATE 23. Bazille, *Summer Scene (Bathers)*, signed F. Bazille 1869, 63¼″ × 63¼″, The Fogg Art Museum, Harvard University, Cambridge, Massachusetts. Gift of M. and Mme. Meynier de Salinelles (D. 44).

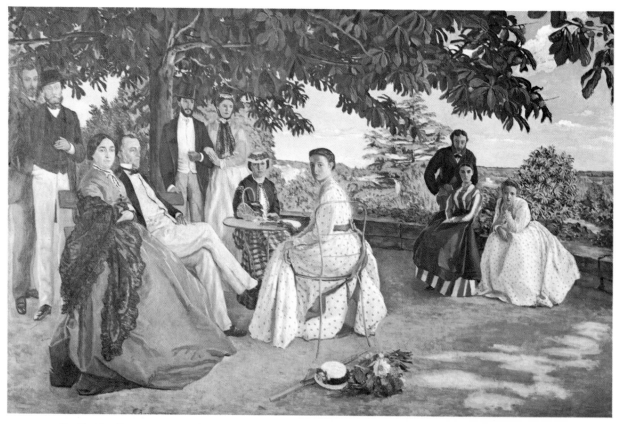

PLATE 24. Bazille, *Family Reunion*, signed F. Bazille 1869, 60¾″ × 91″, Louvre, Paris (D. 29). Photo: Cliché des Musées Nationaux.

PLATE 25. Sisley, *Chestnut Grove at Saint-Cloud*, signed A. Sisley, 21″ × 27⅓″, Ordrupgaard Museum, Copenhagen (D. 2).

PLATE 26. Sisley, *Village Road in Marlotte*, signed Sisley 1866, 25⅝″ × 36¼″, Albright-Knox Art Gallery, Buffalo, New York (D. 3).

PLATE 27. Sisley, *The Canal Saint-Martin*, signed Sisley 1870, 20⅞″ × 27″, Louvre, Paris (D. 16). Photo: Cliché des Musées Nationaux.

tapestry of soft darks and abrupt highlights across the surface of both pictures. The palette of blues, blacks, and browns is atypical for Monet but clearly a function of conditions at hand. The selection of these conditions, however, appears to be related to Monet's desire to continue the soft, somewhat generalizing technique just noted in the *Mme. Monet in a Red Cape*. If anything, Monet's brushwork is here even more generalizing than it is in the earlier picture, tending to work across the surface in flat dashes and dabs, following the light as it acts here and there to distinguish various forms. The brushwork is highly flexible in its response to light but relatively indifferent to any other range of effects. As a result, the scene which in type recalls the hearth scenes of Millet becomes an abstract spectacle of light rather than a moment of human activity. Monet does not noticeably suppress the human element, but he makes it yield under the force of purely optical effects.

Coming after the two Sisley family pictures, it is frustrating to find the *Déjeuner* a much less successful picture than one might reasonably expect. However, to demand that Monet be perpetually critical regarding his work and that he develop in a logical and linear fashion is wholly unrealistic. The fact is that Monet does not now and will never work in a thoroughly conscious and logical fashion. While he may test and solve certain formal problems in individual paintings or groups of paintings, he does not learn (in the exact scientific sense) from his solutions. When moving from one picture to another his behavior remains at least partly instinctive—limited in some ways by what he has done previously but responsive to other considerations suggested by the subject directly at hand.

Monet set out in the *Déjeuner* to do two things. First he planned to summarize his work at Fécamp, second he hoped to succeed with a large figure picture, painted from nature. He worked without the small-scale studies he had made for his unsuccessful *Déjeuner sur l'herbe* and without the exact technical preparations that seem to have anticipated the *Mme. Gaudibert*. He confronted the challenges of the indoor *Déjeuner* with more general preparations and precedents, relying on the overall momentum of his recent work to carry him along. The Sisley family pictures are so small in comparison to the *Déjeuner*, and their effects so geared to their scale, that they could anticipate only a few of the situations to be faced in the larger format. Nevertheless, these pictures are the closest thing to a trial run that Monet made, and certain echoes do appear in the *Déjeuner*.

Most obvious echoes exist in the arrangement of the various elements of the motif. The large *Déjeuner* uses a table as the main device for grouping the figures. A slightly overhead viewpoint continues from the small pictures into the *Déjeuner*, but the vertical directionality which this viewpoint implies is exaggerated by the steep, vertical shape of the format and by the vertical alignment of foreground and background elements that continues from one side of the picture to the other. The effect of all of this is to underline a multiplicity of elements that seem to push forward to the surface of the picture. Then, as if to emphasize this multiplicity even more, Monet's technique shifts radically from one element to another.

The flat, patchy drawing of highlights noted in the Sisley family pictures appears in the foreground chairs. The tablecloth is developed in the schematized brushstroke patterns of the Gaudibert portrait. The figures directly around the table and the still-life elements of the luncheon achieve a simultaneous clarity and simplification which recall the *Still Life with Fish*. The figure of Camille (standing at the left) is painted more heavily in the manner of the pictures of Jean in his cradle, while the curtains just behind have the dry, soft, but relatively untextured quality of similar passages in the *Mme. Monet in a Red Cape*. There is in other words a broad technical summary of almost the whole of Monet's

Fécamp work, but a summary that tends to place various effects in opposition. In the final analysis Monet is forced to rely on a rich, tonal palette to bring his diverse effects into balance. Prevailing blues, burgundies, and browns tend to mask the wild variations in brushwork and paint quality and to give to the whole painting at least the appearance of unity.

In the *Déjeuner*, Monet succeeded in his effort to do a large figure piece without elaborate preparations. Also, he succeeded in summarizing his work at Fécamp. But for these successes he sacrificed all sense of spontaneous response. In place of this response he made quotations from his own work wherever they could be applied. For a moment the character of his art appears to be reversed. He seems both self-conscious and academic. But despite all of this, and partly because of it, the *Déjeuner* is in the last analysis a masterpiece of a very special sort. While it appears misguided conceptually in the face of Monet's later work, the fact is that all of the complexities are somehow made to resolve themselves. The actual means through which this resolution is effected, the obsessive verticality and the richness of the coloration, may appear tenuous, but the image remains one of the most vital Monet ever produced.

The *Déjeuner* is a summary of Monet's work at Fécamp, but does not answer the many questions of style and technique that emerged during this particular campaign. Although more successful than *Mme. Gaudibert*, the *Déjeuner* did not encourage Monet to continue figure painting on a large scale. When he moved to Bougival for the summer of 1869, he returned to landscape motifs in formats of moderate size. In these he eventually found the sense of direction which the paintings from Fécamp failed to provide.

On a more personal level Monet's stay at Fécamp began and also ended with financial problems. The Gaudibert commission was poorly received and the *Déjeuner* rejected at the Salon; Monet found himself penniless again. None of his compromises had paid off, but a glimmer of hope appeared as younger artists in Paris suddenly became interested in his work.

Writing to a friend in April 1869, Boudin, who had just visited Monet, reported the following:

> Monet, you know, has come back to Etretat completely starved, his wings clipped. He discovered at the closing of our exposition [in Le Havre] that all his pictures had been seized and sold for the profit of his creditors. The large seascapes went to M. Gaudibert for the laughable sum of 80 francs, I believe. He contends, as always, that his aunt is treating him strictly and refuses him his pension. Finally, his two paintings have been refused [by the Salon] this year, but he is taking his revenge by exhibiting at one of our [paint] merchants [in Paris], Letouche, a study of Ste.-Adresse, which has horrified his fellow artists. There is a crowd outside the window all the time, and for the young people, the generalization of this picture has produced fanatical responses. It is this which compensates for his refusal at the Salon.[12]

12. Jean-Aubry, *Boudin*, p. 72.

4. Renoir—Alternative Conventions

The descriptive inadequacy of the term *impressionism* is manifest in the gulf of style that separates Renoir from his friend Monet. It would be difficult to find two other painters in the history of Western art who maintained such close personal ties and who, at the same time, seem to have held such opposed views regarding the challenges and obligations of the art they practiced.

Renoir was never "modern" in the same sense as Monet. Like Manet, Renoir was responsive to the qualities of past traditions of painting but, unlike Manet, he retained an attitude toward the past which was essentially confident and which never required the gestures of formal and psychological self-examination that seem to have guided Manet. Renoir's respect for the past was that of a craftsman venerating the achievements of his predecessors—achievements offering a complex range of imagery and technique which stood ready to be inherited, continued, and carefully advanced.

Renoir's attitude toward the art of his contemporaries was much the same. Delacroix, Courbet, Whistler, Fantin-Latour, Manet, and Monet as well were part of the craft-history of painting as soon as any of them picked up a brush and set it to canvas. The work of his contemporaries stood as part (the most recent part to be sure) of the spectrum of what painting could be, but it was not necessarily the best part, nor the part into which Renoir felt that he should fit himself unequivocally. For Renoir, painting contained innumerable masterpieces from the past as well as the present, almost any of which could serve as a viable example of the craft of painting upon which to draw in one context or another.

Most of the difficulties that appear in Renoir's art as it developed are directly the result of his panoramic sense of painting's history. With so much available both in terms of style and imagery he seems constantly to have wondered what to do or, more specifically, what to paint. The processes of his art, operating as they did, never defined their own developmental directions. Renoir's "next step" is never clear as a prospect, and when it happens, it is never self-evidently right or wrong, good or bad. The moves which Renoir makes are frequently erratic, when measured by Monet's standards, and as a result Renoir has in each move more at stake artistically.

Throughout his career Renoir makes abrupt conceptual shifts from one group of works to another immediately following, and these shifts often require an almost complete remarshalling of his formal and technical resources. Frequently, these shifts are occasioned by changes in subject—from portraiture to landscape, for example, which may be self-induced or responsive to demands of, or hopes for, patronage. Whatever the case, these changes are in fact the moving force in Renoir's development. It is through them that the desire to paint is kept alive. They force Renoir's glance in one direction or another across the history of painting and give his art the appearance of momentum.

Renoir's art is academic in essence. Like all academic art good or bad, it is able to bring immense resources to bear on challenges with which it is presented, but these challenges always seem to be imposed from without, rather than deduced from within. The reason that Renoir behaves as he does is rooted deep in his past, and much the same can be said for Monet, who began as an amateur caricaturist and was turned from this to landscape painting by his tutor Boudin. A scaffolding of flexible conventions which shifts slightly in response to the descriptive exigencies of each new situation continues from the caricatures into Monet's behavior as a painter and forms the guiding principle of his development.

Renoir on the other hand began as an imitative craftsman—first as a painter of porcelain and then as a decorator of window shades, painted to look like stained glass windows and used by French missionaries in Africa.[1] In both jobs Renoir was called upon to duplicate specific types of traditional art, and this led quite naturally into his subsequent training at the École des Beaux-Arts, where he worked on regularly assigned competition projects clearly related to the painting of masters from the past.[2] Renoir retained throughout his life a methodological tie with this background and a certain respect for its values.

Besides providing an eclectic sense of method, Renoir's background was, like Manet's, primarily involved with figure painting. Taken alone, this involvement would not necessarily dictate a development standing in opposition to Monet's. As we have seen, Monet spent a great deal of time and effort on figure during the 1860s. However, Monet's figures tended almost immediately to become scenic facts, stripped of all humanistic identity. For Renoir, and for Manet as well, this reduction of figures to scenic anonymity was intolerable. In their work, figures would remain the dominant vehicles of artistic expression. Despite their continued commitment to realism Renoir and Manet, on this point at least, aligned themselves with standard academic principles.

Of the painters whose names later identify impressionism as an artistic movement in the 1870s, only Degas and Bazille (and he only in certain works) seem to share this attitude with Manet and Renoir. Pissarro and Sisley move increasingly toward Monet and concentrate their efforts on pure landscape. The schism that appears as a result of these divergent attitudes toward the importance of the human figure serves to emphasize once again the diversity inherent in the impressionist movement as a whole.

The most important of Renoir's early paintings—those done directly after leaving the École des Beaux-Arts—are highly symptomatic of his interests throughout the 1860s. Equally, these paintings are a splendid introduction to the high level of quality that his work maintains from the very beginning despite its erratic shifts in emphasis. Four portraits from the period late 1863 through early 1865 (Figs. 42, 44, 46, and Plate 16), announce the appearance of a major talent. Sitters are known for three of the portraits, and it is possible that all were commissioned. The fourth and earliest is of an unknown subject, and it may well have been intended as a pure costume piece of the sort painted by Courbet in his *Mme. Boreau* portraits (Figs. 47, 48) of 1862.

It is clear in the unidentified portrait (Fig. 42) of a woman in a black Spanish shawl that Renoir is fully aware of a wide range of recent and past precedents, including Goya, Diaz, Couture, Courbet,

1. Ambroise Vollard, *Renoir, An Intimate Record*, trans. by H. L. Van Doren and R. T. Weaver, 1934, pp. 26–27.

2. Robert Rey, *La Renaissance du Sentiment Classique*, 1921, pp. 45–46.

and a minor (but at the time popular) portrait painter from Marseilles, Louis-Gustav Ricard. Very much a period piece reflecting the popularity of Spanish subjects (also evident in the work of Manet and Ribot), this portrait nevertheless represents Renoir's ability to assimilate several borrowed elements of style and to reconcile them.

The portrait itself presents a rather bland image of the sitter. The face is softly drawn and warmly toned in the manner of Ricard (Fig. 43). However, Renoir's handling of the black costume, the lace shawl, and the flowers which decorate the sitter's bodice and hair, has a great deal of character, despite its suggestions of Courbet and Diaz. The simultaneous clarity of definition and richness of texture which Renoir here provides is thoroughly personal in character and predictive of increased technical subtleties in portraits from the following year. Similarly the warm coloration of the picture, which manages to give life to the rather large areas of black, already defines a mastery of tonal painting. While this portrait does not yet offer the arresting definition of a truly unique artistic personality, it does suggest the stuff from which such a definition will be wrought.

In the *Portrait of William Sisley* (Fig. 44), dated 1864 and shown in the Salon of 1865, Renoir becomes less anonymous if equally eclectic. For the alert, three-quarter, seated pose, Renoir looks to Ingres and works such as the latter's *M. Bertin* (Fig. 45) of 1831. For the softly fused but rather generalizing brushwork and for the narrow range of tones Renoir seems to be following precedents in the early works of Fantin-Latour. Comparing Renoir's Sisley portrait with Fantin's *Two Sisters* (Fig. 50) of 1859 the source appears to be quite direct. Renoir is here pairing elements from artists of two different generations in order to generate a forceful portrait image. The critical polemic of classicism and realism that separated Fantin from Ingres offered no barrier to their reconciliation in Renoir's hands. The various properties contained in the works of Fantin and Ingres seemed useful to Renoir, and he obviously felt that the combination of properties required no apology or explanation beyond that of his completed picture. Clearly, Fantin and Ingres were better examples to follow than Ricard, whose work seems lifeless beside the Sisley portrait. This painting is in fact a splendid document of Renoir's ability to choose well from available sources and to use his borrowings to distinct advantage.

Even more remarkable in this portrait is the way Renoir is immediately able to grasp the stylistic essentials of his sources and make them yield to his will. The viewer is not aware of Fantin and Ingres in looking at the portrait, which seems to operate so easily on its own terms, but one realizes that the portrait gains force through its precedents. The subtle modulation of black and dark grays in Sisley's suit, and the linking of these to the red-brown chair and to the softly brushed mid-brown ground indicate a complete assimilation of Fantin's example, while the vigorous definition of contour and facial details, and the carefully placed accents of white, demonstrate the lesson of Ingres. Yet the portrait image as a unit is dominated by neither source. The figure possesses a sense of volumetric relief which is neither so scruffed and veiled as it is in Fantin, nor so firmly demonstrative (almost diagrammed) as it is in Ingres. Renoir's brushstrokes do form a soft, Fantin-like surface, but they also become more focused at certain points in order to inflect the quality and substance of the surface they describe.

Ingres's example links the Sisley portrait and another Renoir of roughly the same date, the *Mlle. Romaine Lacaux* (Plate 16), but in place of Fantin, Renoir's attention here moves to Fantin's friend Whistler, whose *White Girl* (Fig. 49) had been a realist rallying point in the Salon des Refusés of 1863. Technically Whistler's work was closely related to Fantin's, but in the *White Girl* Whistler had tested

a coloristically ambitious interaction of close-valued whites, yellows, and grays. Renoir seizes on the subtlety of Whistler's tonal effects, discovering in them a way to project the visual and psychological delicacy of his sitter.

The Lacaux portrait presents several characteristics which will continue throughout Renoir's work of the 1860s. These characteristics have little to do with the stylistic sources from which he derived the broader principles active in the portrait. Most evident as a departure from direct precedent is Renoir's use of background elements of flowers and a white drape to act as a loose and flexible frame for the figure itself. Because the background elements respond to the figure through contrasts of shape, color, and texture, they obviate the need to describe the various parts of the figure so precisely as to destroy the soft, painterly quality of Renoir's technique. The focus on background elements is far less distinct than it is on the figure, so there is no sense of visual conflict. Instead, the background serves a complementary function, wholly subservient to the projection of the figure.

This basic conception of the background as a system of more or less legible props whose arrangement and definition are conditioned by the figure projected in front of them may not be unique, but it becomes a virtual constant in Renoir's figure paintings whether done indoors or in a landscape setting. His decision to work in this way strongly influences Renoir's sense of pictorial space. Increasingly as his art develops, Renoir seems to fear a coherent and legible description of space. Such description inevitably conditions and in a way controls figure elements active within it, and in Renoir's mind this appears to subvert the whole challenge of projecting the figure as a forceful image.

By painting background elements and the spaces implied by these elements *around* the figure, so to speak, Renoir levels an attack on traditional Western conceptions of pictorial space. This attack is hardly less radical than Monet's bold equivocations of two- and three-dimensional definition. In Renoir's hands the figure is given the power of determining the space around it and in so doing achieves an absolute visual primacy. The whole of a given figure painting develops as a pictorial radiation or extension of the primary figure or group of figures. The effect of this procedure on Renoir's work in nonfigure subjects is equally important, since it inclines him to develop landscapes and still lifes as rather flat interweavings of irregular surface arabesques which yield a sense of depth at certain intervals but tend for the most part to operate with a sense of rich but low sculptural relief, a tendency first noted by the critic Roger Fry.[3]

The conception of pictorial structure that emerges from this tendency to compress foreground and background into an active low relief permits Renoir to do certain things technically which Monet was never able to manage. In a painting like the *Mlle. Romaine Lacaux* Renoir can juxtapose quite different sorts of paint-handling in adjacent areas. He can for example shift from the rhythmically brushed flesh passages to drier and more broadly handled areas of costume and from this to sharp details without really seeming arbitrary or inconsistent pictorially. The gentle relief quality of his pictorial surface leaves just enough room (figuratively speaking) to contain these shifts and inconsistencies. Comparable shifts in works by Monet, such as those noted in some of his Fécamp pictures, seem instead to build up on the picture surface and threaten the coherence of that surface two-dimensionally. Monet's paintings are always so boldly conceived that the pictorial surface itself virtually refuses to contain inconsistencies.

3. *Vision and Design*, 1920, p. 270.

Besides containing variations in paint texture, Renoir's surfaces permit variations in modeling. In works like *Romaine Lacaux*, modeling in close color values and modeling in chiaroscuro exist together. The particular method of modeling and the quality of the paint are calculated for maximum effect in each section of the picture. So long as shifts from one effect to another are kept from becoming too blatant, nothing disastrous occurs, but when these shifts become abrupt, as in the wooden chair back in the *Romaine Lacaux*, the soft fabric of the picture is violated and the unity of the whole is compromised. This discussion of Renoir's manner of achieving pictorial coherence, as it contrasts with Monet's, presents a subtle question of cause and effect. Does this quality result from Renoir's sense of the craft of painting as a composite or is it developed in order to contain this sense? Both of these possibilities probably contain a germ of truth.

Interestingly, one of Renoir's contemporaries would complicate a pictorial surface, conceived in terms of low relief, even more intensely but at the same time more systematically than Renoir. That man was Cézanne, and Renoir was one of the first and most dedicated of his admirers. The two artists, despite their differences, shared a similar attitude toward the qualities of the pictorial surface, which would make it possible for Renoir to assimilate elements from Cézanne's work during the early 1880s at a time when any of Renoir's other contemporaries held very little interest for him.

Although it is possible to formulate certain directions on the basis of Renoir's portraits from 1864 and from the *Romaine Lacaux* in particular, subsequent events in his painting are in no sense simple or completely predictable. The next five years of his work contain a wealth of experimentation. At first Renoir seems most attracted by the work of his contemporaries, but this work is constantly tested against the past and, by the end of the 1860s, much of Renoir's interest in contemporary artistic events is already exhausted.

One of the first interests evident after the completion of the *Romaine Lacaux* relates to color. The combined impact of Monet and Manet seems to have drawn Renoir momentarily away from the tonal orientation of Fantin and Whistler. Renoir had known Monet as early as 1863, when both artists worked along with Sisley and Bazille in the atelier of Charles Gleyre. Like Monet, Renoir was certainly aware of Manet's work as it appeared both in Salons and in private showings. The crisp contrasts of black and white and the brilliant accents of pure color, which characterized Manet's work from 1860 onward, began, as we have seen, to influence Monet in his figure paintings of 1864. About the same time, or shortly after, a similar influence is evident in Renoir's work.

This influence is perhaps clearest in the fourth of Renoir's early portraits, the *Mlle. Sicot* (Fig. 46) of 1865, but prior to this picture it appears in two related paintings of flowers from late 1864 (Fig. 51 and Plate 13). Looking at these flowers it is difficult to believe Renoir's own recollections of this period, where much stress is placed on his interest in Diaz.[4] Except for a certain amount of bitumen in his palette, which tends to merge and blur the brown, gray, and black tones, the color interest in these pictures is centered in the manipulation of the intense and high-value blues, yellows, and greens in the flowers themselves. These tones, which operate over and through the soft convolutions of flowerpots, greenhouse boxes, and the generalized areas of background, provide brisk contrasts. The contrasts are dispersed over several areas of the pictures and they provide a kind of optical vitality and freshness that is completely different from the visual delicacy of the coloration in the *Romaine Lacaux*.

4. Vollard, *Renoir*, pp. 33–34.

Considering the moment in which these pictures were produced, it is most likely that this new optical vitality reflects Manet. The flat, heavy impasto brushwork that carries these new bright and more contrast-oriented tones seems further to emphasize this likelihood.

Whatever the case with the flower pieces, the Sicot portrait is quite close to the color orientation of Manet, even though it is finally less vigorous in its display of paint-handling. For this portrait Renoir has chosen, it seems, to combine the delicate passages of brushstroke texturing noted in the *Romaine Lacaux* with the more vigorous coloration of the two flower pieces in order to have as a result a bold but elegant portrait style—one which he may have hoped would be comparable in type to Ingres's portraits of women from the 1830s and 1840s. Further, in the precise and somewhat stiff character of Renoir's drawing and in the rather harsh definition of costume textures, a lingering admiration for Ingres remains, only partly submerged beneath levels of Manet and Renoir himself. The Sicot portrait is an important summary of interests and influences, but as a painting it sacrifices the sureness and subtlety of execution that appears in Renoir's best work throughout his life. Various textures of costume and flesh are labored technically to such a degree that the sense of soft pictorial relief which is so successfully handled in the Lacaux and Sisley portraits becomes flat and rather wooden.

It was probably fortunate that in the summer of 1865 two of Renoir's friends, Sisley and the amateur painter-architect Jules LeCoeur, convinced him to accompany them to Marlotte in the Forest of Fontainebleau for some landscape work out-of-doors.[5] This change of scene forced Renoir to think of his painting along new lines. As noted above, he seems always to have needed such challenges imposed from without in order to develop as an artist.

Renoir's stay in Marlotte was not his first venture into landscape painting. As early as 1863 he had followed Monet's lead and, along with Sisley and Bazille, he worked outdoors,[6] but in subsequent recollections of his early work Renoir was unclear about exactly when and for how long he worked at landscape between 1863 and 1865. At some point in this three-year period he supposedly met Diaz, who encouraged Renoir to move away from the conventional Barbizon methods which he had apparently followed up to that time and to paint less darkly.[7] All of this, however, is difficult to reconstruct visually, since almost nothing remains in the way of paintings to document Renoir's landscape work in this pre-1865 phase.

On the other hand, several paintings document Renoir's visit to Marlotte in 1865. These paintings indicate that Renoir began almost immediately to think of landscape as a setting for the human figure, rather than as landscape pure and simple. Monet, working only a few miles away at Chailly and preparing studies for his *Déjeuner sur l'herbe*, was proceeding for the moment at least along very similar lines, but it is doubtful that much important contact occurred between the two artists. On the basis of extant paintings it is clear that Sisley's work, rather than Monet's, paralleled many of Renoir's interests.[8]

Sisley's early work is only slightly known, but what remains indicates a close adherence to Corot's landscape style. This along with gradual influences from Courbet forms the basis of Renoir's Mar-

5. See Douglas Cooper, "Renoir, Lise, and the LeCoeur Family—A Study of Renoir's Early Development," *Burlington Magazine*, no. 674 (May 1959), 163–71.

6. Daulte, *Bazille*, p. 35.

7. Vollard, *Renoir*, pp. 33–35.

8. See chap. 8, p. 91–93.

lotte work as well. The rich development of color values and pigment textures which were provided by the examples of Corot and Courbet made it possible for Renoir to transfer into landscape painting many of the pictorial interests which had previously engaged him in his formal portraits and still lifes. This transfer provided a factor of continuity within Renoir's work of 1865 and enabled him to use the shift from portraits to landscapes to best advantage. On the one hand, he needed the change of scene and subject, but by bringing to it previously developed skills and interests he made the entire experience more meaningful.

Courbet and Corot together contribute the dominant elements in Renoir's landscape style of 1865, but they do so in a balance that shifts increasingly as the summer develops toward Courbet's bolder paint-handling, with its emphasis on the application of pigment with a palette knife. Renoir's *Road near Marlotte* (Fig. 52) represents the high point of his interest in Corot. It is probably an early work in the Marlotte campaign, paralleling as it does the contemporary paintings by Sisley and hypothetical efforts by Jules LeCoeur, who had actually painted with Corot in the early 1860s before deciding on a career as an architect.

Road near Marlotte uses a type of vertical format seen frequently in Corot's informal landscapes (Fig. 53). It presents a simple view down a road with houses and shrubbery balanced to either side. Two figures and a dog occupy a portion of the road, but the dominating elements in the motif are two trees, positioned in the center of the picture above the figures and controlling the design of the picture as a whole. The tonality of the picture is generally neutral. The technique is soft and feathery in a fashion again freely reminiscent of Corot. The painting is less atmospheric than comparable Corots, since Renoir integrates the various areas of the scene less smoothly and permits the brushwork in many passages to gain a visual identity in its own right. The painting appears rather flat as a result of this but, more important, this unconcealed brushwork anticipates the move toward Courbet which becomes apparent in a second Marlotte landscape, *Clearing in the Woods* (Fig. 54), where large areas of flatly scrubbed and brushed pigment serve to evoke complexities of vegetation and rockbound terrain.

Renoir's treatment of the forest portions of this second landscape very nearly transforms the normally inviting recesses of the Forest of Fontainebleau into something fierce and almost barren, reminding one of Courbet's views of landscape scenes near Ornans (Fig. 55). This suggests, of course, the weight of Courbet's example not only as a source of technical devices but also as a source of precedents for selecting certain characteristic aspects in a landscape motif. In *Clearing in the Woods* Renoir abruptly juxtaposes broad and flat rock strata with luxuriant foliage. He introduces almost nothing to mediate the resulting tactile and pictorial oppositions, and predictably he does little to dramatize spatial relationships. Renoir accepts the rugged, unyielding quality of Courbet's landscape style and the type of motif which that style characteristically describes.

There is, to be sure, a somewhat wider variety of paint handling in Renoir's *Clearing* than one normally finds in Courbet's pure landscapes. This variety is a function of Renoir's view of style as a composite rather than an absolute. He refines Courbet's example at the very moment that he is directly affected by it. His refinements are not necessarily improvements of Courbet's example, but they are characteristic of Renoir's unwillingness to commit himself to single solutions. Although he was by mid-1865 working closely along lines defined by Courbet, Renoir's dedication was far from complete. His work over the next eight or ten months retains a strong link with Courbet, but the

character of the link shifts from one of influence to simple tribute. Influence continues in two paintings which were probably worked on during the winter of 1865–66, the *Interior of the Forest* (Fig. 56) and the *Portrait of Jules LeCoeur* (Fig. 57). The portrait is dated 1866, but for reasons discussed below it relates to activities of the previous summer. The relationship between these two paintings is rather difficult to pin down, but basic similarities of technique suggest that the *Interior* probably served as some sort of trial piece for the *Portrait*.

The *Interior* is a veritable catalogue of technical experimentation. The palette is restricted generally to green which breaks down into a number of different values. Paint is applied in several ways. There is evidence of the palette knife and of brushes of several different sizes. The paint quality, as it builds up across the canvas, suggests Courbet in its dense richness, but the flat, shingle-like handling of foreground foliage at the top of the picture recalls Monet as well. Brushstrokes are alternately dotted, abrupt, and rhythmical. The motif is cramped, mostly foreground in emphasis and, as a result, pictorial activity is sustained in a web of paint (describing foreground elements) very close to the surface of the canvas. Renoir seems to load his motif with as many technical possibilities as he can in order to create a broad vocabulary within which he can continue to work. Courbet's style remains as a firm point of reference, but Renoir displays considerable freedom in his efforts to push every technical effect to a point of maximum intensity.

The *Portrait of Jules LeCoeur* certainly benefits from the range of effects, which Renoir cultivated in the *Interior of the Forest*, but it does not attempt to incorporate every effect. Instead, the *Portrait* assumes a more conventional stance vis-à-vis Courbet. As a hunting portrait it declares its debt to the imagery of Courbet, and it further respects this debt in obvious conventions of color and technique. A generally green and brown palette and the rendering of grass and foliage with a rough scrub of the palette knife suggest greater respect for Courbet's prototypes than one finds at any other point in Renoir's work. However, the way in which Renoir organizes the picture through a steep overhead viewpoint and a concentric arrangement of landscape elements which move outward from the group of LeCoeur and his dog are clearly in opposition to Courbet's more sober and straightforward precedents. This manner of organization is not surprising in the context of Renoir's own work, since it tends as do the backgrounds in his early portraits to use nonfigure elements as a rhythmical reinforcement for the dominant figure. It is predictive of the way in which Renoir will continue to relate landscape and figure elements as his career develops and is, as noted previously, a virtual constant in his style.

Besides providing a summation of at least the known parts of Renoir's early landscape interests and a monument to the impact of Courbet, Renoir's LeCoeur portrait suggests a characteristic type of painting which will engage him throughout the 1860s and moderate his position as a realist. It is impossible to label the picture either as a simple portrait or as a costume piece with narrative overtones. It is both, and Renoir's figures throughout the 1860s (except when they are directly intended as portraits) are both. Thinking ahead to works like *Diana, Summer (Lise), Odalisque, Bather with a Griffon*, and *Lise Holding a Parasol*, (Figs. 60, 74, 88, 89 and Plate 15), it is evident that Renoir, as he planned his paintings, considered not only the scenic impact of his figures but also their potential to assume a role in the context of traditional imagery. If one were to characterize the most basic conceptual interest guiding Renoir throughout the 1860s it could best be expressed as an effort to devise traditional roles for increasingly direct and arresting realist images. Consistent with technical eclecticism which weighs the advances of the 1860s against the achievements of the past is this eclec-

ticism of imagery which carefully invests each new image with the attributes of some traditional type.

In the same period (mid-1865 to mid-1866) when Monet had moved in his figure paintings to a scenic equivocation of landscape and the human figure, Renoir turned from a few efforts in pure landscape to renewed interest in figure painting of a distinctly traditional sort. Courbet's influence may have been responsible for Renoir's behavior in this regard. After 1865 Courbet's work featured increasingly traditional figure subjects, and these were achieving considerable recognition in official circles.

In his work following the *Portrait of Jules LeCoeur* Renoir was not, however, content simply to follow Courbet. He had exhausted his interest in Courbet's style as a whole, and he began to work away from it along the lines already defined by the *Interior of the Forest*. In a large painting, *Mother Anthony's Inn* (Plate 17), dated 1866, Renoir's relation to Courbet made the turn mentioned above from influence to tribute. In this picture Renoir's style moves progressively away from Courbet, while the subject itself continues to recall prototypes in Courbet's work. But even before this large work, a flower still life dated 1866 (Plate 14) suggests broad changes in the orientation of Renoir's interests. The picture begins by rejecting the dominantly palette-knife technique of the LeCoeur portrait and offers instead considerable variations in brushwork. In a later statement to his friend, Albert André, Renoir recalled this moment in his career:

> I painted two or three works with the knife following the procedure of Courbet. Then I worked with brushes in broad impasto. I was successful in some parts, but I did not find it adaptable to reworking.[9]

At the time of his work on the LeCoeur portrait, Renoir had considered technical methods derived from Courbet to be in his words "la vraie peinture"[10] but, as the flower still life indicates, Renoir had changed his mind. Just as he had in his two still lifes of 1864, Renoir uses a painting of flowers as a springboard for revising his style and for incorporating new elements. Throughout his career, flower painting continued to serve him in this fashion. He seems to have felt a degree of relaxation when dealing with flowers, and this enabled him to experiment more freely than he could in other contexts. Commenting at a much later date to a friend and biographer, Georges Rivière, Renoir noted:

> I just let my brain rest when I paint flowers. I don't experience the same tension as I do when confronted by the model. When I am painting flowers, I establish the tones, I study the values carefully, without worrying about losing the picture. I don't dare do this with a figure piece for fear of ruining it. The experience which I gain in these works, I eventually apply to my [figure] pictures.[11]

In other words, Renoir's flower pieces were generally experimental in character and are as a result the likely place to look for indications of change which will subsequently appear in more ambitious works. But here an important distinction must be made regarding the function of experiment in Renoir's work in contrast to Monet's. In simplest terms Monet can be said to have set up his projects as investigations or challenges, while Renoir experimented in a more or less random fashion, never binding himself to a consistent problem-solving procedure. Renoir would emerge from experiment

9. Albert André, *Renoir*, 1928, p. 81.
10. Cooper, "Renoir, Lise, and the LeCoeur Family," p. 164.
11. Georges Rivière, *Renoir et ses amis*, 1921, p. 81.

with the realization that he had mastered a new skill or a new sort of pictorial effect, while Monet would gain a clearer perspective on a whole range of questions, none of which would necessarily be resolved.

Following chronologically from the *Portrait of Jules LeCoeur*, the flower still life is a vigorous burst of bright color, removed completely from the palette of Courbet. Like contemporary flower pieces by Fantin-Latour (Fig. 58), Renoir's picture features a mixed bouquet of flowers, which differ considerably among themselves as to coloration. Blues, pinks, and yellows, nearly all in high values, predominate. Although these colors are not violent in their contrast with one another, the picture does reject the tonal orientation that had dominated Renoir's color, with the exception of a few works done around the time of the Sicot portrait. The painting is almost uniformly "light," requiring only the gray passages of the table top and background wall to keep the lightness from becoming blatant and harsh.

Renoir's technique is very flexible, delicately projecting the different texture and shape of each flower, describing the pattern on the blue porcelain vase, and suggesting in a broader fashion the surface of the table and the background wall. The paint quality is neither dry like Fantin's nor so weighty as Courbet's. It operates at every point in conjunction with open or tight brushstrokes to distinguish pictured elements, while at the same time providing a consistent painted surface. The delicate balance between the descriptive emphasis of Renoir's technique and the surface unity which it supports is remarkably effective and makes this still life one of Renoir's most successful productions to date. Without relying on any obvious precedents, this picture has a directness of pictorial impact which Renoir rarely manages to duplicate. There is in the still life an obvious attempt to break out of the mold of Courbet and to explore new areas of color and technique, but there is also the relaxed desire to make a simple and unaffectedly beautiful picture.

This momentary efflorescence in Renoir's work is short-lived, and his ambitions soon lead him to another figure-painting project—the most monumental of his efforts to date. *Mother Anthony's Inn* (Plate 17) is the first of Renoir's great group portraits. It documents the place and company of his work at Marlotte in 1865. The painting may have been started at Marlotte, but it was almost certainly finished in Paris, after Renoir moved into Bazille's atelier in July 1866.

As a type this painting recalls traditions of group portraiture in seventeenth-century Holland, but more directly, it seems a tribute to one of the most successful of Courbet's early works, *After Dinner at Ornans* (Fig. 59) of 1849. In Renoir's published conversations with his dealer, Vollard, there exists a quite complete description of the subject of the picture.

> The subject of the picture is the common room, which did double duty as a dining room and lounge. The old lady with the kerchief is Mother Anthony herself. The handsome young girl handing around the drinks is the servant, Nana. The frizzly white dog is "Toto...who had a wooden paw [and which had also figured in the *Portrait of Jules LeCoeur*]. I got some of my friends to pose around the table, among them Sisley and Jules LeCoeur. The "motifs" in the background of the picture were borrowed from sketches actually painted on the wall—these "frescoes," unpretentious but often quite successful were the work of the artist *habitués* of the place. I myself painted the profile of Murger, which appears in the picture, high up at the left.[12]

12. Vollard, *Renoir*, pp. 42–43.

Mother Anthony's Inn is an important painting for several reasons. As the first group portrait of his friends and fellow artists at ease in a characteristic habitat, the picture provides a formula for later efforts by Renoir such as the *Moulin de la Galette* of 1876 and the *Luncheon of the Boating Party* of 1881. The scale of the picture demonstrates Renoir's ability to work a large Salon canvas with nearly life-size figures, grouped in a convincing but informal fashion. Stylistically the picture demonstrates a successful combination of powerfully conceived figures positioned in the foreground of the picture in the manner of Courbet but painted with a lightness and delicacy that is in complete contrast to Courbet's somber chiaroscuro. The successful handling of dominantly light tones, noted in the flower still life, makes itself felt in this picture, even though Renoir does define his tonality more strongly as he moves to work on a much larger scale.

In this first group portrait Renoir is absolutely convincing in balancing individual portraiture and a sense of the group of figures as a unit. Flesh tones are conceived in vibrant high values so that faces project clearly from the soft blacks and grays of costumes, but Renoir is careful elsewhere in the picture, particularly in the brightly painted still life passages on the table, to provide other areas of equal lightness. His brushwork is as flexible as it was in the flower still life. It is broad, almost Courbet-like in costume passages, delicate and rhythmical in flesh passages, and crisp (almost Manet-like) in the brilliantly painted still life. That ability to select without hesitation the most convincing technical procedure for each passage and to respect at the same time the pictorial unity of the painting as a whole continues undiminished from the previous flower still life. Renoir's success at interweaving subtle yellows, blues, pinks, and whites through bold blacks and grays declares immanent mastery of nearly every sort of color effect. Areas such as the loosely brushed "fresco" work on the background wall and the powerfully modeled brushstroke web that projects the dog at the bottom of the picture suggest a real virtuosity that will, as Renoir's career develops, convey both his strengths and weaknesses.

Considered as group portraiture, and more specifically as realist group portraiture, *Mother Anthony's Inn* is unequivocally straightforward. Although traditional (not to say academic) in its triangulated arrangement of the figure group, the painting presents the figures in easy conversational relationships to one another. These relationships are not contrived, nor are they dramatized in any obvious fashion.

Mother Anthony's Inn brings to a close the first major phase of Renoir's career, continuing and raising to a monumental scale nearly all of the qualities which his art had assumed to date. During the following year the character of Renoir's art would shift, as he ventured more consciously into the public arena. In order to become a recognized figure in the world of painting, it was necessary to score successes at the Salon. The efforts and concessions required for such successes posed less of a problem for Renoir than they did for Monet for obvious reasons, but this does not mean that Renoir was able to face the Salon without effort. Proceeding in 1867 with an eye not only toward Salon acceptance (which he had had twice already) but also toward major success, Renoir interrupted the rather free development of his early work and planned his strategy with considerable care.

5. Renoir and Monumental Figure Painting, 1867-1868

Like Monet, Renoir was not one to underestimate his own potential as an artist. Either man could have settled into a comfortable career, working within the stylistic confines of his earliest successful paintings, but neither was inclined to do this. Renoir did not intend to spend his life as a journeyman portrait painter any more than Monet intended to fit the conventional image of a regional landscapist.

In two paintings of 1866, the *Portrait of Jules LeCoeur* and *Mother Anthony's Inn*, Renoir made his first moves toward the development of a monumental style in figure painting. Both paintings followed Courbet's precedents in one way or another, as Renoir found in Courbet a variety of technical and iconographical elements he deemed worthy of emulation. Despite his eclectic awareness of the past of painting, Renoir belonged in certain basic ways to the 1860s, and realism carried him in its wake. Although never exactly driven by the most contemporary of realist developments, Renoir's work invariably begins from a fundamentally realist point of view.

Renoir was attracted to Courbet's art because it echoed so many of his own interests; although it was the source of the whole realist polemic, it was bound to tradition in many of its technical features and increasingly involved in traditional types of figure subjects. The female nude and the romantic costumed figure were as much a part of Courbet's art as his landscapes. For many of the same reasons, Manet would continue to exercise an influence on Renoir, even though Renoir would never wholly sympathize with the more radical formal and psychological qualities of Manet's work.

In preparing the first of his large Salon figure pieces, the *Diana* (Fig. 60), dated 1866, Renoir had both Courbet and Manet clearly in mind. His initial choice of a mythological subject and specifically of a nude female figure indicates an obvious courting of the Salon jury but an equally obvious miscalculation of the standards of that august institution. The painting was in fact rejected from the Salon of 1867. This rejection serves to isolate one of the most problematic features of Renoir's career in the 1860s and early 1870s. Without really intending to be in any way radical in the context of established artistic standards, Renoir nevertheless had the misfortune of identifying himself through certain features of his work with the realist avant-garde. In a painting like *Diana*, Renoir probably imagined that his gesture toward academically acceptable standards of subject matter gave him the right to practice certain pictorial modes which were unconventional. Then, in order not to abuse this right he

further respected academic demands for precise draftsmanship. The Salon jury unfortunately missed the point of Renoir's demonstration.

Throughout most of his early career Renoir would continue to suffer from such misunderstanding. His painting, its calculated concessions notwithstanding, was bound to appear modern and potentially dangerous to the very academic standards he believed he was respecting. His efforts through the 1860s in particular aim in various ways to achieve an acceptable balance between certain academic standards and the pictorial advances in realist painting which he saw around him. While casting his figures in several different roles in order to strike this balance, he seemed always to miss the desired mark, and, unexpectedly, the approval which he eventually received came not from official circles but from the critics of the avant-garde.

While suffering from a lack of official recognition, Renoir's art nevertheless benefited from his continuing efforts to legitimize realist pictorial modes. These efforts, applied to the shifting roles which Renoir's figures assumed, amplified his powers as a painter considerably. The momentum to develop and assimilate a wide range of possibilities into his art occurred as a matter of course in the process of searching out a balance of apparently contradictory factors in one painting after another.

Considered in this light the *Diana* is an arch symptom of all that will occupy Renoir in his monumental paintings for the next four years. The conflicts of style that form an inevitable part of his work exist here in their purest state. Without intending to do so, Renoir made of the *Diana* a painting which is hardly less ambiguous in the image it presents to the spectator than Manet's controversial *Olympia* (Fig. 1), which had been shown at the Salon of 1865 and may possibly have provided the impetus for Renoir's painting. To Renoir's eyes, the sort of thing that Manet had done in revising a traditional subject through powerfully realist pictorial modes may have appeared an ideal model. Renoir would probably have seen in Manet's picture a gesture of respect rather than of insult toward the past of painting. Although not exactly a total success with the critics and the public at large, Manet's *Olympia* had been accepted at the Salon and had received considerable comment. This would in itself have provided sufficient encouragement for Renoir to attempt a similar exercise.

Looking at the *Diana*, one is hard put to isolate the dominant principles and interests. Neither Manet nor Courbet, nor the academy, gains the upper hand. Nor does Renoir, himself, as a unique artistic personality, seem completely in control. In simplest terms the picture shows Renoir's mistress and favorite model, Lise Tréhaut, posed in the nude as the huntress Diana. Her body is arranged in a complicated contrapposto, designed to please the Salon jury with its difficulty. Beneath Diana at the lower left corner of the picture lies the dead carcass of a deer, its neck pierced by an arrow. Behind and around Diana and the deer are landscape elements of bushes, trees, rocks, distant hills, and a clear sky.

A direct tribute to Courbet exists once again in the choice of the imagery of the hunt, whatever its mythological overtones. This tribute continues technically in Renoir's broad brush and palette-knife treatment of the deer and the various elements of landscape. These areas distinctly recall Courbet's *Deer Haven at Plaisir-Fontaine* (Fig. 61), which like Manet's *Olympia* had appeared in the Salon of 1865. In the figure of Diana herself, and in her brightly colored drapery, Manet becomes the dominant factor in the picture. Lise's fleshy, unclassical proportions are projected in brittle high-value flesh tones which operate without conventional shadow in a manner distinctly recalling Manet. But against this Renoir opposes the tightly controlled drawing of the figure's interior and exterior

contours. Lise's glance is downward, avoiding confrontation with the spectator and softening the brazen stare of *Olympia*. Renoir's emphasis on drawing and his deflection of the figure's glance are obvious attempts to avoid the psychologically assertive qualities of Manet's image and to correct, so to speak, the rough edges of its style.

Renoir's own artistic personality is probably less apparent in this picture than any other. It consists of an impressive ability to combine opposing pictorial concerns and to unify them in a single canvas. The congested, antispatial character of the landscape and its appearance in low relief of the figure assist in this and are broadly characteristic of Renoir's work, as noted previously. The design of background elements as rhythmical reinforcements to the main figure is similarly autographic.

It would be an exaggeration to stress too much the participation of the *Diana* in the problem of painting the human figure out-of-doors. *Diana* is clearly a studio picture involving the combination of many elements determined and studied in advance. Its outdoor setting is even less convincing than Manet's in his *Déjeuner sur l'herbe* of 1862 (Plate 3) and is in no sense a function of the interests which had guided Monet's *Women in a Garden* (Plate 2) in 1866. It was not until the spring and summer following the completion of the *Diana* that Renoir responded in any very direct way to Monet's example in this regard. When he did, he produced several works to document this response. The lightness of the palette in the *Diana* remains a function of Manet's influence, superseding Courbet's, and an extension of interests already noted in the flower still life of 1866 (Plate 14).

A continuation of Manet's influence is evident in a second and considerably smaller figure painting (not intended for the Salon) which Renoir produced at about the same time (spring 1867) as the *Diana*. This picture, the *Portrait of Frederic Bazille at His Easel* (Plate 10), dated 1867, is nearly comprehensive in its examination of Manet's style. Interestingly, the portrait, which pictures Bazille painting a *Still Life with a Dead Heron*, was done in the company of Sisley, who painted the same subject (Fig. 133) from a different view.[1] Moreover, there hangs on the wall over Bazille's head (as seen in Renoir's portrait) a recently completed snowscape by Monet (see Fig. 18). On one level at least, Renoir's picture documents the increasing sense of group awareness of the four painters. The four had long been friends, but artistically their paths were now crossing with increasing frequency. Renoir's interest in Manet was shared directly by Bazille and Sisley. The three paintings which they simultaneously produced mark the closest stylistic approach that any of them ever made to Manet. Then, as suggested almost clairvoyantly by the snowscape on the wall, all three were to shift their attention to Monet over the next few months.

Working somewhat informally in the *Portrait of Bazille*, Renoir is unusually direct in his identification with avant-garde tendencies. For the moment he permits himself to be swept along with the tide of interests he shares with his friends. Like Monet, Renoir was often forced to depend on Sisley and Bazille for lodging and financial support. Through his contact with them, he was affected by their interests as well. It is quite possible that Renoir's eventual interest in Monet was fostered by Bazille, since there is little in Renoir's own character and background as an artist that would have inclined him toward Monet's forcefully anti-traditional tendencies. In fact, Renoir may have intended a mild allegory of his developing interests in the portrait of Bazille. He was perhaps looking through Bazille to Monet, while producing an image in the style of Manet.

1. Rewald, *History of Impressionism*, pp. 182–83.

Whatever the case, the *Portrait of Bazille* is a major document to the firmly realist undercurrent in Renoir's style of early 1867. The crispness of his brushwork, the abruptness of his modeling and the brilliant control of the generally light tonality of the picture as a whole demonstrate a complete mastery of Manet's example—a mastery so complete as to make Bazille's and Sisley's still lifes alternately stiff and spineless by comparison. Appropriately enough, Manet later bought the picture.

Shortly after the opening of the spring Salon, Renoir followed Monet's example and painted his first important outdoor picture, the *Pont des Arts* (Fig. 21), which has already been discussed in conjunction with Monet's cityscapes of 1867. In this picture Renoir accepted many of the essentials of Monet's current style, while holding to more traditional views of the city than those generated by Monet from his location on the balcony of the Louvre Palace. From the Pont des Arts Renoir moved to the outskirts of the city, working from the parks along the Champs Elysées (Fig. 62), where the World's Fair was in progress, and finally from the park of St.-Cloud (Fig. 63). In the course of this work Renoir modified the crispness of his technique in the *Pont des Arts* and moved to a softer more sketchy manner, where groups of figures are rendered summarily. These figures remain small in scale and are surrounded by avenues of luxuriant trees. The trees are generalized into brushstroke webs of green with sharply stippled highlights as Renoir hastily records the action of light without analyzing or structuring it with any great care. Obviously experimenting with a new idea of painting inherited from Monet, Renoir does not labor any of its consequences, and instead he moves to Chantilly to begin work on his Salon picture for the following year.

Predictably, Renoir's plans for the Salon of 1868 involve the idea of a monumental figure painting, but one which operates without the pedantry and self-consciousness of the ill-fated *Diana*. Having rapidly adjusted himself to working directly out-of-doors, Renoir projects a figure-piece conceived and painted in an actual landscape setting. But besides this, Renoir intends that his figure be something more than the scenic nonentitites of Monet's *Women in a Garden*. If not a mythological goddess, this figure must at least suggest some sort of equally dignified modern counterpart. Lise, whose less than ideal proportions had reduced the image of Diana to the level of the imperfect and mundane, would now don the most elegant modern dress and assume the bearing of a more contemporary female deity, appearing in the straightforward context of the promenade.

The challenge which Renoir set out for himself was not so lacking in precedent as may first appear. He had the support of a long tradition of English monumental portraiture which from the time of Reynolds gave to its patrons an olympian bearing through the landscape that surrounded them—a bearing supported by the costumes they wore. Into the role of a proud, almost deified English female aristocrat, Renoir cast his second monumental Salon figure, *Lise Holding a Parasol* (Plate 15).[2]

Renoir's interest in Monet's work during the summer of 1867 and his development of that interest in a projected Salon picture of a distinctly traditional sort, point once again to the uncommitted, almost cynical qualities of Renoir's attitude toward the realist avant-garde. Monet's style offered Renoir certain useful devices, which could be called upon for working out-of-doors. These devices join with those already gleaned from Manet to produce a new composite in Renoir's hands.

A selective process of borrowing from his contemporaries continues to guide Renoir's art during

2. Douglas Cooper, "Renoir, Lise and the LeCoeur Family—A Study of Renoir's Early Development," *Burlington Magazine*, no. 676 (September–October 1959), 322–28.

this period. Such borrowings seem necessary in order for him to realize his various projects. His eclectic character as an artist inclined him to borrow for means rather than ends, and he was never particularly concerned with the relationships established between means and ends by the artists from whom he borrowed. Renoir could not conceive of the painting of his era as being substantially different from that of any era in the past. His sense of artistic progress was (as Delacroix's had been) fundamentally additive. The achievements of the present added to the achievements of the past in a quantitative fashion. Renoir would not, and probably could not, have accepted the proposition that basic changes in the craft of painting, such as those effected by Monet and Manet, might predicate a basic change in the character of the art form of painting itself. From being additive and synthetic, painting became in the hands of Manet and Monet self-conscious and analytical—hence modern. Renoir never in his long career as a painter granted this modernist redefinition of painting. Instead he used the externals of modernism to support essentially traditional efforts and aspirations.

What Renoir learned from Monet in 1867 made it possible for him to develop a specific type of subject in the context of a large Salon picture. The role of the figure in this picture had already emerged in two small portraits of Lise from 1866, *Woman with a Bird (Lise)* (Fig. 64) and *Lise Sewing* (Fig. 65). Both of these pictures set a semiportrait figure (in half and three-quarter views) in a highly generalized landscape setting. Lise is stripped of the mythological pretense she had assumed in the *Diana*, and she appears first as a fashionable and then as an everyday young girl.

In the course of several preparatory works at Chantilly, Lise's role becomes more formal and monumental, as Renoir works toward his goal of the large *Lise Holding a Parasol* and gradually formulates his image of the grand modern lady. At least four steps (Figs. 66, 67, 68, 69), and possibly many more, were involved in Renoir's preparation of the large *Lise*. The paintings which remain to demonstrate his progress indicate the search for both an appropriate image and appropriate technical ways of accommodating this image. While considering Monet (and Manet), Renoir did not bind himself to their methods. The style that Renoir finally devises for his *Lise* is as distinct from Monet as the imagery of the *Lise* is distinct from the *Women in a Garden*.

Renoir seems to have begun his project with rough, heavily painted sketches of the figure. One of these (Fig. 67) shows the figure seated in the grass and the other (Fig. 66) has the figure in profile standing with a parasol slung over the right shoulder. A letter from Bazille to his friend Edmond Maître reports that Renoir was experimenting during this period with pigment chemistry and varying the process of mixing his paint. This experimentation may have carried over into his preparations for *Lise Holding a Parasol* and explains the unusual character of the paint in these sketches. As to the actual nature of Renoir's experimentations, however, Bazille's description is far from clear:

> Renoir, the painter, is at this moment at Chantilly. The last time I saw him in Paris he was working on some strange paintings, having given up turpentine for a weak sulfate and his palette knife for a small syringe.[3]

Whatever Bazille meant by this, Renoir does in these sketches develop his figure with a dense web of small but heavily loaded brushstrokes. Within this web relative color values are sharply defined, but at the risk of a very active paint surface. The overall character of Renoir's brushwork reflects a desire to represent the crisp movement of light across a complicated motif. By mixing pigments in a

3. Daulte, *Bazille*, p. 64.

syringe with sulfate solution he may have extended the range of color values available to accomplish this. His technique of mixing and applying as it appears in these sketches is better adapted to intricate costume textures than to passages of flesh. For the faces of both figures Renoir is forced to model in deep darks in order to balance out the activity of pictorial effects in the web of paint that defines the costumes. Although successful in recording small changes of color value, this particular technique is clearly cumbersome and difficult to control when it confronts wide variations of texture. In response to this problem, Renoir moves in his next two studies of Lise to a manner of painting which is both broader and softer in its effect and which in essence recalls his much earlier work in the *Portrait of Mlle. Romaine Lacaux* (Plate 16) of 1864.

The second pair of studies redefines the role of the figure as well. The random and highly informal poses of the previous sketches are replaced by more considered arrangements. For his standing figure from this second pair (Fig. 68), Renoir makes a direct quotation from Monet's highly publicized *Camille* (Plate 8). The figure is posed in a diagonal rear view which emphasizes the broad flow of Lise's white dress. The result is clearly too impersonal for Renoir's taste since it reduces the figure to an anonymous scenic element in an ambiguous landscape setting. In the second picture from this pair (Fig. 69) Renoir rejects this arrangement, and poses the figure in a semiseated, nearly full-front view. The face is now in plain sight. Lise's right arm holds the parasol, so that it appears above and behind the head and casts very little shadow. The left arm rests in the subject's lap, and the image assumes a distinctly Reynolds-like demeanor (Fig. 70).

For his eventual Salon canvas, *Lise Holding a Parasol* (Plate 15), Renoir's gesture to the tradition of English monumental portraiture is more veiled than it appears in the study of Lise seated. For the final canvas, Renoir tries to strike a compromise between the scenic qualities of his standing study and the more traditional posed view of Lise seated. He emphasizes both scenic and imagistic qualities in his Salon piece, attempting once again to strike that balance between tradition and the recent avant-garde which seems to have guided nearly all his public efforts from 1866 through 1869.

Renoir is clearly more successful here than he had been in the *Diana*. *Lise Holding a Parasol* finally achieved its artistic as well as its practical ends. It was accepted by the Salon of 1868, and it received critical comment, most notably from the pen of Emile Zola, who grouped it with works of Monet under the critical heading, "actualist."[4] Although enthusiastic in his support of the work of many young painters, Zola was frequently insensitive to the real issues at stake in the art of his contemporaries. His grouping of Renoir's painting with works by Monet was well intentioned but blind to the basic differences involved. It seems doubtful that Renoir would have appreciated such wholesale grouping with Monet, and he would certainly have been bothered by Zola's inability to define the more traditional aspects of his picture.

In his effort to isolate new directions in painting Zola made the mistake of assuming that the broad similarities between Renoir's *Lise Holding a Parasol* and paintings like Monet's *Women in a Garden* (Plate 2) were part of an integrated program. Had he looked more closely and sympathetically, he would have found that the challenge of painting a figure out-of-doors meant two things to the two men. Even without exact knowledge of Renoir's campaign of preparation for his Salon entry, Zola should have realized from the painting itself that Renoir was operating from a conceptual framework, substantially different from Monet's.

4. Zola, *Salons*, p. 132.

Lise Holding a Parasol (Plate 15) is, like all of Renoir's preparatory versions, a figure viewed in an outdoor setting. The figure itself was almost certainly studied outdoors, although not necessarily in a setting identical with the one that provides the background in the picture as it finally appears. Renoir uses the background elements in a typical fashion to echo and reinforce the form of the figure, but he also relies on it to provide an essentially realist validation of the lighting for the figure. This was something to which he had been rather indifferent in earlier studies, where the background remained much more in the background, so to speak. Renoir's figure appears partly in sunlight and partly in a shade produced by a combination of her parasol and the tree above and slightly behind her. The situation of half-light, half-shadow is clearly intended to show off the range of Renoir's mastery of natural light effects. He has, in effect, two more or less separate systems of color and color value active in a single figure, one occurring in direct light, the other in semishadow.

In order to achieve maximum variety in both lighted and shadowed portions of the figure, Renoir draws the long, ribboned train of Lise's dress around to her right side. As a result of this her white chiffon dress, the flesh tone of her right hand, and part of the black ribbon respond to direct light and require broad shifts of color value in order to achieve relative position and texture as defined by the overhead and slightly frontal light source. Shadows on white areas of the dress are blue-gray in tone. They appear soft and transparent in relation to the black ribbon and recall in their effect similar passages in Monet's *Women in a Garden*. The semishadowed upper portion of Lise's figure, although more subdued in its value structure, is more varied in coloration, as Renoir adds to the tones active in the lower portion the salmon neckband of the dress. The background is generally dark in tone but far from characterless. Spots of sunlight flicker at irregular intervals, drawing the background into a subtle visual dialogue with the more evenly lighted figure. The background does not dramatize the figure as it so often does in the English portrait tradition. Instead, it assists in maintaining a relatively even pictorial fabric from one edge of the canvas to the other.

Generally speaking, the image possesses a quiet, aristocratic elegance. Nothing in Renoir's style appears at variance with the bearing of the figure. In the final analysis, all the external complexities of Renoir's style dissolve and lose their identity as independent factors. The role and the bearing of the figure dominate, not by suppressing individual elements of style but by engaging them completely in the coherent visual spectacle which the painting offers. The painting is a complete success on Renoir's terms and on any others one might apply.

The "coherent spectacle" of *Lise Holding a Parasol* passes almost immediately. An important commission which Renoir received sometime in the winter of 1867–68 seems to have brought about the collapse. Although frequently able to make good use of challenges imposed from the outside, and sometimes even needing them for developmental direction, the contract for *The Clown* (Fig. 71) produced difficulties for Renoir which foreshadowed in degree those that Monet faced in his *Mme. Gaudibert* (Plate 9) a few months later.

Much less is known of Renoir's personal circumstances than of Monet's in this period. The variety of letters by and about Monet has no counterpart in Renoir's career in the 1860s, but sufficient information remains to make it perfectly, if indirectly, clear that the two artists had equally rough going financially. Whereas Monet relied on money from family and friends to live independently, Renoir took frequent advantage of the hospitality of people like the LeCoeur family, the Sisleys, and Bazille. But, despite these differences, both Monet and Renoir stood in desperate need of funds in 1868 and

were willing to take any commission that seemed even remotely acceptable. For Renoir this meant, as he later reported to Julius Meier-Graefe, agreeing to produce what was in essence a permanent poster for a winter circus, featuring the figure of the circus's most famous clown. The details of this commission Meier-Graefe records as follows.

> Renoir painted a picture for the Café des Cirque d'Hiver. The prearranged price was 100 francs. The owner of the show went bankrupt and the picture remained in the artist's possession.[5]

While it is simple enough to classify Renoir's commission as a permanent poster (or signboard), it is more difficult to reconstruct the position in which Renoir found himself as he began to work on this commission. The "art" poster had not yet come into being. The sort of publicity image which Renoir was hired to create had no real tradition in type. Visual advertising during the 1860s consisted for the most part of handbills with crude *images d'Epinal* and of roughly painted signboards. No respectable artist would have voluntarily reduced himself to the making of advertising images, but Renoir was in dire financial straits, and his background as a reproductive craftsman prior to his enrollment at the École des Beaux-Arts probably encouraged him to turn to the world of commercial image-making when other opportunities seemed nonexistent.

Renoir took the project quite seriously. While the painting as it stands is far from successful as a painting, it does suggest that Renoir proceeded in a highly original fashion. He made a genuine effort to adapt current trends of style to commercial requirements. Instead of being content to reproduce the usual sort of crude, artless advertising image, he tried to raise commercial art to a higher aesthetic plane. In doing so he clearly anticipated in principle, if not in quality, the efforts of the great poster artists of the 1880s and 1890s.

The particular contemporary style which Renoir found most applicable to his project was Manet's, and later recollections of his early feelings about Manet suggest the reasons for this selection. Speaking to his dealer Vollard, some twenty-five or thirty years later, Renoir recalled with regard to Manet:

> Courbet, Delacroix, Ingres were bewildered by what seemed to them merely the naive efforts of an *imagier d'Epinal*. Honoré Daumier is said to have remarked at a Manet exhibition: "I'm not a great admirer of Manet's work, but I find it has this important quality, it is helping to bring art back to the simplicity of playing cards."

The very qualities in Manet that attracted Daumier repelled Courbet. "I'm not academic," said Courbet, "but art is not so simple as designing playing cards."[6]

What Renoir reported to Vollard in this context is almost certainly not a record of actual statements by the people to whom these statements are attributed. It is, quite obviously, a dialogue constructed to convey Renoir's own ambivalent feelings about Manet, and important for the present discussion is the fact that he did recall Manet in these terms. The qualities of simplicity and directness in Manet's art called forth associations with *images d'Epinal*, so it is wholly consistent to see Renoir turning toward Manet when faced with the challenge of producing a large popular image. The relationship which Renoir sensed between Manet and popular art was given concrete visual definition in *The Clown*, as Renoir reapplied Manet's style to one of the sources from which it appeared to

5. Julius Meier-Graefe, *Renoir*, 1929, p. 29.
6. Vollard, *Renoir*, pp. 47–48.

derive, and in so doing he raised that source to the level of fine art. A similar analogical procedure would appear in the 1890s as Bonnard and Toulouse-Lautrec reformed popular imagery with devices of style derived from Degas and Japanese art.

However, it was not only for stylistic reasons that Renoir turned to Manet during the course of his plans for *The Clown*. Manet's art offered several direct precedents in subject for Renoir's figure. Beginning with his *Guitar Player* (Fig. 72) of 1860, Manet did a large number of paintings of theatrical performers at various intervals throughout his life. Confronted with the requirement of painting a circus performer, Renoir could hardly have avoided recalling Manet's precedents.

It is evident in *The Clown* that Renoir did in fact operate with reference to Manet both stylistically and typologically. Specifically, he attempted to paraphrase Manet's *Mlle. V in the Costume of an Espada* (Fig. 4) of 1862. Renoir accepted first of all the flat, strongly colored image of the figure, standing sharply against a background which is more backdrop than an even extension of the painting's illusionistic space. The pose of the figure with its broad theatrical gesture dominates the canvas as a whole, while the figures of the audience which appear in the background are seen from an uncertain viewpoint and are very small in scale, recalling Manet's treatment of the attendants of the bullring in the upper right of the *Mlle. V*. Renoir brings together sharp contrasts of pure color and of black and white, which, as similar procedures in Manet, give to the painting a vibrant immediacy which is highly optical in character.

Where Renoir's *The Clown* fails as a painting, the failure can be traced to his misunderstandings of Manet. These misunderstandings may have been forced by certain demands of the commission, but they do, at any rate, compromise the success of the picture. The figure of the clown, clothed in a highly patterned red, black, and gold costume, was certainly determined by the commission and was not Renoir's own choice. The costume and the painted flesh of the clown's face provide a problem of color which is virtually unsolvable in Manet's terms, since it dissipates the broad opposition of light and dark tones. The costume forces Renoir to introduce leading and echoing tones throughout the picture in an effort to prevent the figure of the clown from being completely dissociated from the rest of the picture. The violin and the white chair are the most obvious devices introduced to bring about some sense of unification, but color alone does not suffice to control the painting, and Renoir is forced to establish spatial bridges between the figure and the background as well. The placement of the chair and the bow extended by the figure's right arm, which intersects the curved wall of the ring, literally ties the picture together in a way which, while necessary, seems highly contrived. The powerful opposition of foreground and background in Manet's *Mlle. V* is here weakened and the iconic quality of the figure compromised to a considerable degree.

In *The Clown* Renoir used Manet's style as a device for solving an unorthodox and highly problematic commission. His eclecticism was a matter of necessity rather than simple choice. Understandably, *The Clown* was not the sort of painting that could offer direction for subsequent work. The painting's problems were isolated and unique. While predictive of later rapprochement between avant-garde and popular art in the posters of the 1880s and 1890s, *The Clown* is of distinctly limited consequence to Renoir himself. He was not even paid for the picture.

The period following Renoir's completion of *The Clown* contains a number of important figure paintings. These suggest a variety of interests, some of which continue from *Lise Holding a Parasol*, others indicating Renoir's steadily increasing concern for success at the Salon, and one work whose aim remains unclear. The last, the *Boy with a Cat* (Fig. 73), a portrait of young Joseph LeCoeur, posed

in the nude, is mysterious in many respects. This painting has little to do with either the style or typology of Renoir's other work in this period. It does, however, echo certain elements in the contemporary work of Bazille, whose association with Renoir became closer and closer through the late 1860s.

Bazille had a preference for the male nude—a fact usually, if unsatisfactorily, explained by reference to his Protestant background.[7] This explanation cannot, of course, hold for Renoir. Further, *Boy with a Cat* is an indoor picture and as such is clearly unattached to the controversial "nude figure in the out-of-doors" program of Bazille's male nudes. The possibility that Renoir's picture represents a commissioned portrait seems rather slight. The most probable explanation for the picture, which was apparently done in the winter of 1867–68, lies in Renoir's continuing search for roles which his realist figures could be made to assume. In the case of *Boy with a Cat*, the role he develops is somewhat ambiguous but not without certain features which could have been understood by the public of the period.

Children were prime subjects of the academicism of the mid-nineteenth century, and animals were scarcely less popular. The nude figure was the established academic test of technical proficiency, and erotic imagery of one sort or another covered the walls at every Salon. Renoir's painting makes use of these facts. The choice of an adolescent boy rather than a mature female nude circumvents the issue of ideal proportions for the figure and validates an image of tactile rather than conventionally sexual eroticism. This tactile eroticism appears in the contact of flesh and soft textures. But, all of this granted, Renoir's images make the same appeal to the lower senses, so to speak, as do the contemporary nudes of Cabanel.

Concessions to prevailing standards of taste are equally clear in the way in which Renoir chooses to paint his nude figure. The figure is modeled in a heavy academic fashion with dark, nearly black shadows. Details of anatomy are rendered carefully in a pose that is both unusual and difficult. The more broadly painted passages of the picture are clearly secondary in importance and very much a foil for the figure. Although he apparently did not submit this particular painting to the Salon jury, Renoir continued many of the same considerations in one of his Salon works of 1869, the *Lise (Summer)* (Fig. 74) which he entered as a "study."

It is important to keep in mind that Renoir's *Lise Holding a Parasol* (Plate 15) appeared in the Salon of April 1868 and that the majority of his work from 1868 was unfolding at the same moment in simultaneous reaction and response to critical comment. Zola, a critic clearly aligned with the avant-garde, had written appreciatively about *Lise Holding a Parasol*. From an academic point of view, Zola's appreciation placed Renoir in a delicate position—one in which he risked so firm an identification with the realist avant-garde that his reputation with the Salon jury might suffer by association. In order to correct for this, Renoir sought to demonstrate more actively the academic side of his art while at the same time attempting to appear distinct from routine academicism through his contact with the realist avant-garde.

Boy with a Cat suggests one extreme of Renoir's conscious academicism, while *Lise (Summer)* already points to the eventual reconciliation of this academicism with the style of *Lise Holding a Parasol*. However, the kind of reconciliation which *Lise (Summer)* was to accomplish demanded certain basic modifications of Renoir's style. In order to contain somewhat tighter drawing and

7. Daulte, *Bazille*, p. 128.

more academic modeling procedures, Renoir was faced with the necessity of developing a simpler, more contrast-oriented color scale.

An undated flower still life (Fig. 75) appears to have been the test piece in which Renoir moved from the refined and delicate tonal systems of *Lise Holding a Parasol* to the heavier, more definite coloration evident in *Lise (Summer)*, and in another important figure painting of 1868, the portrait of *Alfred Sisley and His Wife* (Fig. 76). The flower still life, a subject frequently used for experimentation by Renoir, demonstrates bright, almost brittle development of color with greens, blacks, and whites dominating. Individual elements are defined sharply by heavily loaded but carefully controlled brushstrokes. The fusion of tones and brushwork is relatively slight, and the general character of Renoir's style becomes demonstrative rather than delicate.

Much the same is true for the *Lise (Summer)*. Although presented as an outdoor subject, this picture is forced and unnatural in its lighting, providing deep shadows in the flesh passages and brilliant highlights in the foliage backdrop. In the figure, academic modeling and flat, rather lifeless drawing define the essential elements of costume, hair, and flesh, while the background is roughly painted and highly generalized in aspect. The partial sunlight, partial shadow of *Lise Holding a Parasol* is here reduced to a scheme of oppositions.

The role of the figure has beeen modified along the lines of the *Boy with a Cat*. The figure is made sensuous and heavy as a result of the manner of modeling. The hair and the bodice are disheveled in a gypsy-like fashion, and the image as a whole projects both the unself-conscious sexuality of eighteenth-century peasant subjects in the tradition of Greuze and the waxy eroticism of many contemporary Salon paintings.

The reactionary qualities of the *Lise (Summer)* are somewhat tempered in the portrait of *Alfred Sisley and His Wife* (Fig. 76). As a dress portrait of husband and wife this picture fits itself quite naturally into the English mode which had previously assisted Renoir in his *Lise Holding a Parasol*. Although less formal in demeanor, Renoir's subjects recall such English types as Sir Thomas Lawrence's *Mr. and Mrs. Dunlop* (Fig. 77).

Renoir poses his subjects in elegant formal dress before a parklike landscape. They gesture to each other in an intimate fashion, so that a compromise is achieved between formal posing and a more natural situation of social intercourse. While modeling flesh passages in the rather academic manner of the *Lise (Summer)*, Renoir paints the delicate textures of the costumes and landscape setting in the softer, more fused manner of *Lise Holding a Parasol*. Drawing remains slightly stiff and demonstrative, but at no point does it become flat. The sense of natural light is convincing if less subtle than it appeared in *Lise Holding a Parasol*.

More than *Lise (Summer)*, the *Alfred Sisley and His Wife* seems to strike a successful balance between the role and the realist situation, and between academic convention and avant-garde style. The painting conveys few pictorial surprises but is undeniably attractive. Skillful rather than inventive, the painting does seem to justify its rather devious formulation simply because its level of quality remains so high. A lesser artist than Renoir, a Tissot or a Carolus-Duran, invariably collapses artistically when he operates from a similar position vis-à-vis academicism and the avant-garde, but Renoir with his truly immense powers of selective assimilation is almost invariably able to wrest a coherent style from the most contradictory components. Assimilation seems a natural function of Renoir's character, so compromises rarely seem forced.

For a critic accustomed to Monet's more consistent evolution of style, Renoir's work of 1868 appears chaotic and, in a painting like *Lise (Summer)*, even doomed by its premises. The fact is that considerable confusion does exist, but it is a kind of confusion which Renoir is able to control. All this is amply demonstrated by the *Alfred Sisley and His Wife*.

Renoir's activity in late 1868 and early 1869 was severely limited by his failing finances. The works he did produce in this period seem to lead him once again (and again briefly) into Monet's orbit. These works must as a result be considered in conjunction with Monet in order to understand the importance of the two artists' work together at La Grenouillère on the Seine near Bougival in the late summer of 1869.

6. Monet and Renoir at La Grenouillère

There is little in the work of Monet and Renoir prior to 1869 that predicts a rapprochement of style between the two artists. With the singular exception of their simultaneous work on cityscapes of Paris in 1867, the two artists had developed quite independently of each other. There were, to be sure, several mutual interests that bound them into general currents of realism, but the actual character and motivation of their separate painting remained distinct.

Of the two, Renoir was the more open to artistic and nonartistic influences. As his work developed over the period 1864–68 it examined a wide range of styles and subjects, drawn from a variety of contemporary and historical sources. Monet's work by comparison appears relatively closed. In fact Monet actually seems to have feared the consequences of becoming involved too directly in factors that were not generated by the processes of his own work. A passage already quoted in a letter from Monet to Bazille demonstrates the almost compulsive single-mindedness of Monet's efforts.

> Don't you think that one is better off alone with nature? One is necessarily preoccupied with what one sees and hears in Paris, if one is to remain strong; what I do here will at least have the merit of not resembling anybody, because it is simply the expression of what I've experienced myself.[1]

By remaining away from Paris, the very setting in which Renoir seemed to thrive, Monet isolated himself from the traditional politics of French painting, which continued in the dialogue between the realism of Manet and Courbet, and the standards of the academy. The past of painting, which academic practice represented, was a closed issue for Monet, and the basic challenges he chose to confront were, for the most part, derived from the art of Manet and Courbet—from the realist avant-garde itself. Monet's art developed as a critique and extension of the most advanced tendencies in contemporary painting. Boudin's example had preconditioned Monet's response to avant-garde realism, and the strength of this conditioning served to keep Monet's eyes on the present rather than the past.

Any rapprochement between Monet and Renoir was predicated upon the latter's more or less complete immersion in the interests of the former. However, this does not necessarily imply that the actual artistic results of such a rapprochement would be wholly one-sided in character. Monet could

1. Poulain, *Bazille*, p. 130.

not blind himself to the efforts of another artist who had chosen to work on Monet's own terms. In this sort of situation Monet would prove capable of both interest and respect.

In late 1868 and early 1869 Renoir began to provide the basis in his own work for an important rapprochement with Monet. As Julius Meier-Graefe noted in his classic study of Renoir:

> This sensibility (Renoir's), which had struggled with Manet and Courbet, was to involve itself for an entire year in impressionism with Monet. [However] For Renoir the Louvre was never [just] a mausoleum, but the living example of the great circle that Monet shunned, but which he could not.[2]

Renoir's direct involvement with Monet began in two paintings (Figs. 78, 79) from the winter of 1868–69, both of them snow scenes. Figure 78 is dated 1868, *Skating in the Bois de Boulogne*, and Renoir mentioned it in his conversations with Vollard many years later.

> Yes, the *Bois de Boulogne* ... the one with skaters and onlookers in it. I have never been able to stand the cold; it is the only winter landscape I ever did ... Oh, no there were two or three other studies as well.[3]

This comment occurs in the context of Renoir's reminiscences of his work at La Grenouillère, so the link forward to his campaign with Monet was clearly recognized in retrospect. The second snow scene mentioned above and undated (Fig. 79) probably represents one of the "other studies."

Looking first at *Bois de Boulogne* (Fig. 78) it is apparent that Renoir's Salon-courting behavior of the previous summer has momentarily given way to other considerations. Like views of St.-Cloud and Paris done under Monet's influence in 1867, the present picture is wholly lacking in academic pretense. *Bois de Boulogne* is a realist exercise pure and simple, and it is more than anything else a landscape, although a landscape in which figural activity is quite important.

Several things about the picture point directly toward Monet. First of all the use of the rather steep overhead viewpoint and the grid-like character of the composition suggest that Renoir either remembered or had recently seen again Monet's cityscapes of Paris. These may have been in Bazille's studio or on view at the shop of the paint dealer Latouche. At any rate there is little in Renoir's own work, including his cityscapes, which would have suggested the particular sort of view he now develops. Similarly, the coloration of the picture is highly atypical for Renoir's work of the period. The dominant high-value grays and browns which carefully follow Renoir's observation of atmospheric perspective recall Monet's subtly modulated grays and gray-greens in the Paris cityscapes.

The elements in Renoir's picture that seem most removed from Monet are, while less striking, important for Renoir's contribution to joint efforts at La Grenouillère. Figures, even in the context of groups, are given a more specific role and gesture, as Renoir catalogues the variety of activities involved in the scene. The overall quality of Renoir's brushwork is delicate and frequently rhythmical in character, thus it is able to contain greater variations in paint quality as well as greater detail in the specification of landscape and figural elements than one finds in any related work by Monet. Although working with a panoramic view, Renoir attempts to define various elements precisely. Foreground foliage appears heavy under its burden of snow while figures move lightly across the hard-packed ice, and all of this is conveyed through changes in Renoir's application of paint.

2. Meier-Graefe, *Renoir*, p. 36.
3. Vollard, *Renoir*, p. 51.

Renoir is as attentive as Monet to shifts of color value which define space and position in the scene as a whole, but he avoids the flat and hard character of Monet's paint surface. Renoir makes his surface yield in that low-relief fashion that has already become a trademark of his art. Rather than accepting, as Monet does, the flattening character of his viewpoint, he uses this flatness as a foil for the pictorial relief generated by his handling of paint. Where Monet's procedures seem consciously exclusive of certain effects, Renoir's attempt to be comprehensive.

The second winter scene (Fig. 79) is a simple landscape. It presents a somewhat crowded view of two outbuildings of a country house. Masonry walls and vegetation of several varieties move through the scene in a highly complicated fashion that nearly obscures the buildings from view. The scene appears under a thick blanket of snow which is rendered with a heavy impasto and in almost uniformly pure white tones. Areas that emerge from the snow are painted in somber tones of gray, brown, and black.

Renoir is chiefly concerned in this picture with projecting this substance of the snow cover—its overbearing weight as it lies or hangs heavily upon each element in the landscape. The uniformity of tone in the snow and the quality of the view make it appear spaceless except for the suggestion of background trees in the upper center. However, this spacelessness is no more flat or diagrammatic than it is in the *Bois de Boulogne*. Instead, Renoir relies upon the two-dimensional appearance of the view to contain the bold and rhythmical manipulation of pigment. The painted surface is visually and physically dense, but rich rather than schematic in effect. The low-relief quality of Renoir's conception of the pictorial is evident once again—more evident perhaps than at any other moment of his career.

The two snowscapes provide the factors of style which Renoir eventually carries into his work with Monet at La Grenouillère. These factors already convey a substantial influence from Monet in terms of the viewpoint and the overall conception of landscape subjects. Renoir appears to retain relatively few of his own interests from the figure paintings of 1868, but certain basic predispositions do in fact remain, which have to do primarily with his sense of paint texture as a source of surface rhythm, coherence, and relief. A continuation of his fundamentally craft-minded approach to the art of painting, this concern with paint texture yields to Monet's precise analysis of color value, but it retains its primacy as the stylistic basis upon which all other interests are built. The continuity of this concern with paint texture makes possible the seemingly effortless shift in interest from Monet to Delacroix that appears unexpectedly in Renoir's work in early 1870.

Feeling the need in late 1869 for a somewhat wider range of coloristic effects than he found in Monet, Renoir would have no qualms at all about turning to Delacroix (Fig. 88) for guidance. As is always the case in his work, Renoir's engagements in 1869–70 first with the style of Monet and then with Delacroix involve only relative commitments which will in the final analysis be made to serve uniquely personal ends. In this period Renoir is still searching for ideas and techniques. His work remains immature in many ways. He is open to the world of art at large, and his style is coherent in only the most general terms.

The spring and early summer of 1869 found Renoir absolutely penniless. He was unable even to afford paints and canvas. When he finally joined Monet in late August at La Grenouillère, the snowscapes still constituted recent work. Monet, despite continuing financial disasters, was considerably better off, although this period in his work was not in any sense comparable to 1866 or 1867 in productivity.

By the time Renoir had arrived at La Grenouillère, Monet has at least three important landscapes to his credit (Figs. 80, 81 and Plate 6). In these works a considerable degree of stylistic direction had been recovered, after the confusion of the Fécamp period.[4] Somehow Monet had managed to clarify that confusion, and he may even have benefited from the demands that had been forced upon him.

In a large painting of one of the hanging cliffs of Etretat (Fig. 80), Monet proceeds with obvious conviction. He had not approached a motif so forcefully since the *Terrace at Le Havre* (Plate 5). A strong factor of surface geometry returns to organize a view that brings together various landscape elements at different distances from Monet's primary viewpoint, with paintings such as *The River* (Fig. 30) providing a source of background for Monet's realization of areas of rock, water, and sky.

Bold contrasts of color and color value form a major part of Monet's sunset (or sunrise?) *Cliff at Etretat*. These contrasts along with the interweaving of topographical elements are made hyperactive visually by the consistent flatness of his brushwork and the unyielding dryness of his paint quality. By isolating passages of light and dark tones in jagged patterns, which interlock in an irregular fashion across the surface of the canvas, Monet achieves an image which, despite its romantic connotations, possesses a stark optical force. The treatment of the rock cliff demonstrates this most clearly, as Monet abruptly breaks from light to dark without modulating the shadow at all. In a fashion which is radical even by Manet's standards, Monet provides optical distinctions which receive no plastic reinforcement. Volume is virtually negated, as shadowed zones of the rock flatten out areas of foreground and background. The rock cliff, the primary element of mass, reads equivocally as volume and silhouette; in the same way the view through and to the right side of the rock makes a pattern which is simultaneously foreground and background. Without actively denying visual facts, he removes the conventional implication of these facts.

Monet's selection of this particular motif with its clear recollection of the traditional picturesque is itself significant as an index to his motives. Like Manet, he for the moment at least demonstrates his unique concerns by imposing them upon a type of image that automatically suggests certain traditional conventions. Barbizon painting, and the more romantic works of Daubigny in particular (Fig. 82), act as a foil for Monet's demonstration. The contrast between Monet's form of gesture to tradition (albeit recent tradition) and that of Renoir is absolutely basic. In fact one almost feels that Monet made the gesture in this particular instance not so much for the spectator's benefit as for his own. The implications of his art, which had remained somewhat veiled and confused at Fécamp, here emerge in full force, acting powerfully upon a base of preestablished (hence anticipated) conventions of landscape painting.

Monet used this form of gesture once more, immediately after his arrival at Bougival. His *Seine at Bougival* (Fig. 81) directly recalls prototypes in Daubigny. While perhaps less forceful in its displacement of anticipated conventions, this painting continues along the path marked out in *Cliff at Etretat*. The high-contrast palette continues unchanged, although light tones become somewhat less prominent, possibly because of the shift to a much smaller format.

4. The dating for Monet's paintings from this period is based on both stylistic and locational evidence. On the basis of letters to Bazille quoted in the text above, Monet appears first of all at Etretat in the spring of 1869 and later in the summer at Bougival with Renoir. The internal chronology for the paintings is presented as a linear progression of style from Etretat to the paintings of La Grenouillère.

Following Daubigny, Monet accepts a ground level and slightly diagonal view of the river. He chooses once again the traditionally romantic moment of sunset with its tinted, irregular light and its transformation of the normal appearance of the sky and the water. At this point, however, the gesture stops as Monet isolates the purely optical action of light and color, rejecting completely the unifying narrative of shadow which Daubigny would have seized upon to dramatize the interaction of elements in the view. The right foreground of Monet's view becomes equivocal as space definer and silhouette. The tree at the right edge links portions of earth and sky in a vigorous dialogue of variously lighted and colored shapes. Monet's description of natural elements is purposely ambiguous; his brushwork continues the flat and demonstrative character seen in *Cliff at Etretat*. Relative tone distinguishes one element from another while simultaneously causing the cluster of buildings on the far bank of the river to assume an almost phantom-like appearance.

Monet's color here achieves a resonance which is difficult to describe. He does not invent obvious harmonies, nor does he actively reject them. Greens, salmons, and yellows oppose stark white, black, and gray areas in vigorous sequences. Like the brushwork, the color tends to be rather coarse in the traditional sense. Everything in Monet's style is geared to produce the most powerful definition of optical interactions. Craftsmanship in Renoir's terms is ignored. Realization of observed effects in their most primary optical form is the true focus of Monet's interest.

What Monet achieved through a gesture of opposition to Barbizon romanticism in the *Seine at Bougival* provided him with certain procedural formulae for one of the greatest and most prophetic masterpieces of his early career, his *Bridge at Bougival* (Plate 6). Here for the first time Monet seems not only to recapture the sense of direction, apparent in his pre-Fécamp work but, more important, he manages to advance it.

While benefiting from the experience gained in the two previous pictures, *Bridge at Bougival* does not owe all of its success to the accumulation of elements it inherited as a result of its apparent chronological position in a campaign of painting. The picture constitutes a fresh response to a type of motif that engaged many of Monet's best efforts throughout his life. Simply stated, the picture is a straightforward view of a village at a moment of bright midafternoon light. All the major elements native to the subject are brought together—the buildings of the town, the river in front, the hills behind, the bridge to the opposite shore, and a sampling of the population—everything seen beneath a wide expanse of sky.

There is nothing exceptional in the motif, but it is comprehensive. The subject, if it can be spoken of as such, is clearly a rural corollary to the views of Paris from 1867 (Figs. 22–24). Like these, *Bridge at Bougival* possesses what might almost be termed personality, in the sense that while the cityscapes offer the uniquely appropriate urban panorama provided by one of the city's tall buildings, the present picture views the village from the level of the basin of water and land that forms its intimate, natural setting. A great deal of mature impressionism—Monet's, Pissarro's, and Sisley's—will be concerned with settings of this sort. The archetype which Monet here provides echoes loudly over the group efforts of the next decade.[5]

Monet's view is taken from the riverbank opposite the town of Bougival. From this position the

5. For earlier examples of villagescape subjects by Monet see two versions of his *Street in Honfleur* (Boston and Mannheim) and his *Entrance to the Port of Honfleur* (Basel), all of 1864–65.

road across the bridge rises slightly as it crosses the river and in doing so compresses the visual distance almost as effectively as do the overhead viewpoints used at Paris and Ste.-Adresse in 1867. Trees, which rise from the base of the bridge, provide through their vertical accents at the right edge of the picture and at the left of center a core of geometrical organization. The trees interrupt the horizontals of the distant shore and vary the dominant horizontality of the canvas format itself. This geometry is understated by Monet's usual standards, but it is sufficient to organize the complex of elements which the scene presents.

The shadowed foreground which Monet uses as a foil for broad passages of full sunlight derives from the preceding *Seine at Bougival* (Fig. 81) but the general aspect of light and color of the picture is quite different. The brilliant whites of the sky and of the highlights on the river surface center the tonality in high values. Bright orange and crimson accents move crisply across the scene, interacting with medium and high values of green and gray. Areas of multiple coloration are numerous, beginning in the road surface in the right foreground where blue-gray shadows and yellow-brown lights intermingle in streaks. The group of buildings overlooking the river at the left provides a spectacular demonstration of Monet's ability to situate contrasting colors stably through a precise determination of relative values. Bold contrasts are maintained but never at the expense of a coherent description of the view.

Monet's firm control of color values which operate outside the limit of a single tonality and the structural base which his view provides projects his most optically arresting landscape scene to date. Further, his brushwork rejects the flat, demonstrative character of his Fécamp period, which had remained in evidence in his Etretat canvas and in his *Seine at Bougival*. Although Monet's actual paint remains dry and opaque, brushstrokes have become more flexible and less distinct one from another. They seem capable of specifying virtually any element of plane surface or contour without fear of sacrificing either identity or surface uniformity.

The style of Monet's forthcoming work with Renoir at nearby La Grenouillère, a riverside dance hall and dock for pleasure boats, derives from this view of the *Bridge at Bougival*. Having done this painting, Monet possessed a strong foundation upon which to build at La Grenouillère. Renoir on the other hand came into the campaign with virtually nothing to show for the previous four or five months. Nevertheless, Monet's mood remained despondent, as he wrote to Bazille about his work at La Grenouillère.

> Here comes the winter, a season very appropriate to unhappiness. And after that comes the Salon. I haven't even considered that, since I won't have anything ready. I'm dreaming of a picture, the swimming area of La Grenouillère, for which I have done some bad sketches, but it is a dream. Renoir, who is spending two months with me, also wants to do this picture.[6]

This note from Monet to Bazille suggests two very important features of the campaign at La Grenouillère. First, the tone of the note clearly places Renoir's work in a position of dependence upon Monet. Renoir had apparently decided to join Monet in a project which the latter already had underway—a project which was probably linked to previous work by Monet done at two other sites near Bougival in advance of Renoir's arrival. Second, this note indicates a change in Monet's attitude

6. Poulain, p. 161.

toward the Salon. He had no specific plans for a Salon canvas, although there appears in the note a veiled hope that one of the projected La Grenouillère works might suffice. There is, however, nothing in the note to compare with the elaborate plans which Monet had described to Bazille in his long letter from Fécamp (quoted in full in Chapter 3) in the autumn of 1868.

It is possible to interpret the present note as indicating that Monet had given up all hope of sending something to the Salon simply because he had been unable to do anything he thought good. But it is equally possible that he meant to imply he was no longer willing to go through the motions of painting for the Salon, occupied as he was with his own "dreams." If one accepts the second interpretation, which seems reasonable considering the fact that Monet's work was in no sense at a standstill, the melancholy mood which the letter conveys becomes a function of the risk that Monet knew he was taking in venturing to ignore the Salon. He realized that the effort he had expended in works like the large indoor *Déjeuner* (Plate 7), rejected in 1869, had been wasted. What reputation he had gained in recent years had come from work he had shown outside the Salon. Thus, with a complete awareness of possible consequences, Monet began to consider abandoning the traditional paths of success at the Salon once and for all.

It would be difficult to overemphasize the revolutionary nature of such a move on Monet's part. Renoir would not have been capable of initiating it under any circumstances. However, the radical form of development that Monet's art was taking virtually necessitated an assault on the political institutions of art. Just as the Salon jury could not accept Monet on his own terms, he could not force his work to follow predetermined academic lines. Further, and most important, Monet's decision to pursue a course independent from the Salon, once made, would never waver. In this regard the revolution in art politics which he eventually brought about was complete and in total contrast to earlier and momentary gestures of independence made by Manet and Courbet.[7]

Official institutions could no longer contain the threat that Monet represented. Neither side was entirely to blame. Concessions were in fact no longer possible. Monet's art ignored any absolute standards of craft, style, and subject which official critics might apply. The emphatic simplicity of Monet's style could not be viewed as an extension of the traditions of art, as could Renoir's and Manet's, so there existed no grounds for reconciliation between Monet and the Salon jury. Manet, whose paintings contained a threat to academic standards which was in essence as fundamental as Monet's, nevertheless retained in his work components of traditional imagery and style that made it possible for the Salon jury to accept him as a sort of "house radical." However, in order to accept Monet, this same jury would have been forced to recognize the relativity, even the obsolescence, of nearly all recognized artistic goals.

Once the Salon jury had forced (or left) Monet to go it alone, the breach between academic and avant-garde painting in France was complete. The avant-garde proceeded to develop along lines which it defined for itself. One avant-garde movement would react against another, but rarely in a very serious fashion against academic standards. Probably because of the complete isolation of official and avant-garde tendencies, France became the center of developments in modern painting. No other country could offer such clearly defined alternatives.

Monet's eventual resolve to abandon the Salon for good received considerable reinforcement

7. Rewald, *History of Impressionism*, pp. 16, 171.

through circumstance. Shortly after the Salon of 1870, the first in which he had chosen not to partic-
ipate, the outbreak of the Franco-Prussian War forced Monet and Pissarro into exile in London.
During the course of this exile Paul Durand-Ruel contracted to purchase and exhibit their works. In
other words, the owner of a private gallery seized the initiative in judging and marketing works of
art, no longer relying upon the Salon for authorization. Durand-Ruel took up the cause of the avant-
garde as a commercial enterprise and, after a decade of financial uncertainty, proved the feasibility of
that exclusive alliance between private galleries and the avant-garde which has continued to develop
down to the present day.

To return to Monet and Renoir at La Grenouillère, it is clear that the moment was a crucial one for
each artist. Renoir was undergoing his most complete absorption in the trends of Monet's style. For
Monet it was a moment of truth—he had decided to go his own way without regard for the Salon.

In his note to Bazille, Monet implied that he had made some trial sketches of the swimming area of
La Grenouillère, possibly in advance of Renoir's arrival (since Monet says "I" rather than "we").
After these "bad sketches" both artists centered their attention on the motif. The group of six known
paintings (three by each) breaks down into three distinct pairs (Figs. 83 and 89; 85 and 86; Plates 11
and 12), each containing one work by each painter. Two of the pairs are of virtually identical views
(Figs. 85 and 86; Plates 11 and 12), while the third shows related but clearly different views. None of
the three paintings by Monet appears to be a sketch, each having a pendant by Renoir, so it is likely
that the "bad sketches" by Monet were destroyed and that the pictures that remain document the
work which Monet projected in his report to Bazille. The two pairs of paintings of identical views by
both artists are clearly the most important and climactic efforts of the campaign; the first pair ap-
pears more tentative and distinctly different from the others.

Looking at Monet's contribution to the first pair (Fig. 83), it is obvious that he has in a predictable
fashion begun with a recollection of one of his previous paintings of a similar subject, namely *The
River* (Fig. 30) of 1868. The motif is organized in a related fashion in both paintings, although the
starkness of the earlier picture is relieved somewhat in the later picture by the greater variety of
elements. These elements—figures, boats, water, trees, and the riverside pavilion—all figure in
subsequent paintings of La Grenouillère.

In his first view of La Grenouillère Monet presents a shadowed foreground and a contrasting area
of bright sunlight. The view moves across the river to the buildings on the far bank in much the same
way it had in *The River*. He is still hesitant to risk a motif which is fully and evenly sunlighted, and
he relies to a considerable degree on contrast for a definition of the effects of natural illumination. He
has, however, rejected the overcast, tonal quality of the light he had favored in paintings of 1867.
Further, he attempts to sustain the simultaneous breadth and flexibility of his brushwork that ap-
peared in his *Bridge at Bougival* (Plate 6), but he forces it more strongly in his efforts to distinguish the
congested elements in his scene. He has some difficulty with the prominent figures and boats in the
foreground. These are rendered very flatly against a silhouette of foliage and appear rather unstable
two-dimensionally in relation to the more delicately painted view across the river at the left. Monet
finds it hard to unify his treatment of lighted and shadowed surfaces in a motif as complicated as this
one. For subsequent versions he modifies his view in such a way that the sunlight and shadow inter-
weave more gradually, and his ability to maintain a balance of pictorial activity in all sections of his
canvas increases directly.

Monet's first view seems to reflect Renoir's influence in one very important way. Figures within the scene are given much greater prominence than one would expect in a scene of this type by Monet. Not only are the figures prominent in scale, but their roles are also quite clearly defined. While Monet tries to sustain the visual relativity of each figure to the scene as a whole, he seems almost equally concerned with specifying the varieties of figural activity which the scene contains.

In Renoir's first view of La Grenouillère (Fig. 84), this concern for the variety of figural activity is magnified to a considerable degree, but more striking is the degree of Renoir's assimilation of stylistic traits from Monet. Beginning with the direct and basically geometrical organization of the view, Renoir makes a comprehensive effort to understand and master Monet's example. His technique as it appears in this painting is clearly derivative; at no other point in his career had Renoir painted so broadly and so flatly. The painting of the surface of the river with its complicated reflections recalls directly Monet's generalizing brushwork with its boldness and lack of fusion.

In spite of the radically flat and open quality of Renoir's brushwork here, the total pictorial effect is much softer, for several reasons. To begin with, Renoir has chosen to work with smaller brushes than Monet's. As a result the intervals between individual brushstrokes are smaller, and a degree of optical fusion occurs despite the separateness and flatness of each stroke. Moreover, there appears to be a kind of intrinsic elegance in Renoir's brushwork which can never be wholly masked. Glancing across the picture as a whole, it is evident that Renoir's brushwork tends, almost in spite of itself, to gather in small rhythmical clusters which control the sensuous effect of the picture.

Renoir has obviously not sacrificed himself totally to the means and ends of Monet's style. As is invariably the case, Renoir corrects as he borrows; at least he intends to correct. This correction is apparent in the present picture, even in those sections which most obviously duplicate Monet's effects. In the painting of the figures of the crowd, for example, Renoir picks out individual details of gesture and costume with delicate traces of drawing. By so doing he relaxes the intensity of Monet's abruptly generalizing flatness. Renoir's painting is, despite its derivation from Monet, both more passive in its description of the motif and at the same time more attractive in its surface appearance. It seeks to charm, while Monet's efforts strive to overwhelm through sheer optical energy.

Factors of similarity and difference between the respective works of the two painters continue unchanged through the campaign at La Grenouillère. Besides the considerations already discussed, the question of color looms as a basic and irreconcilable issue. At this point the foundation of any positivist definition of whatever it was that Monet and Renoir were doing begins to crumble. It is not enough to say simply that the two painters perceived color differently at the time they sat painting side by side for the second two pairs of works at La Grenouillère. In actual fact each saw what he wanted to see or, more accurately, each made what he wanted from what he saw. Neither "recorded" what he saw in a purely transcriptive sense. Seated side by side, each was aware of what the other was doing, and each certainly knew why he was proceeding as he was. Their respective paintings do not represent alternative views of the same natural spectacle; they represent separate *definitions* of that spectacle.

In all his paintings from La Grenouillère Renoir pushed his color toward pastel tones of greens, blues, yellows, and pinks, using the motif in front of him as a guide in the selection of relative values. Renoir's palette, so composed, assumes a distinctly eighteenth-century cast and suggests that he was developing his color quite consciously along eighteenth-century lines. He had demonstrated in his

figure paintings of 1867 and 1868 a predisposition to cast his subjects in traditional roles, and it is probable that he was proceeding in a similar fashion in his development of a landscape subject so clearly posed as a nineteenth-century corollary to the *fête galante*. In fact, one might almost imagine that the small island connected to the pavilion of La Grenouillère (Fig. 86 and Plate 12) was linked in Renoir's mind to Watteau's amorous *Isle of Cythera* (Fig. 87). Throughout his life Renoir maintained a love affair with the eighteenth century, and in the present context that century provides a buffer to soften Monet's impact and to assist Renoir in projecting his own sense of the motif.

There is absolutely nothing of the eighteenth century in the palette through which Monet saw La Grenouillère. There is, instead, an intensification of effects which had first appeared at Etretat and had continued through his earlier work at Bougival. To convey the brilliance and variety of sunlight effects Monet weaves together zones of full sunlight and semishadow.

For his last two works at La Grenouillère Monet (Fig. 85 and Plate 11) loads the darker side of his palette with a wide range of colors in low values. Blue-green and crimson tones provide the definition of the shadowed foreground elements of water and two boats. These colors appear in broad opaque dashes of paint, which through interval rather than shape separate elements one from another. Although low in relative color value, these tones are quite active optically, and they manage to contain highlights of yellow and white without losing their positive coloration. The foregrounds of both paintings work gradually through a system of lessening contrasts into brightly lighted backgrounds. From deep resonant foregrounds to bright bleached backgrounds, Monet's color remains uniformly active while containing a major shift in the color key. The pictures assume as a result the appearance of a gradually changing mosaic of color, hyperactive in all sections but capable of projecting all the optical essentials of the motif.

Like Renoir, Monet uses the available view of the motif as a point of reference for calculating relative color values. However, the primary visual interests which are served by this point of reference are totally different. The particular coloration achieved by each artist is a determined artifice, and the natural event to which this coloration refers is a visual scaffold that acts both to initiate and control this artifice. The success of the paintings depends upon the internal coherence of pictured color, rather than upon the scientific accuracy with which this color transcribes the motif as seen. In more general terms, the motif provides a certain unique range of effects, but these effects are comprehensible, hence useful, only to the degree to which they stimulate a combination of those modes of visualization that each artist carries with him into the situation and those he is able to derive from that situation.

In the present instance of comparable works by Monet and Renoir, color and brushwork link the respective paintings to the stylistic background of both artists. The motif which they share and the fact of their being together, working side by side, generate a complex of unique responses. The meaning of the sort of painting which results is poetic in the most abstract sense. The paintings are visual "correspondances"[8] in Baudelaire's sense, for the motif; they are sensuous commentaries which contain the special response of each artist. More than pictures of the world, they are visual poems about it.

The character of this visual poetry varies according to the particular sensibility of each artist.

8. Angel Flores, ed., *An Anthology of French Poetry from Nerval to Valéry in English Translation*, 1958, p. 21.

Monet's paintings are bold and rhetorical, presenting configurations which equivocate linear perspective and surface geometry. Color, as conveyed by rough, disjointed brushstrokes, is resonant and at points almost brazen. Renoir's paintings are very different. Surface organization is understated. Brushstrokes and color combine to produce a delicate tapestry of shapes, textures, and tones. The result is highly lyrical and at times almost melancholic. What Zola called "temperament"[9] when discussing realist art achieves concrete definition in these paintings. Here the same reality is cast in two forms, both of which attain poetic distinction through purely visual means.

It would be difficult to overemphasize the importance of Monet's and Renoir's work at La Grenouillère for subsequent developments in impressionist painting. The appearance of these paintings and their poetic content are both central factors in impressionism during the 1870s. For various reasons Pissarro and Sisley were uniquely prepared to recognize these factors and to work with them. The basis for this recognition lies in their own painting of the 1860s. By examining this it is possible to understand individual directions in later impressionism more clearly.

9. See Zola, *Salons;* the term "temperament" is used frequently through the sequence of Salon notices.

7. Pissarro—The Progress of Realism

Pissarro was born on July 10, 1830, in St. Thomas (Danish Virgin Islands). He was nearly a decade older than those artists—Monet, Renoir, Sisley, and Cézanne—with whom he would later associate. Although educated in France (1841–47) Pissarro did not move permanently to the Continent until 1855. By that time he had already been a practicing artist for some five years.[1]

The kind of painting Pissarro had done before his final move to France was clearly provincial in type but important for his later career; it consisted primarily of landscape subjects. Two Danish painters, the brothers Fritz and Anton Melbye, befriended him during a visit to St. Thomas in 1852. Through them, Pissarro gained a secondhand knowledge of two important European landscape styles—those of Corot and of the mid-century school of Düsseldorf. Pissarro's St. Thomas landscapes (Fig. 90) respect both precedents without marking off any substantial direction of their own.

Pissarro remained a student, figuratively speaking, for most of the first fifteen years of his career as a painter (1850–65). During this time he worked in a systematic, year-by-year fashion through successive types of romantic and realist landscape. Düsseldorf painting, Corot, Rousseau, Daubigny, and Courbet were examined one after the other, and at considerable length, as Pissarro sought out an individual focus within the context of the most current traditions of landscape painting.

Like Monet, Pissarro never sought academic training. He worked periodically in informal studio schools and attempted to make personal contact with the painters he most respected. But for the most part he worked on his own and tried through his own work to come to grips with ideals and methods of the best landscape work he saw around him.

Pissarro's introduction to modern landscape occurred without benefit of the enlightened tutoring that Boudin and Jongkind had given Monet. As a result Pissarro was forced to work out a great deal on his own. Fortunately, the polemics of artistic and political liberalism that dominated France in the late 1850s had a lasting effect upon Pissarro, and he emerged with a firm belief in the notions of progress and evolution. This belief served him well during his early years as an artist. It encouraged him to examine the historical development of realist landscape painting. Gradually, he was able to assimilate the basic issues of realism and in assimilating to understand.

By 1870 Pissarro's artistic destiny along with Sisley's interlocked with those of Monet and, to a lesser extent, Renoir. But prior to this time Pissarro seems to have stood consciously apart from the

1. Ludovic Rodo Pissarro and Lionello Venturi, *Camille Pissarro, son art—son oeuvre,* 1939. Unless noted otherwise this is the source for biographical facts for Pissarro used in the present text.

others. Separated by the particular dynamics of his own early development, Pissarro appears in the role of an outsider who more by circumstance than purpose finds himself involved in the wake of nascent impressionism. Having worked systematically through the various modes of realism, Pissarro finally arrived at a point where the radical qualities of Monet's painting appeared as an inevitable next step.

Pissarro first met Monet in the late 1850s during one of the latter's early visits to Paris. At this time Pissarro was working regularly at the informal Academie Suisse. Monet later recalled having found Pissarro proceeding tranquilly in the manner of Corot—a manner which Monet himself respected at the time.[2] Subsequent contacts between the two painters during the 1860s seem to have been relatively infrequent, and those between Pissarro and the other future impressionists virtually nonexistent. Although he was undoubtedly aware of what Monet and others were doing over the course of the 1860s, Pissarro developed his interests separately. Exactly what these interests were and how they developed is apparent in Pissarro's extant works from the period.

Two small landscape paintings (Figs. 91, 92), one from 1858 and the other from 1859, mark Pissarro's entrance into the mainstream of contemporary landscape painting. The first of these, a view of a hay wagon (Fig. 91), is an obvious attempt to understand the principles of Barbizon landscape, particularly those of Theodore Rousseau (Fig. 93). Rousseau's work appealed to the Düsseldorf side of Pissarro's background. Like much German landscape painting in this period, Rousseau's work emphasizes strong local color (mostly earth-centered), small brushes, and thick, rather greasy pigment. Because of his previous exposure to the Düsseldorf manner, Pissarro's picture is generally brighter and more varied in coloration than the comparable Rousseau, and less concerned with dramatic complexes of light and shadow. But the subject, the panoramic horizontal view, and the broad area of sky clearly reflect Rousseau's general formulae.

In the second painting (Fig. 92) Pissarro has moved toward Corot. On a very small canvas, comparable to that of Figure 91, Pissarro concentrates on refining his perception of color values. No longer pleased with the simple distinction of local tones, Pissarro tries to follow Corot's example and to specify the delicate changes in the value of a single color (in this case the green of trees and grass) as that color appears modified in relation to prevailing light, to the distance from the primary viewpoint, and to the substance which projects the coloration. The picture itself is no more than a study, and it pretends to be nothing more. One is tempted to imagine that it was a study such as this which drew an often-quoted comment from Corot. Intending to encourage Pissarro, Corot is reported to have remarked:

> You are an artist...you don't need advice except for this. Study values. We don't see things the same way. You see green, I see grey and blond. But this is no reason for you not to work at values, because they are above all what one feels and experiences, and one can't make good painting without them.[3]

In 1859, the year after this picture in the manner of Corot, Pissarro had a landscape accepted at the Salon—a view of Montmorency, which is now lost. The painting seems to have attracted little interest and no comment from the critics. Probably it was indistinguishable from numerous other

2. Monet, *An Interview, 1900.*
3. Marthe De Fels, *La Vie de Claude Monet,* 1929, p. 38.

efforts of young painters who followed Corot. There is no positive indication that Pissarro submitted anything to the Salon of 1861. If he did, it was rejected, since his name does not appear in the official catalogue. In 1863 Pissarro definitely did attempt to show at the Salon, and that year he was one of the vast number of rejected artists who were given the option of showing at the Salon des Refusés. Here, too, Pissarro's work was passed over by the public and the critics, who reserved their attention for the more spectacular efforts of Whistler and Manet.

There is nothing in Pissarro's work of the period 1860–63 that could truly be termed revolutionary. Although it is clumsy and sketchy it hardly seems calculated either to impress or offend. Two paintings from this time, *White Horse* (Fig. 95), dated 1862, and *Telegraph Tower, Montmartre* (Fig. 94), dated 1863, demonstrate the range of his interests. Both are roughly painted with small brushstrokes spaced at very close intervals to follow basic changes in color value and to give rough indications of relative mass and texture. Drawing in the sense of contour or detail definition is absent. Viewpoints are low (ground level), but foregrounds are flat and open. Pissarro shows almost no interest in modulating his space in a consistent fashion. Instead he tends to build up his pictures vertically from bottom to top—foreground to background—in generally lateral bands which contain a strong central focus. He adapts the horizontal or vertical format of his canvas to the character of his motif in each instance. All these stylistic devices, while recalling Corot, appear heavy-handed by comparison and relatively unsubtle, but this is a function of Pissarro's process of learning. Each Corotesque device is exposed and exaggerated so that its implications are clearly understood.

The strongest factor of individuality appears in Pissarro's actual brushwork. This has a distinctly constructive, almost masonry-like aspect. Architectural members are rendered in flat and quite regular patches. Other areas, depending upon a general definition of their texture and substance, require either more even or more diffuse brushing. However, all these distinctions occur within a constant overall quality of Pissarro's paint surface, which remains very dense in its impasto. This surface is heavy rather than rich, as in Renoir, and busy rather than direct, as in Monet. Pissarro's surface seems mortar-like and earthbound in its essence. The sense of manual labor involved in the buildup of the surface is very strong and suggestive of the peasant ruggedness of the motifs themselves.

In a more ambitious painting of 1863, *Corner of a Village* (Fig. 96), which may have appeared in the Salon des Refusés, Pissarro's stance in the general context of realist landscape is clear. In comparing this picture to a work by Monet of about the same date, *Farmyard* (Fig. 97), variations in emphasis and interest are very apparent. Monet's picture contains virtually every element that will guide his work throughout the 1860s. The view is organized in a forcefully two-dimensional fashion which centers on the triangular junction between the sky and the land. The barn in the left center is directly reflected in the pool beneath it, providing Monet's standard equivocal resolution of surface and spatial dynamics. Paint is applied flatly and quite evenly over the entire surface, making only minimal concessions to the definition of texture and substance. What is in fact a contrast-centered Barbizon palette rejects almost completely the soft richness of Barbizon shadows in favor of crisp silhouettes.

Similarities of motif between Pissarro's and Monet's picture are strong. However, in Monet's the element of genre is submerged beneath considerations of overall pictorial impact. Pissarro, on the other hand, seeks a balance of formal conception and genre description. Although his brushwork continues its constructive character and his paint surface remains consistent and heavy, Pissarro emphasizes figural and architectural detail, and, interestingly, he uses color to assist in this emphasis.

By most contemporary French standards, Pissarro's color, as it appears here, is most unusual. It is brittle, and somewhat garish in its emphasis on high-value reds, and red-browns, with accents of primary blue and yellow. Drawing either from his own secondhand Düsseldorf background or from current French practice in exotic landscape (e.g. Fromentin's North African pictures), Pissarro here uses color for the descriptive clarification of his motif. Predictably, his handling of values suffers and the picture is highly unstable both two- and three-dimensionally.

At roughly the same time he was working on *Corner of a Village*, Pissarro moved with his family from Paris to the country, locating himself at Varenne-St.-Hilaire from 1863 to 1866. Here he was surrounded by simple rural motifs which he would learn to love. As he worked at Varenne-St.-Hilaire, his art began to lose some of its tentativeness and uncertainty. In a certain sense it became more derivative, relating to Daubigny's precedents in a very direct fashion. But, most important, a distinct artistic personality began to emerge as Pissarro produced a succession of large Salon landscapes which were more forceful than anything he had accomplished to date.

At this particular moment in his career, Pissarro saw in the work of Daubigny a number of important attractions. First, Daubigny's painting represented the most monumental form of pure landscape currently acceptable at the Salon. Moreover, it contained a strong component of Corot in its sensitivity to effects of natural light and in its concern for the careful modulation of values in a limited tonal style. Finally, Daubigny's subjects of simple landscape and riverscape scenes (Fig. 98) reflected what Pissarro found in his surroundings at Varenne-St.-Hilaire. All of this led Pissarro to apprentice himself informally to Daubigny and, as previously with Corot, to make a thorough investigation of both general and specific elements of an adopted style. It is probable that Daubigny appeared more "progressive" than Corot in Pissarro's eyes, since the former's subjects were purer, simpler, and less a function of poetic generalities about beautiful landscape.

Here again there appears an obvious distinction between Pissarro's behavior and Monet's. Monet had appreciated Daubigny's work from the moment he first became aware of it. He even owned a painting by Daubigny in the early 1860s. He had been given it by his aunt, and he sold it at some point in 1863 or 1864.[4] Elements of Daubigny's style figure strongly in Monet's work in the early 1860s. This is clear in paintings like the *Farmyard* discussed above, but Daubigny was only one of several artists whose techniques interested him generally. Looking at Daubigny, Corot, and Jongkind together, he saw a variety of realist and semirealist conventions rather than a simple progression from one point to another. Monet assembled his style from selected elements in the art around him. He organized these elements on his own terms. Pissarro, on the other hand, seems to have learned sequentially, assimilating one thing after the other in a direct, straightforward, and generally chronological fashion.

Daubigny's impact on Pissarro's work first appears in a painting which seems to have been shown in the Salon of 1864. This picture, the *Tow Path* (Fig. 99), is unexpectedly large and shows Pissarro working toward the scale of the conventional Salon entry. Here again Daubigny's example is critical, since his efforts had to a large degree validated the idea of the monumental realist landscape in the context of the Salon.

In the particular instance of *Tow Path* there remains not only the Salon picture itself, but also

4. Ibid., pp. 42–43.

Pissarro's small oil sketch (Fig. 100) done in preparation for the Salon picture. This sketch provides a clear demonstration of Pissarro's working method for this period. Since large numbers of Pissarro's works were destroyed at the time when his house was occupied by enemy soldiers during the Franco-Prussian War, the existence of the present sketch is fortunate, to say the least.

Visually, the most remarkable fact about the sketch for *Tow Path* is its closeness to the final Salon canvas in spite of the enormous difference in scale. The sketch is in almost every particular a mock-up for the finished canvas. Daubigny's precedent is very active in the sketch. Although Pissarro's brushwork is heavier and less rhythmical than Daubigny's in similar sketches, the subject, its composition, and its coloration are obviously derivative. The river is viewed in the soft diagonal fashion so characteristic of Daubigny. The landscape is rendered in several values of green and brown. Sharp passages of light in the sky are echoed in the sun streak falling across the tow road, in the reflective surface of the river and in the high values of the distant landscape. The scene is presented concisely, employing broad elements. Although the picture appears relatively flat as a result of its demonstrative brushwork, devices of the road, the river, and the atmospheric treatment of the distance resolve the view spatially.

In moving to the large canvas, Pissarro makes some definite departures from Daubigny. Instead of using the enlargement of scale as an opportunity to fill in greater topographical detail (as Daubigny does) Pissarro tries to sustain the pictorial breadth and directness of the sketch in the context of the Salon picture itself. Pissarro does, to be sure, even out many of the transitions from one pictured element to the other in the large canvas. He does smooth out his brushwork and specify topography somewhat more sharply but, most important, he tries wherever possible to sustain identical effects from one canvas to another. In other words, he attempts to reduce as much as possible the distinction between the sketch and the completed picture. As a result of this effort Pissarro's Salon picture appears rather crude in comparison to the distinctly precious delicacy and refinement of Daubigny's Salon landscapes. In his efforts to break down the barrier of finish that was conveyed by the Salon distinction of "study" and "painting," a barrier which both Daubigny and Corot respected, Pissarro was moving, perhaps unknowingly, into the path of Manet and Monet. His attempt at this time to sustain the forceful expression of the most basic formal dynamics of his work is radical in fact if not in intention.

It is impossible to know exactly how Pissarro felt about his final Salon canvas, but he did reform his efforts during the following year (April 1864 to April 1865). He moved even closer to Daubigny and painted for the Salon of 1865 the *Banks of the Marne at Chennevières* (Plate 19). For this picture no directly preparatory sketches remain, but a related sketch, the *Ferry at Varenne* (Fig. 101), demonstrates a momentary distinction between Pissarro's informal and Salon styles.

The sketch of *Ferry at Varenne* follows closely the broad, direct effects of Pissarro's work from the preceding year. The palette is less somber but not in any sense garish in its emphasis on higher color values. The lateral view of the riverbank is both more direct and more ambiguous spatially than that assumed in *Tow Path*, but the style is in general quite similar in both efforts.

The same cannot be said for his Salon painting, *Banks of the Marne* (Plate 19). Here Pissarro cultivates effects, best described as "pretty." The view itself derives from Daubigny's paintings of open river motifs (Fig. 102) done in the late 1850s. The banks of the river and the irregular line of the horizon provide subtle hints of traditional linear perspective. Reflections in the surface of the water are

carefully recorded. The coloration is fresh and ingratiating, appearing to describe accurately the action of natural light on surfaces of various tones and textures. Despite this appearance, however, the color is carefully manipulated to produce the most "harmonious" effects. The painting is dominated by a soft interweaving of green, blue-green, and blue with off-tone accents of salmon red and yellow. Numerous passages of pure white and of high-value green create an impression of light-ness through contrast rather than through the analysis of relative values. This sort of "lightness," derived from Daubigny and tracing its ancestry to the works of Constable, is sharp and very definite in its focus on individual elements of the motif. To contain this definition Pissarro's brushwork becomes delicate and at points almost petty in its inflections.

Here again, Pissarro's use of small but abrupt accents of bright color threatens the success of one of his major paintings. While stemming from a different range of considerations, *Banks of the Marne*, like *Corner of a Village* of 1863, involves Pissarro in an optically unstable system of color which he can neither contain nor develop with any real confidence. The painting has all the weaknesses of similar paintings by Daubigny, so it is, if nothing else, at least honest to its source. Fortunately, Pissarro never again plunged so completely and so uncritically into the style of Daubigny, or for that matter into the style of any other painter.

Pissarro's work directly after *Banks of the Marne* marks a clear departure from the derivative qualities of that picture. Once again Pissarro faces the issues implicit in his earlier *Tow Path*. Many of these issues had received definition and reinforcement in an important series of lectures on the philos-ophy of art given at the École des Beaux-Arts during the winter of 1864–65 and published shortly thereafter. These lectures were given by Hippolyte Taine, a positivist, a Darwinian, and a supporter of the realist art of the 1850s.[5]

In a period of probable indecision about the character and goals of his painting, Pissarro would certainly have felt encouraged by Taine's words:

> It is the aim of art to manifest a predominant character, some salient quality, some important point of view, some essential condition of being in the object. This essential condition is a quality from which all others derive, according to determined relationships or affinities [p. 50].
>
> …in confronting objects the artist must experience original sensations; the character of objects strikes him powerfully and the result must be a strong personal impression. He seizes with watchful, infallible tact every shade of difference and every relationship and distinguishes one from another naturally; it may be plaintive or heroic tones in a sequence, or the richness or soberness of two complementary or contiguous colors. By this faculty he is able to penetrate to the very heart of things and seems to be more clearsighted than other men [p. 61].
>
> Under the force of the original impulse the active brain recasts the object, now to distort and grotesquely pervert it; in the bold, free sketch, as well as in the violent caricature, you readily detect, with poetic temperaments, the ascendence of uncontrollable impressions [p. 62].
>
> The end of a work of art is to manifest some essential, some salient character, consequently some important idea, clearer and more completely than is obtainable from real objects [p. 64].

Echoing the words of Taine's lectures were those written by Zola in his review of Pissarro's *Banks of the Marne, Winter* (Plate 20) from the Salon of 1866. Here the case for the importance of Pissarro's

5. H[ippolyte] Taine, *The Philosophy of Art*, 1867.

bold departure from his work of the previous year is stated with considerable force.

> M. Pissarro is an unknown artist about whom nobody will probably talk. I consider it my duty to shake his hand warmly before I leave. Thank you, sir. Your winter landscape refreshed me for a good half hour during my trip through the great desert of the Salon...You should realize that you will please no one, and that your picture will be found too black. Then, why the devil do you have the arrogant clumsiness to paint solidly and to study nature frankly...An austere and serious kind of painting, an extreme concern for truth and accuracy, a rugged and strong will. You are a great blunderer, sir—you are an artist that I like.[6]

Pissarro's *Banks of the Marne, Winter* decisively rejects all the qualities that made *Banks of the Marne* of 1865 so cleverly attractive. It presents instead the aspect of a "bold free sketch," which conveys the "salient character" rather than any elegant externals of style. As Zola noted, it is both frank and clumsy in its appearance. Like the *Tow Path* of 1864, *Banks of the Marne, Winter* is broadly and powerfully painted. It raises to a monumental, Salon scale the vigorous generalized transcription of scenic essentials normally associated with the "sketch."

Using the bleak emptiness of a winter landscape as a pretext, Pissarro develops his most uncompromising and unyielding manner to date. For the easy spatial resolutions of the earlier *Banks of the Marne*, he now presents bold lateral bands of landscape moving from the bottom to the top of his canvas. Recalling some of his small sketches of 1862–63, these bands specify the various elements of the motif in a way that remains consistently two-dimensional. The roadway that enters from the lower left corner implies a broad sweep of pictorial space without compromising the basic two-dimensionality of Pissarro's conception. In fact, Pissarro uses the interaction of this roadway and the slope of the distant hillside to organize his picture in two dimensions. He compacts his foreground and background by flat cross readings such as that which bridges the screen of trees along the road at the left of the picture and the prominent and complicated surfaces of architectural elements at the right.

Coloristically the picture is somber and dark, as Zola noted. Browns, blacks, and deep greens with occasional highlights appear in the landscape sections while the sky is a murky, overcast gray with considerable value development. Pissarro's paint itself, and the way it is applied with broad, heavily loaded brushes and with the palette knife, suggests a new and important factor in his style—the art of Courbet. Although the painting as a total unit is flat and somewhat featureless by Courbet's standards, it is clear that Courbet has superseded Daubigny as the prime object of Pissarro's respect.

Encouraged by the voices of Taine and Zola, and possibly guided by the similar interests of the young Paul Cézanne whom he had met in the early 1860s at the Academie Suisse, Pissarro abandoned the possibility of easy popularity and rapid success. Instead, he began to investigate in the boldest, most direct terms the formal properties of Courbet's style in its least diluted form. Although never surrendering himself unequivocally to Courbet's example, Pissarro was more influenced by it than by any other artist of the period. Unlike Renoir, who had seized upon several of the external aspects of Courbet's technique and imagery, Pissarro searched out the most basic implications of Courbet's style as a whole. Having accepted the values of Courbet's art, Pissarro's impulse was to test and learn, rather than simply to adopt. In this situation the contrast between Pissarro's and Renoir's sense of

6. Zola, *Salons*, p. 78.

artistic progress is clear. For Renoir, new elements of style were added to the available arsenal of the past. For Pissarro, these elements, if they were valid, replaced the past.

The first evidence of Pissarro's interest in Courbet appears in a minor work done at some point during 1865 or 1866, the *Promenade with Donkeys at La Roche-Guyon* (Fig. 103). In its subject, its coloration, and its odd relation of figures to a landscape setting, this picture directly recalls Courbet's famous *Women of the Village* (Fig. 104) of 1851. However, Courbet's influence in this picture remains quite superficial, as Pissarro's brushwork, his drawing, and his handling of highlights still relate to the rather delicate effects noted in the *Banks of the Marne* of 1865.

In a more important picture from late 1866 or early 1867, the *Square at La Roche-Guyon* (Fig. 105), Pissarro demonstrates a thoroughgoing concern for the basic elements in Courbet's style. Singnificantly, this concern appears in pictorial terms which are even more absolute than those of Courbet himself. To begin with, Pissarro covers the surface of the picture with uniformly broad and heavily loaded strokes of the palette knife. In essence, what he does here is to take a technical device which is basic to the effects that Courbet had achieved and to study its implications in a pure and unadulterated exercise.

Each planar surface of the motif is evoked through single or coupled strokes of the palette knife. Contrasting values of the prevailing brown tonality separate these surfaces from one another, while the density of the paint itself remains virtually uniform in all sections of the picture. Individual buildings or parts of buildings are made to slant in a fashion that suggests linear perspective, but this provides only the implication of consistent pictorial space—an implication left wholly undeveloped, either by the manipulation of color values or by the choice of viewpoint. While the regularity of Pissarro's palette-knife stroke tends to reinforce the two-dimensionality of the surface on which he works and to deemphasize pictorial space within the motif, another kind of spatial sensation emerges. As each stroke shifts to describe the shape and position of some element within the motif it moves out of alignment with the regular geometry of the painting's rectangular format. The visual consequence of this is that individual strokes threaten to hover at some interval slightly in front of or behind the surface upon which they sit. They are prevented from generating these abstract intervals of space by the sheer physical weight of Pissarro's paint. What Pissarro seeks to contain, namely the ambiguous spatial effects that occur when geometrical units inside a painting compete with rather than echo the prevailing geometry of the painting's format, cubist painters will cultivate forty years later, following the lead of Pissarro's friend Cézanne.

As he moves to the second of his palette-knife paintings, Pissarro varies the size and shape of individual strokes of paint, and he is no longer faced with this conflict of internal and external geometry. This second painting, a still life (Plate 18), replaces the regular architectural surfaces of the *Square* with kitchen articles of several different shapes and textures. Pissarro places these elements against the regular geometrical bands of the table and the background wall. With his motif so arranged, his problem is to specify the qualities of each still-life member without violating the continuous flatness of the setting against which these elements are seen.

The consistent breadth of pigment applied with the palette knife provides the basic device for resolving the problem as Pissarro sets it up. Individual strokes of the knife are just regular enough to provide a unified effect over the picture surface as a whole. Pissarro, then, projects individual qualities of modeling and texture through shifts in color value.

In this still life Pissarro achieves a perfect balance between a surface consistency which unifies the painting as a whole and a precise development of color values which characterizes part from part. Challenged by the bold but unwieldy quality of Courbet's palette-knife technique, Pissarro has forced himself to master the most basic challenges of pictorial organization and definition. But even more important, he has done so without having turned to the work of any other painter for conventions of style that might have assisted him.

Pissarro moved in his two palette-knife pictures to a point of coincidence with the contemporary art of Monet—a point of coincidence which he may or may not have recognized. Both painters discovered almost simultaneously that a uniform field of brushstrokes (or palette-knife strokes) possessed everything necessary for the development of successful realist paintings. While this field emphasized the flatness of the picture plane to a considerable degree, it offered a sure means of pictorial organization. The kind of organization implied by this field stressed continuity. It did not provide hierarchical arrangement and emphasis in the same way as traditional composition, but it permitted, because of the regularity of intervals between its internal parts, an unprecedented development of color and color value. Through this development, relative accents of volume and space could be achieved optically rather than by measurement or position.

Although Pissarro did not immediately develop the implications of his work in these two palette-knife paintings, his awareness of these implications provided a basis for his rapprochement with Monet, when the moment for that rapprochement finally arrived. Pissarro realized in the period directly following these paintings that the mastery of palette-knife effects which he had achieved was not the sort of progress that the Salon jury would appreciate, and he began immediately to look for ways of incorporating what he had learned into large paintings that would be acceptable to the tastes of the jury.

Looking at the steep, hilly terrain of the area around the village of Pontoise, Pissarro found a type of landscape scenery completely different from that he had chosen for his work up to this time. Fortunately, his work at Pontoise had been anticipated by Daubigny. The latter had in 1866 painted the large *Hermitage at Pontoise* (Fig. 106), and this picture provided a schema for Pissarro's series of pictures of the same subject, done between mid-1867 and the spring of 1868. This series is composed of four large canvases (Figs. 107–109 and Plate 21) of different but interrelated views of the subject. Two of these served as Pissarro's contributions to the Salon of 1868.

This group of four pictures is the first instance of Pissarro working in a true series (in Monet's terms). The paintings represent a related sequence of views, each of which provides a unique grouping of effects which derives from subtly shifting viewpoints. Only the last and largest of the pictures (Fig. 109) is "composed" in the traditional sense; the other three attempt to use the particular qualities of their respective viewpoints and the general regularity of the technique of painting to achieve structure. Daubigny's precedent established the constant factor of a high vantage point (or a direct view facing a hillside) with the motif spread horizontally and the horizon set rather high up on the picture surface. However, the precedent only serves to get Pissarro started on his own investigation. It does not in any way dictate the precise forms his views will take. Daubigny's picture serves the same function for Pissarro that photographs had served for Monet in his work on cityscapes of Paris begun a few months before. In both instances a painted or photographed view set the general form for individual developments. Although Pissarro may have known about Monet's series of Paris

cityscapes, this knowledge is not in any sense a necessary consideration in his development of the Hermitage pictures.

Both the sequence and the method of Pissarro's development of the Hermitage pictures are open to some question. Two of the paintings are dated 1867 (Fig. 107 and Plate 21), one 1868 (Fig. 109), and one is undated (Fig. 108). Except for the last and largest (the one dated 1868, which was one of two shown at the Salon of 1868), all were very probably begun outdoors and finished, or touched up, in the studio. No oil sketch remains for any of these works, but roughly finished portions of the two 1867 canvases are very close in technique and coloration to an undated sketch, *Landscape from Ennery* (Fig. 110), which is clearly outdoor in origin, so it seems reasonable to assume that in this campaign, and probably here for the first time, Pissarro did a considerable amount of his work on major paintings out-of-doors, studying and weighing his effects directly.

The two paintings dated 1867 (Fig. 107 and Plate 21) are the most freely and broadly painted of the group. Although relatively large in scale and probably intended for the Salon, they continue to recall Courbet in their abruptly flat technical effects, in their continuously worked paint surfaces and, to a certain extent, in their selection of the motifs (Fig. 55). However, brushes of varying sizes have replaced the palette knife. Pissarro finds it desirable to generate more subtle distinctions of color and texture in the motif as he studies its complicated appearance in full natural light. His palette is still restricted to earth tones of greens and browns, but the value range is quite broad. In their general aspect both paintings clearly recall Daubigny's view of the same subject, but Pissarro shuns Daubigny's soft interweaving of lights and shadows in favor of a much brighter and more even tonality. As a result of this, Pissarro's two paintings are much bolder in their abrupt juxtaposition of the hillsides and open fields which are compressed spatially in the context of particular viewpoints he has selected.

In the smaller of his two 1867 canvases (Fig. 107) Pissarro stresses the irregular interweaving of variously shaped areas of terrain, relegating architectural elements to the background. A roadway leads in from the foreground, but it does not seriously affect the dominantly lateral aspect of the picture as a whole. The larger 1867 painting (Plate 21) features a much greater concentration on architectural elements. These occupy most of the central portion of the canvas and stretch out laterally toward the edges. To complement this, the patches of foreground terrain and the line of the horizon are made stiff, almost geometrical in character. Planar architectural surfaces are broadly and sharply defined. They are nearly ungraded by shadow, so that the sort of volume–surface ambiguity previously studied in the *Square at La Roche-Guyon* (Fig. 105) dominates the picture.

A third view of the Hermitage area (Fig. 108) seems to represent an attempt on Pissarro's part to bring together the different aspects of the two previous paintings. For this view Pissarro has located himself on a hillside which looks out over the houses into the valley of the Hermitage and across to an adjacent hill. From this vantage point elements of topography and architecture interlock very compactly. Pissarro emphasizes the flat geometry of the midground group of houses to a certain degree, but more important he balances this geometry of square and rectangular surfaces against the soft slopes of the hills and against broad patches of vegetation. Neither the geometry derived from architectural elements nor the patchy treatment of irregular landscape shapes controls the picture completely. Instead, a careful structural interdependence is established between these two factors.

Although this third and undated picture conveys a richer variety of landscape elements than either

of the two previous canvases from 1867, it stands as the most radical of Pissarro's four views. In the way it uses the dip of the valley in conjunction with a rather high viewpoint and in the abrupt termination of the scene at both the horizontal and vertical edges, this painting attacks the accepted conventions of landscape paintings with such force as to obviate the possibility of understanding and success at the Salon. To achieve this understanding and success Pissarro produced his largest version of the scene, where he attempted to clarify the effects of his three previous efforts and in doing so to facilitate the acceptance of one of those works as well. From contemporary descriptions it is difficult to determine which of the three previous pictures went to the Salon as a "rider."

As suggested earlier, this final and largest version of the Hermitage (Fig. 109) is quite traditional in its composition. Elements of different sorts are carefully placed through the picture, rarely overlapping or interacting in a very vigorous fashion. Consistent pictorial space is achieved through the careful separation of different elements, through the manipulation of large zones of light and shadow, and most important by the action of the roadway curving in from the lower right corner. Technically the picture is more finished in appearance than are previous versions of the subject, but Pissarro tries in spite of this to maintain a breadth and consistency in his technique over the whole picture. Finally, genre figures provide a suggestion of narrative which is obviously calculated to please the Salon jury.

The picture as it stands is a set of compromises. As such it is characteristic of the Salon efforts of virtually every progressive painter of the 1860s. Although the makeup of the Salon jury shifted from year to year, it was never liberal in a true sense. People like Daubigny, when they were jury members, could be counted on to support the younger realists like Pissarro and Monet, but the effect of their support could never be determined in advance, so the safest policy for any young artist was a policy of intelligent and hopefully respectable compromise.

Despite the compromises that Pissarro made in a work like the large version of the Hermitage, the style of the picture still represented something unorthodox by Salon standards, and it was left to Zola and other critics with a firm realist bias to express their appreciation. The voice of the young art student-critic, Odilon Redon, was perhaps most eloquent in its approval:

> The color [of these pictures] is somewhat dull, but it is simple and well felt. What a singular talent which seems to brutalize nature! He treats it with a technique which in appearance is very rudimentary, but this denotes above all his sincerity.
>
> M. Pissarro sees things simply, as a colorist he makes sacrifices which allow him to express more vividly the general impression, and this impression is strong because it is simple.[7]

With the completion of his group of paintings of the Hermitage, Pissarro stood at the point where the consecutive lessons of Corot, Daubigny, and Courbet had been fully digested and analyzed. A firm personal direction, paralleling Monet's in many of its essentials, had begun to appear. Having exhausted the full range of possibilities in realist landscape painting which were available to him, Pissarro was at a point in his career where it was up to him to dictate the next step his art would take. Instead of viewing progress from the outside, he would now be responsible for working it out for himself.

Unfortunately, many of the paintings that were left in Pissarro's home in Pontoise and destroyed

7. Redon, "Le Salon de 1868," *La Gironde*, July 1, 1868, translated by Rewald, *History of Impressionism*, p. 188.

during the Franco-Prussian War seem to have been products of the critical late 1868–69 period.[8] For the last part of this period in particular almost nothing remains. However, it is possible on the basis of a few paintings from 1868 and early 1870 to make a tentative description of Pissarro's development away from the style of the Hermitage pictures and toward the stylistic aims of the early 1870s which he would share with Monet, Sisley, and at times Renoir.

The basis for a development parallel with Monet's had existed in Pissarro's work from the time of the palette-knife paintings of 1867, but this parallelism did not mature until Pissarro actually began to work on motifs which were themselves related to Monet's. Pissarro never actually apprenticed himself to Monet so completely as he had to earlier masters of realist landscape, but he was more than ready to recognize factors that paralleled his own work as well as innovations that existed in Monet's current painting. In order to advance the cause of realist painting, Pissarro was willing to engage in an informal partnership with Monet. At first, Pissarro took more than he gave to the partnership, but he tried at any rate to keep the effects of his own work distinct.

After a few landscapes which were done as a sort of postscript to the Hermitage paintings, Pissarro moved (in mid-1868) to the subject of the cityscape and produced two paintings (Fig. 111 and Plate 22) which would be of considerable importance to his work in the early 1870s. The cityscape (or the villagescape in the context of Pontoise) as a subject drew Pissarro firmly into Monet's orbit.

Except for a related (but undeveloped) effort the previous year,[9] Pissarro had not shown any inclination toward such subjects. His village scenes from the early 1860s project an image of rustic genre which is not at all in evidence in the two paintings of 1868. Instead, the subject matter of the city in paintings of 1868 is accepted on Monet's terms as a scenic fact which is interesting from a purely visual standpoint.

Rather than assuming the radical viewpoints that Monet had used in his cityscapes of Paris, Pissarro seeks out views that provide a more conventional resolution of surface design and pictorial space, and that reinforce the unity implicit in his continuous field of brushstrokes. The view of the *Quai des Pothuis* (Fig. 111) relies on the traditional geometry of linear perspective and on the relationship of this geometry to the line of the horizon for its basic organization. The different pictured elements derive their shapes and details from subtle inflections of brushwork and coloration. Pissarro's palette is limited in its range—yellow-browns, blues, and warm grays predominate—but values are effectively handled and convey a convincing sense of natural light. While successful in what it sets out to do, the picture remains conservative by the standards of Monet's Paris pictures.

The second of Pissarro's cityscapes from 1868, the *Road to Gisors* (Plate 22), is less comprehensive in its transcription of urban variety but stronger in its definition of a unique and personal approach. Like so many of Pissarro's village street scenes from the early 1870s (Fig. 112), this picture offers a subject which is completely lacking in tangible character. What is distinctive is the opportunity the motif provides for examining a specific type or moment of outdoor light. This light derives from overcast, possibly somewhat stormy conditions that cause local coloration to assume a muted and distinctly unreal quality. Pissarro tries in this picture to achieve an equivalent for this quality through the careful keying of his color to a tonality based on slate grays and blue grays which shifts to green and

8. A. Tabarant. *Pissarro*, 1924, p. 18.

9. John Rewald, *Camille Pissarro*, 1963, p. 66.

brown without much change in value. Brushwork is broad and uniform, defining very little detail, while the surface and spatial organization which the view provides is simple but adequate to the situation. Nothing is permitted to compete with the quality of the coloration. It is this quality that conveys whatever description and expression Pissarro intends the picture to have.

It would be hard to overestimate the importance of this painting to Pissarro's subsequent work as a member of the impressionist group in the 1870s. His paintings from Louveciennes (Fig. 112) done in early 1870 follow directly from *Road to Gisors*. Under Monet's influence, Pissarro's brushwork becomes more regular in character as it follows changing color values, but beyond this the Louveciennes paintings continue the direction marked out in *Road to Gisors*. Everyday scenes, organized by the simplest of means, provide a scaffold for the making of expressive equivalents of nature in painted color. Nature viewed directly under differing conditions of light and atmosphere provides both the source of sensation and the means for controlling it. To Monet's optical rhetoric and Renoir's lyrical sensuousness, Pissarro adds an unaffected simplicity.

8. Sisley and Bazille—The Talented Amateurs

For all of their obvious differences of personality and circumstance, Sisley and Bazille were parallel figures in French art of the 1860s. In contrast to Monet, Renoir, and Pissarro, all of whom were forced to consider painting as a commercial as well as artistic enterprise, Sisley and Bazille were financially independent. Both of them had quite wealthy bourgeois backgrounds, and their financial support was constant despite any initial misgivings their families might have had about painting as a career.

On the surface it would appear that Sisley's and Bazille's financial situation was ideal for a young artist. Each could concentrate on his painting without worrying too much about sales, Salon approval, patronage, and all the other facets of the commerce of art. However, neither Sisley nor Bazille possessed a sense of total dedication to his work—a sense that could drive him to produce and develop in the absence of external pressures. Both clearly loved to paint, and both gained a degree of personal fulfillment from painting, but this fulfillment did not involve the life-or-death urgency that marks the efforts of Monet, Renoir, and Pissarro.

The lack of commitment that lies at the base of Sisley's and Bazille's painting in the 1860s is evident in two very important facts, which are actually two manifestations of a single problem. Sisley painted only a few important pictures during the 1860s and these were invariably in response to the schedule of the annual Salons; Bazille produced a much larger number of paintings, but many, if not most of them, are unfinished. Those that Bazille did finish tend like Sisley's to have been produced for the Salon. It is possible to infer from this a relative absence of personal motivation which seems to have affected both painters almost equally. Each appears to have needed the artificial stimulus of the Salon to produce on a regular basis. To a greater or lesser degree the Salon had been a yearly obstacle for Monet, Renoir, and Pissarro, but for Sisley and Bazille it provided the only source of regularity in their artistic lives. The freedom from financial responsibility encouraged a laxness and an absence of focus in their work. For this reason their work retains the character if not the quality of amateurism.

It does not necessarily follow, however, that poverty is essential for artistic motivation and direction. Both Manet and Degas survived their comfortable circumstances, and it is conceivable that Monet, Renoir, and Pissarro might have been consistently productive even if their circumstances had been different. But the fact remains that Sisley and Bazille were not. Although the present study is concerned primarily with the painting of the 1860s, it is important to note that Sisley's financial

situation changed in 1870, as a result of the collapse of his father's business. When this happened, Sisley's output increased considerably, but it continued to rely on direction from the outside— usually direction dictated by Monet's work. This appears to suggest that Sisley's behavior in the 1860s resulted as much from a basically dependent artistic personality as from the simple force of circumstances. Similarly, Bazille's artistic convictions appear to have been fundamentally weak. It is perhaps harsh to judge a painter whose career was so tragically cut short as Bazille's, but there is nothing in his work of the period immediately prior to his death in the Franco-Prussian War which suggests even the remotest possibility of change or maturity in the overall character of his art.

Judged by the standards of Monet, Pissarro, and Renoir, Sisley's oeuvre of the 1860s appears timid and tentative in its commitment to contemporary currents of realist painting. Bazille's work is rarely timid but is equally tentative in its commitments. Where Sisley is hesitant and careful in his perusal of realist painting, Bazille is almost completely uncritical, and he is capable of looking in several directions at once without taking time to examine any one possibility in depth. Personality differences between the two painters provide at least a partial explanation of the distinctions that appear in their work.

Sisley appears to have been a refined, slightly remote, and apparently sympathetic personality in the most complete description of him that remains:

> Sisley, a thin, elegant man, completely English in composure and birth, had landed in Gleyre's studio after some unproductive work in the ateliers of English painters. His father, an agent for artificial flowers, had come to live in Paris, afterwards being dissatisfied and returning to England...He [Alfred Sisley] had the rare privilege of being encouraged in his pursuit of painting by reasonable parents. If, at a later date, fortune abandoned him, the good education of his affluent childhood always remained with him to give the illusion of refinement that was part of his transparent nature. Sisley, in deepest misery, wore irreproachable false collars and a perfectly kept beard.[1]

Bazille, on the other hand, was a child of the French provinces. His Protestant family lived in Montpellier. Bazille was educated there up to the point of his primary training in medicine, which took place in Paris. While hailing from a good family, Bazille retained its provincial aspect and often returned to his home in the south. His family had excellent connections in Paris which enabled Bazille to move in social circles there that were considerably above those of most of his painter friends. He was avidly fond of music and very much aware of important figures of the moment— Wagner in particular. Although tall and rather clumsy in appearance, Bazille seems to have enjoyed the society of the comparatively progressive upper class of the Parisian art world. Through it he came in contact with such people as Manet and Puvis de Chavannes. More than any of his friends, Bazille was socially *au courant*—a position which he seems to have enjoyed—and he always remained somewhat hesitant to join with Monet or Renoir in their more solitary ventures.[2]

Bazille's situation encouraged him to behave like a dilettante and this more than anything else determined the character of his work. He was overinvolved and unable to view the artistic events around him with any sense of perspective. Monet, who was genuinely interested in Bazille, frequent-

1. De Fels, *Claude Monet*, p. 66.
2. Poulain, *Bazille*, pp. 20, 24.

ly reproached him for his involvements. Acting almost as a moral arbiter, Monet would challenge Bazille to concentrate on his own work. Monet's long letter from Fécamp in late 1868 is a perfect case in point, but it is only one of many such statements.

> I don't envy you being in Paris. Don't you really think that one is better off alone with nature? One is so completely pre-occupied with what one sees and hears in Paris, if one is to remain strong; what I do here will at least have the merit of not resembling anybody, because it is simply the expression of what I've experienced by myself.[3]

The personality that Bazille developed in the context of the Paris art world was very different from Sisley's. Bazille was an energetic provincial trying to keep in step with everything new and important. Sisley was a refined foreigner, standing on the outside and looking in cautiously. Granted the fact that neither painter had particularly strong artistic ideas of his own, Sisley's position was perhaps more fortunate. He was able to adopt a basically consistent framework for his painting—a framework derived from his contact with Monet and Renoir at Gleyre's atelier and developing at a respectful distance from their landscape work throughout the 1860s.

Generally speaking, Sisley's art world was bounded by Monet and Renoir. They were his closest artistic contacts and he depended upon them for ideas and direction. Like Sisley, Bazille looked for guidance from them but he looked elsewhere, too. As a result his art vacillates among a number of different and frequently contradictory interests. Individual differences notwithstanding, Bazille and Sisley can be considered together as significant secondary figures in the art of the 1860s. Bazille's work remains consistently interesting because it covers, so to speak, so much ground, and Sisley's is important because it provides a firm foundation for personal developments to come.

Both Sisley and Bazille were included in the group of young painters working in Gleyre's atelier in 1863. With Renoir and Monet they formed a circle of friendships that continued to develop throughout the lifetimes of the painters involved. In the relaxed and highly permissive atmosphere of Gleyre's studio the four painters were able to work more or less according to their individual interests. Renoir was enrolled simultaneously at the École des Beaux-Arts, so his time at Gleyre's was probably spent preparing work assigned for regular classes and competitions. Monet, on the other hand, found himself out of place. His enrollment represented an attempt to pacify his parents who were perpetually upset by his avoidance of formal training. During his brief tenure at Gleyre's, Monet tried his hand at drawing exercises from the nude model posed in the atelier, but he was neither interested nor successful. Of the four friends, Monet was the only one who was actively dissatisfied at Gleyre's and also the only one who appears to have minded Gleyre's mild criticisms.

Although none of Sisley's thoughts about Gleyre and his atelier are recorded, he was probably content with the opportunities available to pursue his assignments from the École des Beaux-Arts, where he was enrolled along with Renoir. In letters to his parents Bazille appears to have been both satisfied and grateful for the guidance he received. When the atelier was about to close Bazille wrote to his parents:

"M. Gleyre is very sick—he may even be in danger of losing his sight. All his students are very concerned, since he is dearly loved by all those around him."[4] In comparing this sentiment to that

3. Ibid., p. 131.
4. Poulain, p. 35.

expressed later by Monet it is evident that the situation at Gleyre's was good or bad depending upon individual expectations: "None of them Renoir, Sisley or Bazille manisfested any more than I did the least enthusiasm for a mode of teaching that antagonized both their logic and temperament. I forthwith preached rebellion. The exodus being decided upon we left."[5]

Since Gleyre's retirement rather than Monet's rebellion closed the atelier, the above is more polemic than truth. However, Monet was a rebel, even at this early date, and he had a call that was being undermined by his work at Gleyre's. Whenever Gleyre commented on his work, Monet realized that both he and the whole idea of realist painting were under attack. One of Monet's biographers reports the following comment directed by Gleyre at one of Monet's studies from the posed figure:

> Not bad, not bad at all, this study. But it is too much in the character of the model. You have a heavy-set man, so you paint him heavy set. He has gigantic feet so you render him that way. It is very ugly, all that. Remember young man, that in rendering a figure one must always think of the antique. Nature, my friend, is very beautiful as an element for study, but it does not offer interest beyond this. Style, you must understand; that's the thing.[6]

Monet used the opportunity afforded by the closing of Gleyre's atelier late in 1863 as a lever for challenging his three friends to join with him in some landscape painting. Bazille, who still divided his efforts between painting and the study of medicine, was most attracted by Monet's challenge, and during the next two years he worked with Monet on several occasions. Sisley and Renoir on the other hand continued their work at the École des Beaux-Arts and seem to have worked at landscape only during the summers.

Bazille

Bazille's art began to assume its distinctive character between 1863 and 1865. Both paintings and letters remain to clarify his interests as they developed. A large painting of a reclining nude (Fig. 113) dated 1864 suggests that academic values absorbed from Gleyre continued to occupy Bazille despite Monet's efforts to encourage more forceful directions. This painting is derived from studio sketches and presents the figure of the model in a sensuous if somewhat uneasy pose. In a way that anticipates Renoir's efforts in the *Diana* (Fig. 60) of 1866, Bazille uses the subject of the nude figure as a device for demonstrating his mastery of academic techniques of modeling, drawing, and foreshortening.

Unfortunately, the reclining nude in this picture never really gets beyond its dryly academic premises. Contours are forced. Modeling is heavy and rather coarse without really being successful in its projection of relative volumes. Foreshortening, particularly on the lower sections of the legs, is poorly calculated. While showing an awareness of the difficulties of academic figure painting, Bazille's mastery of these difficulties is far from complete. There are, however, a few indications of features that will become a permanent part of Bazille's approach to painting. Among these are a tendency to isolate crudely areas of light and shadow, and an attitude toward color that stresses an almost primitive contrasting of white with bright primary tones. Both of these features generally tend to emphasize the picture surface, but they fail to generate the kind of optical vitality found in the works of Manet or Monet.

5. Monet, *An Interview*, 1900.
6. De Fels, p. 64.

Bazille's attitudes toward color and modeling rarely succeed in being realized pictorially. He avoids basic decisions about these elements, and as a result rarely seems able to control them. He never commits himself either to flatness or three-dimensionality in his painting. He combines two- and three-dimensional effects almost at random. In this strictly formal sense his art really never develops beyond the point defined by this early reclining nude. Periodically, he does produce pictures that answer directly to Manet or Monet and generate more forceful effects, but for the most part Bazille's work is compromised by its permissiveness and its lack of discipline.

Superficially, Bazille is related to Renoir in his apparent desire to avoid a total commitment to any one stylistic direction, but he is unlike Renoir in his inability to sustain multiple directions. Bazille lacked Renoir's supreme command of the craft tradition of painting, and for this reason he was unable to make effective visual sense of the stylistic factors he attempted to combine. Operating without Renoir's training or Monet's experience in the practice of painting, Bazille rushed confidently into some of the most complicated painting situations imaginable.

From the beginning Monet adopted a paternal attitude; he hoped to discipline Bazille's talent and interest. He tried to give him the guidance he had himself received from Boudin, and he pleaded constantly with Bazille to leave Paris and work with him in making studies from nature. He warned Bazille of the dangers of becoming too concerned with the dynamics of the art world of Paris, and he emphasized the necessity of learning for oneself. The tone of Monet's warning in the letter of 1868 quoted above is already apparent in his correspondence with Bazille in 1864. Monet wrote the following from Honfleur on July 15, 1864:

> I keep asking myself what you could possibly be doing in Paris in such beautiful weather. Here, my friend, it is beautiful, and every day I discover more beautiful things. I'm going mad, because I want to do everything. My head is spinning! It's very difficult to get anything right in all its relationships; I believe that everybody has to content himself with partial success. Oh, well, my friend, I want to struggle, destroy and begin again, because one can do what one wants and understands, since it seems to me that I see it all made, completely written out when I look at nature; afterward, when it comes to getting it down yourself and you're actually working on it, that's when the going gets rough! All this proves that it is necessary to think *only* about nature; it is by the force of observation and by reflection that one makes discoveries. So, we continue to work hard. Are you making any progress? Yes, I'm sure you are. But I'm also sure of this, that you're not working hard enough, nor are you working in the right way. It's not with playboys like your friend Villa [a painter of animal subjects] and others that you are really able to work. It's much more desirable to be alone, and better yet, completely alone; you'll find that there are some things you just can't figure out and that your picture is terrible, nothing but a crude blotch. Have you done your large figure from nature? Some astonishing things have occurred to me as I was in Paris and Ste.-Adresse during the winter. Do you ever go to the country? Above all, come and visit me, I'm expecting you, and if not right away at least by the 1st of August.[7]

On the surface this letter may appear to be a sort of recruitment effort directed at Bazille. It is, however, a great deal more than that. The letter does not dictate what Bazille should be painting, but

7. Poulain, p. 39.

84

it does imply disapproval of the way Bazille was going about his work. Monet encouraged Bazille to think about nature and about painting, and not just to follow the current fads.

For eight days in the summer of 1863 Monet had worked with Bazille at Chailly in the Forest of Fontainebleau. In letters to his parents Bazille was enthusiastic about the help he received at that time.

> I have just spent eight days in the small village of Chailly, near the Forest of Fontainebleau. I was there with my friend Monet, who is very strong in landscape; he has given me a great deal of help which has been very beneficial.[8]

However, even at that time Bazille's interest was divided, since he had just seen an exhibition of Manet's work at the Galerie Martinet. His enthusiasm about that exhibition was also reported to his family: "You wouldn't believe how much I understand studying Manet's pictures. For me a single viewing is worth a month's work."[9] It is possible that some of the emphasis on bright color and patterned modeling that appears in Bazille's reclining nude indicates an initial response to Manet.

Shortly after he had written his long letter to Bazille, Monet was able to exercise his direct influence on Bazille a second time. Bazille traveled to Normandy and joined Monet at a popular haven for artists and writers near Honfleur, the Ferme St.-Siméon. There, while Monet worked on some village scenes from Honfleur, Bazille did a small painting of the farmyard at St.-Siméon (Fig. 114). In this picture and in a seascape of a somewhat later date (Fig. 115) (a painting which may have been copied from a related Monet, Fig. 116), Bazille adopts directly the flat, value-oriented, and basically graphic qualities of Monet's contemporary style. These two paintings are among the most straightforward of Bazille's oeuvre. They indicate the level of quality his painting could achieve under the direct influence of a more formidable talent. Another painting from the 1864–65 period, *Rita the Dog Asleep* (Fig. 117), represents a similarly successful venture into the orbit of Manet. Here, working dominantly in black, with accents of red, brown, and white, Bazille manages to appropriate Manet's stylistic effects.

On the basis of these limited successes Bazille soon had his sights set on more important projects. He seems to have shared with Monet an interest in the challenge to realist painting which Manet had hurled in his *Déjeuner sur l'herbe* (Plate 3). Monet in his work of 1865 answered Manet by working out the problem of painting figures out-of-doors along more consistent realist lines. Monet's own *Déjeuner* (Fig. 5), discussed in Chapter 1, presents the primary formulation of his answer to Manet, and Bazille was intimately involved with the plans for this project from the very beginning. The two painters shared a studio in Paris in early 1865, and the possibility of doing a figure piece set outdoors was probably a frequent topic of discussion. Then Bazille went to Fontainebleau during the summer of 1865 to pose for Monet's *Déjeuner*.

The true significance of the time that Bazille spent in Monet's company during the planning stages of the *Déjeuner* becomes clear in the work which Bazille began after leaving Fontainebleau for an extended vacation with his family in Montpellier. With his eye on the Salon of 1866, Bazille worked out his own painting of a figure set outdoors, the *Red Dress* (Fig. 118). As a painting it is something of a letdown. An odd combination of elements from Monet and from standard academic practice, the painting is typical of Bazille's inability to think through a complicated painting problem.

8. Ibid., p. 34.
9. Ibid., p. 36.

Bazille does not seem to have realized the radically personal premises of Monet's work, nor did he understand the irreconcilability of these premises with academic methods. He was the first of many painters to mistake Monet's flat treatment of outdoor subjects for an extension of academic practice rather than an alternative to it. In *Red Dress* he combines a Monet-like treatment of the village seen in bright sunlight in the background with a densely modeled, semishadowed foreground which contains the figure. The pictorial qualities of the two separate sections are so different that they very nearly dissolve into two pictures on the same canvas. The foreground projects deep volumetric and spatial relief, while the background presses outward to the picture surface. When the two sections overlap as they do around the head of the figure, relationships become ambiguous and unstable.

From the outset of his painting Bazille tried to simplify his problem. In place of Monet's elaborate studies of figures and setting, painted from nature, he worked from small preparatory drawings in black and white which gave him no sense of the relative interaction of color and modeling. He enlarged his drawings by squaring and transferring bit by bit, finally establishing the particular relationships of color and tone as they seemed most appropriate to the subject.[10] To be sure, Bazille saved himself the agonizing frustrations that Monet experienced in his *Déjeuner*, but in so doing he lost touch with the abstract principles that gave Monet's efforts their strength and consistency even in the context of the ill-fated *Déjeuner*.

In a certain sense Bazille was more successful than Monet in getting the project they shared into finished form, but he almost managed to obviate the entire effort by reducing it to a simple and unsuccessful academic exercise. When Monet himself succeeded in giving form to the project in his *Women in a Garden* (Plate 2) of 1866, Bazille bought the painting and in owning it learned, one might almost say, how little he knew. This picture more than any other determined Bazille's greater success in numerous later efforts to produce outdoor figure paintings—one of which has already been mentioned as part of a canvas that Monet had used himself in a trial run for *Women in a Garden* (Fig. 14).

It is certainly to Bazille's credit that he spent much of his time between 1865 and 1867 on small works in which he attempted in one way or another to come to grips with the formal innovations he recognized in the art of the two painters he most venerated—Manet and Monet. As suggested earlier, it is possible that his enthusiasm gradually affected Renoir and Sisley in 1867 when the three worked together in the same studio. Monet often stored his work with Bazille in order to keep it from the hands of creditors, so it was always there for reference. Similarly, spending a good deal of his time in Paris, Bazille was in touch with Manet's most recent work. If he produced no really important canvases in this period, Bazille at least began to make up for some of his own lack of practice, so that he was by 1867 a much more skillful painter. He was, however, no more certain of what his particular interests made possible, and he remained somewhat confused about this up to his death in 1870.

By mid- and later 1867 Bazille was able to use his combined interest in Manet and Monet to greater and greater advantage. Bazille's portrait of Renoir (Fig. 119), probably done before the latter's departure for Chantilly, represents the most complete success Bazille would ever achieve, working after Manet's example. Similarly, in three landscape views of the fortified city of Aigues-mortes (Figs. 120–22), near Montpellier, which he did after leaving Paris in the summer, Bazille successfully adopted the style of Monet's work from early 1867 and added to it the heavier and more

10. Daulte, *Bazille*, p. 195, D (drawing) 17.

liquid paint quality of Manet. None of Bazille's paintings from this period achieves a truly individual quality that might demonstrate an advancement of the elements of style which they inherit. However, they do point up an obvious increase in Bazille's technical assurance.

This increased competence encouraged Bazille to think once again about the problem of figure painting outdoors. With Monet's *Women in a Garden* literally at his side and with the knowledge that Renoir was working on an outdoor figure at the same moment (*Lise Holding a Parasol*, Plate 15), Bazille planned a large group portrait of his family, posed on the terrace of their summer home at Meric, a small village outside Montpellier. This planning eventually resulted in the large *Family Reunion* (Plate 24) which was apparently begun in the fall of 1867 and finished during the following year in time to be exhibited in the Salon of 1868.

The idea for a painting like *Family Reunion* had occupied Bazille for some time before he actually got the project under way.[11] It derives from Monet's *Déjeuner* project of 1865–66 but departs from it in several important ways. Like Renoir's *Mother Anthony's Inn* (Plate 17), *Family Reunion* is in many respects an exercise in group portraiture. Bazille is the first of his generation to attempt to combine the problems of group portraiture with the problems of figure painting in the outdoors.[12] In essence, *Family Reunion* unites the premises of Renoir's *Mother Anthony's Inn* and Monet's *Déjeuner*. Then, it adds to these premises a strong component of Manet as well—a component of both style and figural psychology.

The preparations for Bazille's project were quite complicated and involved two sorts of work, first, drawings from nature to determine the disposition of figures, and second, oil studies to determine relationships of light, color, and space in the setting. There is in these preparations an obvious echo of Monet's procedures during his *Déjeuner* project. Paralleling Monet's views of forest interiors (Figs. 7–9), Bazille made an unfinished oil study of a section of the terrace at Méric (Fig. 123) which is shown surrounded by beds of oleander and shaded by a large tree. This study establishes many of the elements in the setting finally used for *Family Reunion*. Then, in place of Monet's oil sketches of informal figure groups, Bazille works out through several drawings an arrangement of the figures that places each figure in portrait view, but which at the same time represents a hierarchy of family relationships.[13]

As it stands in its final form *Family Reunion* (Plate 24) is more successful as portraiture than as painting in the pure sense. Each figure whatever its position concentrates its glance on the spectator in a way that recalls the psychological directness of certain figures in Manet's *Déjeuner* or his earlier *Music in the Tuileries Garden* (Fig. 124). However, Manet's highly selective concentration is dissipated by the multiplicity of staring faces in Bazille's picture. This multiple focus reduces the spectator's potential for direct involvement with any given figure just as many group portrait photographs do. Bazille neither focuses his attention selectively nor does he accept a scenic orientation toward his group as a whole. The result is visual and psychological confusion.

The picture finally appears as a lateral multiplication of portrait parts. A degree of unity is provided

11. Poulain, pp. 77–82.

12. This picture is because of its specific subject matter related to several types of realist precedents, among them the group portrait (e.g. Courbet's *Burial at Ornans*) and the anonymous figure (or figures) set out-of-doors (e.g. Manet's *Déjeuner sur l'herbe*).

13. Daulte, p. 196, Ds. 20, 21. Also, p. 201, fols. 38, 48.

by the general lightness of Bazille's palette, which is dominated by primary colors and high values. Relying on the precedent of Monet's success with similar devices in *Women in a Garden* (Plate 2), Bazille fails to comprehend the fact that Monet's success depends to a large degree upon his decisively scenic stance with regard to each figure. Where Monet's figures appear as forceful patterns, Bazille's become visual and psychological cutouts. Once again Bazille is the victim of his own inability to determine the priority of effects and to decide upon those which can be made to operate simultaneously.

In a painting of the following year, the *View of the Village* (Fig. 125), Bazille succeeds in better integrating his aims. This picture, which appeared in the Salon of 1869, is essentially a repetition of the motif of the *Red Dress* of 1865 with revisions dictated by Monet's *Women in a Garden*. While continuing the troublesome combination of a shadowed foreground and a brightly lighted background from *Red Dress* (Fig. 118), the later picture is much more sensitive and delicate in its handling of relative color values, so transitions between elements at various distances seem less abrupt. However, in spite of this greater sensitivity to values, Bazille continues to model his figure in soft academic shadow and to shift to sharp, Monet-like techniques for rendering areas in full light. Bazille is, in other words, still unaware of (or unwilling to accept) the basic consistency of approach which Monet's effects demand.

For as long as Bazille, or any other painter for that matter, attempted to use Monet's effects in combination with academic drawing and modeling, the visually harsh and unresolved qualities which are evident here continue to appear. Rather than approaching his painting as a total visual field that had to be developed in a consistent fashion, Bazille once again worked from drawings which were combined, enlarged to the scale of the final canvas, and subsequently colored in response to the motif as it appeared.[14] Whether Bazille's picture can be said to describe natural appearances effectively or not is irrelevant pictorially. When necessary for the qualitative success of a given painting Monet could lie, exaggerate, or underplay much of what he saw. Nature guided Monet, but he would never have forced it to justify exactly what he did in a particular instance. Bazille, on the other hand, could in a case like *View of the Village* perhaps justify his composite procedures on the grounds of natural observation, but he could not force this justification to verify the actual quality of his picture.

In the period following *View of the Village* Bazille's art turns in a rather different direction. He seems to lose much of his enthusiasm for Monet and to turn toward the very different art of Puvis de Chavannes. This finally appealed to the latent academicism that informed Bazille's artistic character. Puvis's art was certainly the most interesting variant of academic painting that the 1860s had to offer. He managed through a unique sense of style to breathe formal life into monumental canvases of classical and historical subjects. His art seems to have challenged Bazille to another grand task, that of reconciling the realist premises of his own art with the most vital contemporary form of academic painting.

Bazille's increased contact with Renoir in 1867 and 1868 probably also encouraged, so to speak, a "wider view of art" than that assumed by Monet. In any case, Bazille began in two important paintings of 1868 to expand his artistic frame of reference by portraying realist figures outdoors in clearly

14. Ibid., pp. 201–02, fols. 52–54.

traditional modes of imagery and by further emphasizing the academic elements of drawing and modeling in his painting.

Beginning in a painting of a fisherman casting his net (Fig. 126) dated July 1868 and therefore done shortly after *View of the Village*, Bazille turned to the subject of the nude figure outdoors. Bazille's move toward the reconciliation of two artistic currents, the academic and the realist, was implicit in the substitution of the nude figure for the clothed figure. The fisherman and the net mender in the background are carefully drawn and broadly modeled in the manner of Puvis. Much attention is given to rhythms of line in individual contours and in the overall silhouette of each figure. The setting is open and not congested by landscape detail. Everything is geared toward maximum clarity and definition. Figures are obviously established in advance of the setting, but their placement and integration are reasonably successful, certainly more so than in similar efforts by Renoir. The palette is composed of tonal greens, grays, and blues which fuse evenly without strong contrasts.

Taken on its own terms the painting achieves a degree of balance between its conflicting interests. The figures do project a simplicity and monumentality that recall Puvis, and the painting as a whole is more consistent in its execution than many of Bazille's efforts. There is, however, a tension between the specific posed action of the main figure and the rather bland self-containment of the figure's design. Bazille appears to be undecided whether narrative gesture or formal architecture should derive from the main figure.

When he takes up the problem again the following year in the *Summer Scene* (Plate 23), exhibited by the Salon of 1870, much of this indecision remains, but it is mitigated by an increase in the number of figures involved. In this picture Bazille projects a realist allegory of summer, centered on the activity of swimming. His landscape setting recalls the previous picture but it adds a much clearer suggestion of linear perspective. In *Summer Scene* space dominates the figures in order to contain their variety.

Bazille's figures in *Summer Scene* form a veritable catalogue of the sport portrayed. They appear in and out of the water, resting, swimming, wrestling, dressing, and undressing. The scene is given an injection of traditional imagery through the vaguely baptismal relationship of the two foreground figures at the right and through the classical river-god pose of the figure lying on the bank near the center of the picture. In a certain sense the imagery of the picture appears to reflect yet another revision of Manet's *Déjeuner*, one that intensifies both the realist and the traditional aspects of that picture.

Programmatically, *Summer Scene* marks Bazille's most forceful effort at bringing into harmony the conflicting interests that engaged him toward the end of his short career. Many of the ideas that lie behind his efforts reappear in the 1880s in the work of Cézanne and Gauguin, and in this sense the particular dynamics of Bazille's last years anticipate the reaction against Monet's impressionism which appears in the avant-garde of the 1880s. However, the motives that lay behind Bazille's efforts were subject to the situation of art in the 1860s. Bazille rephrased Monet's art on the basis of academic and literary values before he fully realized its basic position. Bazille hesitated before the fact of nascent impressionism, while Cézanne and Gauguin (and Renoir as well) react later on the basis of a more complete understanding of what they are reacting against.

Growing as it did from hesitation rather than understanding, Bazille's *Summer Scene* appears confused pictorially. It superimposes an academic clarity of figural definition over passages of subtle

realist illusion. In areas like the water where figures appear partly submerged this superimposition creates a great deal of confusion. Throughout the entire picture details of foliage and such things as the bold striped patterns of the bathing trunks seem to break out of the picture as a whole and project the chaos, if not the simple-mindedness, of Bazille's actual process of picture-making.[15]

Bazille's works of late 1869 and early 1870 follow in the wake of Renoir's turn toward Delacroix. Bazille's *La Toilette* (Fig. 127) of 1870 is a Delacroix-oriented costume piece in the manner of Renoir's *Odalisque* (Fig. 88) and *Bather with a Griffon* (Fig. 89) of the same date. Bazille's final project, left incomplete at his death, is a *Ruth and Boaz* (Fig. 128), complete with recollections of virtually all the stylistic effects of Delacroix's literary subjects.

It is of course impossible to predict exactly what Bazille might have accomplished had he not died in action during the Franco-Prussian War. However, during his short career he emerged as a painter whose inclinations were to make paintings about the painting he saw practiced around him rather than to paint from any particular conviction. Like any knowledgeable dilettante he had many good ideas but he lacked the intellectual rigor to carry them out effectively. To the group of painters—Monet, Renoir, and Sisley—who were his closest friends, Bazille's most important contribution was certainly the moral and financial support which he never failed to provide as long as he lived.

Sisley

Sisley's role in the art of the 1860s is a decidedly minor one, even in comparison with Bazille. The constant involvement with Monet and Manet that makes Bazille's art fascinating if unsuccessful in any real sense finds no echo in Sisley's work. Instead there is in Sisley's painting prior to 1870 an almost overwhelming sense of humility. Of the group of painters who would later appear together as the Impressionists, only Pissarro seems to have moved with comparable caution through contemporary traditions of realist landscape.

Lacking most of the details of Sisley's life during the 1860s, one must rely almost exclusively on the few paintings that remain from his hand for an index of his activities and interests. The basic biographical facts are that Sisley worked at Gleyre's studio while registered (along with Renoir) at the École des Beaux-Arts. From Renoir's recollections it appears that Sisley painted periodically at Fontainebleau, Marlotte, and St.-Cloud in the summers of 1864 through 1866. On the basis of his *Still Life of a Dead Heron* (Fig. 133) it is certain that Sisley worked with Renoir and Bazille in Paris during early 1867. After this he moved to St.-Cloud for a large landscape project. During the fall and winter of 1868–69, he seems to have visited frequently with Monet at the latter's residence in Fécamp. Paintings of urban subjects from Paris place Sisley there for an extended period in 1869 and early 1870. In 1865 and 1866 he and Renoir were engaged socially with the LeCoeur family. He married in 1866 and, given his family connections there, may have visited England at some point, but this cannot be documented.

Fortunately, Sisley's paintings from this period do provide a fairly complete picture of his development as an artist. They demonstrate the truth of one short statement about art which Sisley made rather late in his life at the urging of his friend Tavernier. The most important feature of this state-

15. Ibid., fol. 62. Also, p. 196, D 22.

ment as it relates to Sisley's early work is the emphasis placed on the value of Corot's example.[16] As Sisley's work develops throughout the 1860s it is clear that Corot provided the most significant and durable stimulus. Corot functioned for Sisley in this period as Daubigny and Courbet functioned for Pissarro. That is to say, Corot provided the primary range of interests and effects against which all others would be weighed; he was not simply a phase in Sisley's interests but a constant point of reference which retained its importance throughout Sisley's life.

Although there was probably little if any personal contact between Pissarro and Sisley in the 1860s, the similarities which appear as their work develops demand some comment, especially since the two painters became increasingly close stylistically during the early 1870s. Both Pissarro and Sisley used the 1860s as a period in which to learn rather than to strike off in any radical new direction. For Pissarro this meant, as we have seen, the progressive assimilation of one realist influence after another and the exhaustive examination of each. At the end of this process Pissarro found himself in Monet's train, and able to make coherent responses and contributions to Monet's artistic cause. For Sisley the process of development was related but somewhat different, and the difference has to do with Sisley's veneration of Corot.

Pissarro's sense of progress was absolute and a driving force in his art. Sisley's, like Renoir's, was relative. In Sisley's case each successive phase of realist painting was weighed against the soft and lyrical tonal fabric of Corot's art. Innovations that violated this fabric were approached with caution by Sisley, and they could never be accepted without modification. What this means in actual practice is that Sisley never fully accepts the innovations of artists like Courbet, Daubigny, Manet, or, for that matter Monet and, instead, he chooses selectively from their effects, gradually working himself to a point in 1870 where he achieves a sort of distilled essence of realist currents firmly centered on Corot but open to gradual modifications in response to Monet.

Like Bazille, Sisley appears to hesitate in the face of the most progressive currents of realism. However, the particular dynamics of Sisley's development facilitate a much more effective use of these same currents. In this period, at least, Sisley manages to avoid the confusion that doomed Bazille's efforts. Corot's art provides Sisley with a degree of focus which Bazille was never able to find, and it saves Sisley from the immediate pitfall of dilettantism.

Predictably, Sisley's earliest extant works are very close to Corot, so close that there are some problems of attribution involving works that might be assigned to almost any of Corot's innumerable followers. A Marlotte landscape (Fig. 129), datable to the summer of 1864 or 1865, does appear to be quite firm in its attribution to Sisley and clearly demonstrates Corot's comprehensive influence. It presents a thoroughly orthodox Corotesque view down a tree-lined road. Small dot-like figures appear on the road at a considerable distance from the primary viewpoint, but the chief effect of the picture revolves around the tonal haze of softly brushed foliage and sky. This tonal haze is given a sense of structure by the suggestions of linear perspective in the road and in the corridors of trees. Taken as a whole the picture is a highly simplified transcription of a natural motif. It is generally flat and made effective pictorially only through soft undulations of color values within the overall tonal haze.

The painting is in no way forceful either in its conception or execution. Contemporary work by

16. A. Tavernier, "Sisley," *L'Art Français* (March 18, 1893).

Renoir, such as his *Country Road near Marlotte* (Fig. 52), demonstrates how tentative Sisley's effort really is. But, in two landscapes of a grove of chestnut trees at St.-Cloud (Fig. 130 and Plate 25), one of which is dated 1865, Sisley begins to show promise of greater individuality.

These two St.-Cloud pictures suggest a general interest in Barbizon painting as well as Corot, and the motif selected is very nearly a Barbizon stereotype, reflecting Rousseau among others. In the smaller of the two pictures (Plate 26), which focuses on a narrow portion of the motif included in the larger, Sisley's bold lateral composition of the motif is well chosen. It provides a strong surface order to contain a very effective development of color and color value—a development which is of considerable importance to Sisley's subsequent work.

The small St.-Cloud canvas is a truly virtuoso display of value painting à la Corot. The greens of the chestnut trees are modulated carefully to inflect relative positions in response to prevailing light. Medium-value browns and grays provide basic details of the open foreground. Then Sisley injects into this comprehensive value range of green, gray, and brown a strong accent of brilliant orange to define the sunstruck roadway visible through the trees at the center of the picture. Without the broad spectrum of values active elsewhere in the picture, Sisley could not have controlled this brilliant off-tone of orange. As it is, this accent increases the effect of lightness in the picture as a whole, not through contrast in the typical Barbizon sense but through an intensification of high-color values in all parts of the picture. What Sisley does in this picture is respond in a general way to Barbizon effects, but he revises these effects simultaneously along more value-oriented lines deriving from Corot. In so doing Sisley extends his range of effects but maintains an essentially Corotesque pictorial fabric.

There are certain parallels between what Sisley achieves here and what Monet was doing simultaneously at Chailly in his preliminary studies for the *Déjeuner* project (Figs. 7, 8). This is probably coincidental. Although both artists did introduce quite strong color accents into their views of forest motifs, Sisley's tend to intensify soft effects of modeling while Monet's tend to flatten out and separate light and dark areas.

The second and much larger of Sisley's St.-Cloud pictures (Fig. 130) demonstrates what in effect he cannot do at this point in his career. The devices he uses cannot effectively control a large Salon-scale canvas. Broad lateral stretches of foreground, forest, and sky are simply dissipated when magnified to such a scale. The delicate value structure crumbles, and Sisley is at a loss to provide any alternative emphasis. For his large landscapes of the following two years Pissarro would use Courbet and Daubigny as sources for bolder structural devices capable of controlling large canvases. Sisley, too, will look at Courbet and Daubigny, but for somewhat different reasons.

Sisley's first acceptance at the Salon came in 1866. He exhibited two views of the village of Marlotte (Fig. 131 and Plate 26). Both paintings were apparently done indoors during the winter of 1865–66 and were probably based on some sort of preliminary work now lost. In contrast to works of the previous summer, these views of Marlotte appear highly contrived and calculated. Working with an eye to the Salon, Sisley was careful to make his paintings appear well-thought out and sincere. Like every other young artist, he realized that success was difficult for anyone working in a realist mode and that the only way to gain approval was to soften the shock of realist subjects in one way or another. Rather than seeking to dazzle the Salon jury and the public as Monet did, or to impress it through sheer technique in Renoir's fashion, Sisley tried to charm his audience in a way which once again recalls his veneration for Corot.

The chief element that Sisley would rely upon to charm his audience was color. Sisley's color, beginning in the small St.-Cloud landscape of 1865 (Plate 25), begins to assume a decorative value in its own right. Throughout his life Sisley would rely on the effect of subtle off-tone accents woven into an essentially tonal color system to achieve a calculated effect of delicacy. Off-tone accents would serve the same effect in Sisley's art as do the silver grays and whites that so frequently appear in Corot's work to relieve, so to speak, the monotony of nature.

The effect of this particular use of color is immediately apparent in the *Village Street, Marlotte* (Plate 26), one of Sisley's Salon pictures from 1866. In a motif dominated once again by greens, grays and browns in medium values, Sisley introduces subtle but pungent accents of medium blue and blue-gray, first in the two doors in the garden wall at the left and then in the clothing of the wood-cutter. These accents intensify the color aspect of the picture and provide a foil to the somber tones of the motif as a whole. High values are slightly exaggerated by the effect of the off-tone blues, so that the ponderous elements of architecture and foliage lose their heaviness and belie their obvious sources in Daubigny and Courbet.

In this picture and in many subsequent ones Sisley is willing to sacrifice a great deal in order to achieve a particular color effect. In the present instance he permits an ambiguous and highly unstable interaction of the broad architectural surfaces and the devices of linear perspective. Individual parts of the motif are left unresolved both two- and three-dimensionally. They are not intended to bear the kind of close formal scrutiny that similar works by Pissarro seem almost to demand. Instead, pictured elements pretend to establish relationships which are in fact disregarded in order to achieve a certain color effect. Here, and throughout his career, Sisley is willing even to sacrifice consistency in his rendering of values. His value structure only vaguely responds to the quality and position of pictured elements. More than anything else it serves to consolidate the particular tapestry of color that Sisley desires. The two Marlotte pictures are not in any sense rigorous efforts aimed at dealing with important currents of realist landscape. Courbet and Daubigny (Fig. 132) provide a pretext for Sisley's motif and for certain of its technical details, but they do not markedly affect Sisley's general orientation as a painter. Sisley wanted to learn, but only up to a point.

Very much the same could be said for Sisley's brief interest in Manet in the context of the *Still Life of a Dead Heron* (Fig. 133), which he did in the direct company of Renoir and Bazille. Working in a technical mode that reflects Manet in both brushwork and paint quality, Sisley reduces the impact of Manet's effects by carefully blending adjacent brushstrokes and by centering his tonality in a soft and quite medium gray. Compared to the works that Renoir and Bazille produced at the same moment, Sisley's appears rather hesitant and apologetic.

Except for Sisley's third landscape from St.-Cloud (Fig. 134), dated 1867, which he painted for the Salon of 1868 (assuring its success by obvious reminiscences of Courbet's subject matter), there are few works of any real importance until after his visit to Monet in the fall and winter of 1868–69. Only one of the paintings from the generally unproductive period of mid-1867 to late 1868 appears to have any real significance for Sisley's activity of 1869–70. This painting is an undated view of a landscape subject near the Château of Courances (Fig. 135), apparently done in the summer of 1868.[17]

In this relatively small landscape, Sisley considers a new kind of subject—one that is plainer and

17. Cooper, "Renoir," pp. 322–28.

simpler than those he had treated prior to 1868. Although a variant of the open field with forest back-drop which had appeared in his St.-Cloud pictures of 1865, the Courances painting has a straight-forward everyday aspect that has nothing to do with Barbizon imagery. Sisley's painting does recall in certain respects Corot's most directly realist landscape subjects from the early 1860s (Fig. 136), but it is bland and relatively featureless even by Corot's standards. The most significant aspects of Sisley's picture are the broad and quite generalized rendition of basic landscape elements, and the overall lightness of the tonality, which centers in medium to high values of green, yellow-brown, and blue.

Many of the directions evident in this landscape from Courances reappear in Sisley's first urban subject, the *View of Montmartre* (Fig. 137) of 1869, a painting which, like Pissarro's views of Pontoise from late 1868, focuses attention upon questions of style and subject that are clearly related to the work of Monet. The rather broad ground-level viewpoint which places more complicated elements of the motif in the background continues directly from the Courances landscape to the *View of Montmartre*. However, Sisley inserts into his particular view a screen of trees in the foreground. This device tends to modulate the space of the picture more evenly than does the device of the curving path in the Courances picture. As one might expect, this device (the screen of trees) derives from Corot, and it has the effect of softening the visual impact of the still somewhat radical urban motif. At this point Sisley has no intention of using urban motifs for the demonstration of forceful new devices of style. Instead, he begins by surveying urban subjects cautiously.

In the lightness of the prevailing tonality of *View of Montmartre* and in the unprecedented crispness of his brushwork which now moves vigorously to pick up changes in value and tone, there is the suggestion of Monet's influence. This influence, if it does in fact exist, derives from Monet's work of 1867 rather than from his broader and more demonstrative style of the Fécamp period. Sisley avoids Monet's radical overhead viewpoints, relying instead on Corot's more orthodox vantage points. In 1869 Sisley still maintains his allegiance to Corot's conception of the painting as a screen of related tones and values, which subtly modulate the picture plane. He rejects the flat and rather opaque qualities of Monet's picture surfaces with their equivocal coloristic and linear gestures toward pictorial space.

Without really mending all his differences with Monet, Sisley moved in 1870 to three more views of Paris. These paintings, done at a time when Sisley joined with Monet and Pissarro at the Café Guerbois to discuss with Manet and others the relative merits of the kind of painting each found him-self doing, demonstrate the degree of rapprochement that developed.[18] It is possible to question the developmental importance of whatever work Sisley did directly from nature prior to these three pictures, but the effects which now appear for the first time indicate a firm awareness on Sisley's part of what concentrated work outdoors had made possible for Monet (and Renoir) a few months before at La Grenouillère.

The impact of Monet's example is most obvious in one of Sisley's two views of the *Canal St. Martin* (Plate 27). In this picture Sisley retains his preferred low level viewpoint, but he organizes his picture in a bold, semigeometrical fashion that recalls Monet directly. Sisley's brushwork develops a totally new flexibility, moving easily and rapidly from fragments of drawing to dotted fields that contain the complex coloration of the water surface. Working in resonant blues, yellow-oranges,

18. Rewald, *History of Impressionism*, pp. 197.

and whites with occasional off-tone accents, Sisley generates a kind of optical activity that recalls Monet's work at La Grenouillère without really imitating it.

The particular delicacy and refinement of Sisley's style suggests, however, that Sisley was still weighing Monet's example, not only against Corot but also against other painters of the 1860s who had worked on similar subjects—Jongkind, Lepine, and Vollon to name only a few. Moreover, it is clear that Sisley is continuing his distinctly personal approach to color. The boldness of his conception of the three Parisian subjects is carefully modified by the decorative inflections of his color. By using off-tones to soften rather than to intensify the optical impact of his pictures, Sisley retains a sense of continuity from his efforts of the previous five years, and invests his work with the sense of a personality quite different from that of his friends.

By 1870 Sisley had come to a point where he was able to participate in the efforts of Monet and Pissarro without sacrificing interests, which for better or worse, he continued from his primary involvement with Corot. The effects which his art is able to contain are multiplied by his continuing rapprochement with Monet. Following Monet's lead, Sisley will concentrate increasingly on straightforward outdoor subjects. He uses these subjects as source material for developing the particular visual events he desires—events featuring color effects that are consistently unique and engaging.

9. The New Painting Recognized

By late 1869 and early 1870 the artists who formed the core of a new movement in painting recognized a certain unity in their respective artistic interests. After 1874 this movement carried the name Impressionism. Prior to 1869 Monet, Renoir, Pissarro, and Sisley had proceeded artistically along four quite separate paths. However, while separate, these paths remained within the general confines of realist painting as it was variously defined by figures such as Corot, Courbet, Daubigny, and finally Manet.

Beginning with Monet, each of the four painters came to recognize the value of painting directly in the out-of-doors. Each discovered that the natural motif could be made to yield certain simple and direct keys for organizing their paintings. Further, the motif could be relied upon to suggest factors of emphasis and control to be used in making pictorial equivalents (or "correspondences") for the particular fragment of nature in view. Nature left the particular decisions regarding structure and emphasis in the hands of each individual painter, but once decisions were made as to how and what the painter would choose to see, nature stood as a constant point of reference.

As the work of the four painters developed over the 1860s, the effects of working outdoors became increasingly clear. Seen against the works of Courbet and Daubigny for example, the paintings of the younger artists were uniformly more varied in their treatment of color and less forced in their construction of pictorial space. Rather than developing the traditional picturesque values of landscape subjects the young painters dealt increasingly with a flat visual field which through its particular inflections of color and brushwork gave an unprecedented degree of optical presence to a unique visual moment of nature.

In order to realize their new concerns, the young painters were forced to consider many of the properties of their art in the abstract. Inherited conventions of picture-making provided little assistance, and new conventions had to be formed on the spot and in particular situations. As a matter of necessity rather than choice Monet, Renoir, Pissarro, and Sisley substantially modified the conventions of the art form they adopted. Their modifications had the effect of isolating and emphasizing the basic formal properties of painting to an unprecedented degree.

When the new paintings first appeared they seemed at once simple and exaggerated in their effects. They seemed to be more or less without "style," and those of one artist or another seemed almost indistinguishable. All of this was a function of the fact that the new paintings failed to fulfill preconceived notions of how paintings should look. Rather than looking for what the new paintings did, most contemporary viewers were concerned with what was not done. There was no apparent space,

no modeling, no drawing. Variations of emphasis, or "temperament," which existed to separate the work of one painter from that of another, were not the sort of distinctions that people were apt to look for, so these distinctions generally passed unnoticed.

Most of the critics who supported the young painters seem to have been uncertain in explaining the grounds of their support. Zola's dualism of realism and temperament and Duranty's scientific definition of progress in the optical understanding of nature were two attempts to rationalize what the new painting was about, but both of these critics were insensitive to the basic formal innovations which made the new painting so distinctive in appearance.

By developing the Tainian notion of "artistic temperament" which willfully distorts in order to express more forcefully, Zola tried to project an explanation (or apology) for the unorthodox appearance of the new painting. However, Zola's use of the term "temperament" always has connotations of programmed literary emphasis. In his early criticism of Manet there is the suggestion of an understanding of "artistic emphasis," but this vanishes as Zola becomes involved in his own efforts as a novelist.[1] When he comes in 1881 to write his novel *L'Oeuvre* about the painting of the 1860s, it is clear that Zola's understanding of the visual properties of painting is practically nil.[2]

Probably the most important (and least known) attempt on the part of a truly contemporary critic to suggest the meaning of both the visual and scientific content of the new art was made by Monet's friend Armand Silvestre in an unpublished essay written for the firm of Durand-Ruel in January 1873. This essay was intended to form the introduction for a catalogue of the firm's holdings, which by that time included works by Monet, Pissarro, and Sisley. This catalogue was printed but never sold publicly. Silvestre had been a frequent visitor at the discussions of painting held at the Café Guerbois in 1869–70 and it is likely that Durand-Ruel yielded to the advice of his three youngest and most controversial painters when he chose the author for his catalogue introduction. Whatever the case, the three painters would certainly have appreciated what Silvestre wrote about them.

In reconsidering Silvestre's essay from the historical vantage point of almost a century, important propositions appear veiled beneath an effusive and highly metaphoric writing style. However, several unique points are readily apparent. First of all, Silvestre stresses the historical position of the new painting in the art of the nineteenth century as a whole. He connects it directly to developments in the art of Delacroix, Corot, Courbet, and finally Manet. He sees it as an accumulation of latent properties which finally assume autonomous definition. For Silvestre, Delacroix's influence was profound in stimulating research into matters of technique and into the discipline of the relation of tones. Corot is seen to continue Delacroix's investigations. Then comes Courbet who conceives of style as an element secondary to the quest of generating paintings from nature. Moving to the impressionists, Silvestre stresses the unique importance of color and structure and describes the differences in the character of the emphasis which each of the three young painters gives to his work. He emphasizes the poetry of the new painting and its ability to excite in a way which is unique from the nature it describes and which is in the final analysis more thrilling.

It is hoped that the truth of many of Silvestre's observations has been demonstrated by the present reexamination of early impressionism. In order to make Silvestre's essay better known, and as a

1. Zola, *Salons.* This would apply to most of Zola's writings through 1868.
2. Emile Zola, *L'Oeuvre*, 1886.

gesture of tribute, the present study concludes with the present author's complete translation of the section of the essay which deals directly with Monet, Pissarro, and Sisley:[3]

At this point we come to speak of a group of artists who are even more contemporary—because they are younger—and whom it has been somewhat audacious to represent through several reproductions in this gallery, which is consecrated to the authority of glorious names. But after all, this audacity is only just, and merited by the honor of having greeted one of the grand hopes of modern art, an investment for a later day. First of all one has difficulty distinguishing the differences between the painting of Monet, that of Sisley, and the manner of the last of them, Pissarro. After a little study one finds that M. Monet is the most skillful and the most daring, M. Sisley the most harmonious and the most timid, M. Pissarro the most direct and naive. These nuances are not, however, our only concern. What is certain is that the painting of these three landscapists does not at all resemble that of other masters we've been considering, that one traces its ancestry to a point which appears distant and indirect except for the factor of time to Manet. [Further] this painting states its [premises] with a conviction and a power which imposes upon us the obligation of recognizing and of defining that which we will call, if you wish, its undetermined direction.

That which immediately strikes one when looking at this painting is the immediate caress which the eye receives—it is harmonious above all. What finally distinguishes it is the simplicity of means in achieving this harmony. One quickly discovers in effect, that the secret is based completely on a very fine and very exact observation of the relation of one tone to another. In reality it is the scale of tones, reconstructed after the works of the great colorists of the century, a sort of analytic procedure which does not change the palette into a banal percussion instrument as one might at first believe. The meaning of these relationships, in their precise accuracy, is a very particular gift, and one which constitutes the gift of the painter. The art of landscape does not run the risk of vulgarity in this sort of study. It receives from it qualities which, by their very elementary nature, have not been any the less rare. When one has chased from the choir all those who sing out of tune, the discord will not be great, I suppose. There will be an even larger place for those who arrive with good voices, and the trio of which I speak seems to me to have the principal merit of making seem commonplace the use of the diapason.

Up to this point in his discussion Silvestre has used extended musical metaphors to explain abstract qualities of color. This rhetorical combination of sensuous properties in painting and music is an early manifestation of ideas of synaesthesia which reappear in the symbolist art and theory of the 1880s. Significantly, the use which Silvestre makes of musical metaphors represents an awareness of sensuous abstractness in the thoroughly nonliterary context of early impressionism. The pure and unconditional quality of the effects he describes are seen as a sensuous parallel to the abstractness of music and equally capable of direct expressive effect. In other words Silvestre is implying symbolism in the pure sense of Baudelaire's "correspondences" where the form of artistic sensation creates an effect which abstractly parallels rather than describes apparent subject matter.

For the remainder of his discussion Silvestre restricts himself to the particular effects with which the painters deal:

3. Armand Silvestre, *Galerie Durand-Ruel, Receuil d'Estampes*, 1873, pp. 21–24.

It is M. Monet, who by his choice of subjects themselves, betrays his preoccupation most obviously. He loves to juxtapose on the lightly ruffled surface of the water the multicolored reflections of the setting sun, of gaudy boats, of changing clouds. Metallic tones given off by the smoothness of the waves, which splash over small, even surfaces, are recorded in his works, and the image of the shore is unsettled—the houses are broken down as they are in that children's game where objects are put together from pieces. This effect, which is absolutely true, and which may be borrowed from the Japanese school, strongly attracts the young painters who surrender to it completely. However, its gains are more telling than those of the children's game. The village interiors of M. Pissarro are considerably more complex than one might have expected. Do the painters obviate one another? Certainly not, since no one really knows who will build in its definitive place that rock that each carries to the great edifice [of art]. This uncertainty gives to the arts a singular solidarity. It is essential to give each his part, and that is what we've tried to do.

What could hasten the success of these [young painters] is [the fact] that their pictures are done in a tonal range which is singularly bright. A blond light pervades them, and everything is gaiety, clarity, spring festivals and golden evenings, or apple trees in flower—once again an inspiration from Japan. Their canvases, uncluttered and medium in size, open, in the surface they decorate, windows onto the joyous countryside, onto rivers full of vanishing pleasure boats, onto the sky that shines with light mists, onto the life of the out of doors, panoramic and charming…The dream crosses them and completely impregnated by them passes off toward the beloved landscape which they recall, judging conclusively that the reality of various aspects is more thrilling here. This is an art at once amiable and sincere, *rara avis*, don't you think?

Bibliography

Rewald's *History* contains an extensive critical bibliography. The following list contains only those sources cited in the preceding text and those which were published after the revised edition of Rewald.

André, Albert, *Renoir*, Paris: G. Crès, 1928.

Battock, Gregory, *The New Art*, New York: E. P. Dutton & Co., 1966.

Baudelaire, Charles, *The Painter of Modern Life and Other Essays*, Translated and edited by Jonathan Mayne, London: Phaidon, 1964.

Butor, M. "Claude Monet ou le Monde Renversé," *Art de France*, vol. 1, no. 3 (1963), pp. 277–301.

Cahen, Gustav, *Eugène Boudin, sa vie et son oeuvre*, Paris: H. Floury, 1900.

Champa, Kermit S., "Modern Drawing," *Art Journal*, vol. 25, no. 3 (Spring 1966), pp. 226–34.

———, *Olympia's Progeny*. Exhibition Catalogue, New York: Wildenstein & Co., 1965.

———. Review of *Die "Ile de France" und ihre Maler*, by Leopold Reidemeister. *Art International*, vol. 8, no. 2 (March 1964), pp. 36–38.

Cogniet, Raymond, *Monet and His World*, New York: Viking Press, 1966.

Cooper, Douglas, "Renoir, Lise, and the LeCoeur Family—A Study of Renoir's Early Development," *Burlington Magazine*, no. 674 (May 1959), pp. 163–71; and no. 676 (September–October 1959), pp. 322–28.

———, and Richardson, John, *Claude Monet, Edinburgh Festival and Tate Gallery*. Exhibition Catalogue, London: Arts Council of Great Britain, 1957.

Daulte, François, *Alfred Sisley*, Paris: Durand-Ruel, 1959.

———, *Frédéric Bazille et son temps*, Geneva: Pierre Callier, 1952.

———, *Renoir, Peintre et Sculpteur*. Exhibition Catalogue, Marseilles: Musée Cantini, 1963.

———, *Sisley*. Exhibition Catalogue, New York: Wildenstein, 1966.

De Fels, Marthe, *La Vie de Claude Monet*, Paris: Librairie Gallimard, 1929.

De Trevise, le Duc, "Le Pèlerinage de Giverny," *La Revue de l'Art Ancien et Moderne*, 30ᵉ Année, vol. 51, no. 283 (February 1927), pp. 116–34.

Drucker, Michel, *Renoir*, Paris: Tisné, 1944.

Duranty, Edmond, *La Nouvelle Peinture*. Edited by Marcel Guérin, Paris: H. Floury, 1946.

Duret, Theodore, *Manet and the French Impressionists*, Translated by J. E. Crawford Fitch, London: Grant Richards, 1910.

Fiedler, Conrad, *On Judging Works of Visual Art*, Translated and edited by Henry Schaefer-Simmern and Fulmer Mood, Berkeley and Los Angeles: University of California Press, 1949.

Flores, Angel, ed. *An Anthology of French Poetry from Nerval to Valéry in English Translation*. Garden City, N.Y.: Doubleday & Co., 1958.

Fry, Roger, *Characteristics of French Art*, London: Chatto and Windus, 1932.

———, *Vision and Design*. 1920, Reprint. Cleveland and New York: Meridian Books, 1963.

Gonse, Louis, *L'Oeuvre de Jules Jacquemart*, Paris: Gazette des Beaux-Arts, 1876.

Greenberg, Clement, *Art and Culture*, Boston: Beacon Press, 1961.

Holt, Elizabeth Gilmore, *From the Classicists to the Impressionists: A Documentary History of Art and Architecture in the Nineteenth Century*, Garden City, N.Y.: Doubleday & Co., 1966.

Isaacson, J. "Monet's Views of Paris," *Oberlin College Bulletin*, vol. 24, no. 1 (1967), pp. 4–22.

Jean-Aubry, G. *Eugène Boudin, d'après des documents inédits*, Paris: Bernheim-Jeune, 1922.

Laforgue, Jules, *Selected Writings of Jules Laforgue*, edited and translated by William Jay Smith, New York: Grove Press, 1956.

Mallarmé, Stéphane, *Oeuvres complètes*, Edited by H. Mondor and G. Jean-Aubry, Paris: Bibliothèque de la Pléiade, 1945.

Mathey, François, *The Impressionists*, Translated by Jean Steinberg, New York: Frederick A. Praeger, 1961.

Meier-Graefe, Julius, *Renoir*, Leipzig: Klinkhardt and Biermann, 1929.

Monet, Claude, *An Interview, 1900*, Reprint of an article by Thiébaut-Sisson in *Le Temps*, November 27, 1900, New York: Buskirk Press, 1900.

Mount, Charles Merrill, *Monet*, New York: Simon and Schuster, 1966.

————, "New Materials on Claude Monet: The Discovery of a Heroine," *The Art Quarterly*, vol. 25, no. 4 (Winter 1962), pp. 315–33.

Nochlin, Linda, *Impressionism and Post-Impressionism, 1874–1904*, Sources and Documents in the History of Art Series, Englewood Cliffs, N.J.: Prentice-Hall, 1966.

————, *Realism and Tradition in Art, 1848–1900*, Sources and Documents in the History of Art Series, Englewood Cliffs, N.J.: Prentice-Hall, 1966.

Novotny, Fritz, *Painting and Sculpture in Europe, 1780–1880*, Pelican History of Art Series, Baltimore: Penguin Books, 1960.

Pissarro, Ludovic Rodo, and Venturi, Lionello. *Camille Pissarro, son art—son oeuvre*, Paris: Paul Rosenberg, 1939.

Poulain, Gaston, *Bazille et ses Amis*, Paris: Renaissance du Livre, 1932.

Redon, Odilon, "Le Salon de 1868," *La Gironde*, July 1, 1868.

Reidemeister, Leopold, *Auf den Spuren der Maler der Ile de France*, Berlin: Propyläen Verlag, 1963.

Rewald, John, *Camille Pissarro*, London: Thames and Hudson, 1963.

————, *C. Pissarro*. Exhibition Catalogue, New York: Wildenstein & Co., 1965.

————, *The History of Impressionism*, Revised edition, New York: Museum of Modern Art, 1961.

————, "Notes sur Deux Tableaux de Claude Monet." *Gazette des Beaux-Arts*, October 1967, pp. 245–48.

Rey, Robert, *La Renaissance du Sentiment Classique*, Paris: G. van Oest, 1921.

Rivière, Georges, *Renoir et ses Amis*, Paris: H. Floury, 1921.

Seitz, William C. *Claude Monet—Seasons and Moments*. Exhibition Catalogue, New York: Museum of Modern Art, 1960.

————. *Monet*, New York: Harry N. Abrams, 1961.

Shapiro, Meyer, "Nature of Abstract Art," *Marxist Quarterly*, vol. 1, no. 1 (January-March 1937), pp. 77–99.

Silvestre, Armand, *Galerie Durand-Ruel, Receuil d'Estampes*, Paris: Durand-Ruel, 1873.

Tabarant, A. *Pissarro*, Paris: F. Rieder, 1924.

Taine, H[ippolyte]. *The Ideal in Art*, Translated by J. Durand, New York: Leypoldt & Holt, 1869.

————, *The Philosophy of Art*, London: Williams and Norgate, 1867.

Tavernier, A. "Sisley," *L'Art Français*, March 18, 1893.

Venturi, Lionello, *Impressionists and Symbolists, Modern Painters*, vol. 2. New York: Charles Scribner's Sons, 1950.

Vollard, Ambroise, *Renoir, An Intimate Record*, Translated by H. L. van Doren and R. T. Weaver, New York: Alfred A. Knopf, 1934.

Zola, Emile, *L'Oeuvre*, Paris: G. Charpentier, 1886.

————, *Salons*, Edited by F. W. J. Hemmings and Robert J. Niess, Paris: Librairie Minard, 1959.

Index

Index

Figures

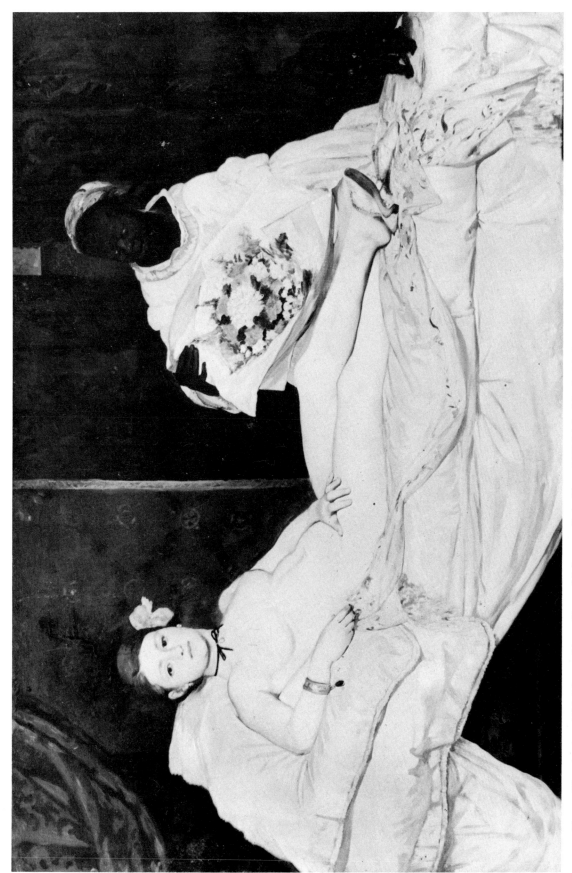

FIG. 1. Manet, *Olympia*, signed Ed. Manet 1863, $51\frac{1}{4}'' \times 74\frac{3}{4}''$, Louvre, Paris. Photo: Cliché des Musées Nationaux.

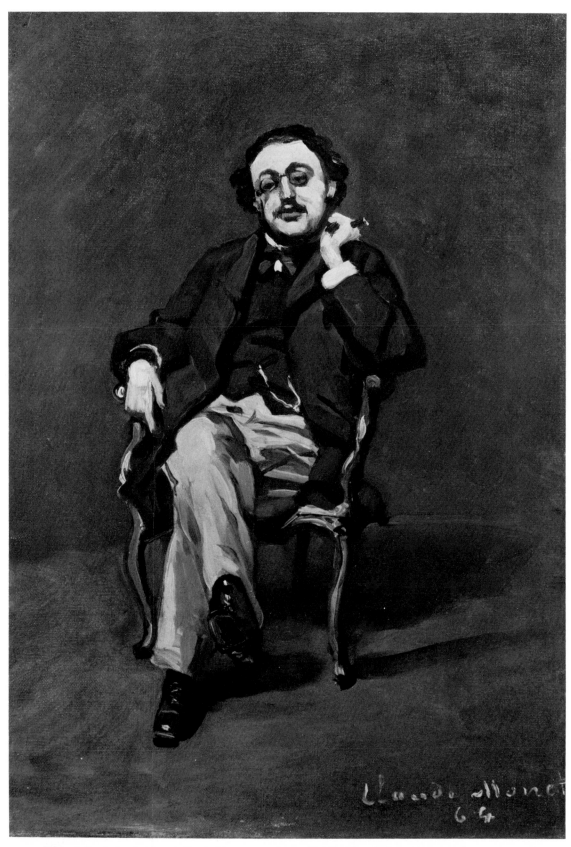

FIG. 2. Monet, *Dr. Leclenche*, signed Claude Monet 64, 18″ × 12¾″, The Metropolitan Museum of Art, New York. Gift of Mr. and Mrs. Edwin C. Vogel, 1951.

FIG. 4. Manet, *Mlle. V. in the Costume of an Espada*, signed Ed. Manet, $65\frac{1}{2}$" × $50\frac{1}{4}$". The Metropolitan Museum of Art, New York. Bequest of Mrs. H. O. Havemeyer, 1929, The H. O. Havemeyer Collection.

FIG. 3. Monet, *Portrait of Jacquemart*, signed Claude Monet, $39\frac{1}{2}$" × $24\frac{1}{4}$", Kunsthaus, Zürich.

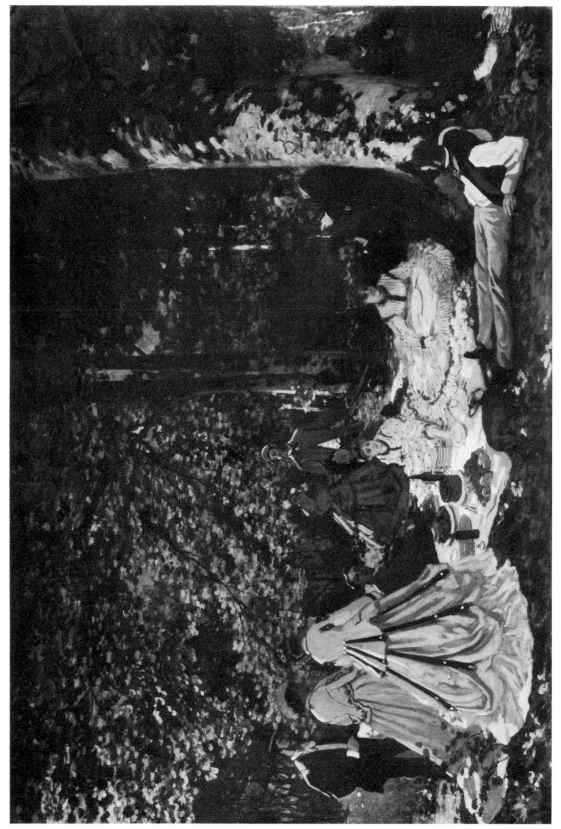

FIG. 5. Monet, *Déjeuner sur l'herbe* (small version), signed Claude Monet 66, $51\frac{1}{2}'' \times 73''$, The Pushkin Museum of Fine Arts, Moscow.

FIG. 6. Courbet, *Burial at Ornans*, signed Gustave Courbet, $122\frac{1}{2}'' \times 258\frac{3}{4}''$, Louvre, Paris. Photo:Cliché des Musées Nationaux.

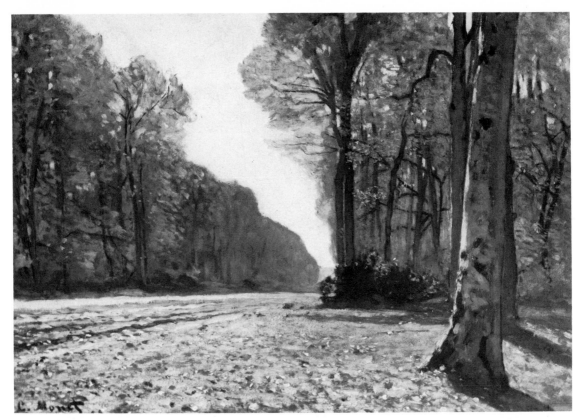

FIG. 7. Monet, *Landscape, Fontainebleau (The Bas-Breau Road)*, signed C. Monet, $17\frac{7}{8}'' \times 24\frac{2}{3}''$, Louvre, Paris. Photo: Cliché des Musées Nationaux.

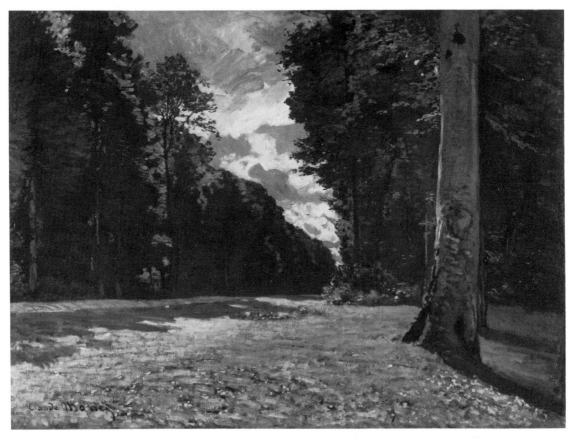

FIG. 8. Monet, *Landscape, Fontainebleau (The Bas-Breau Road)*, signed Claude Monet, $40\frac{1}{2}'' \times 54\frac{1}{2}''$, Ordrupgaard Museum, Copenhagen.

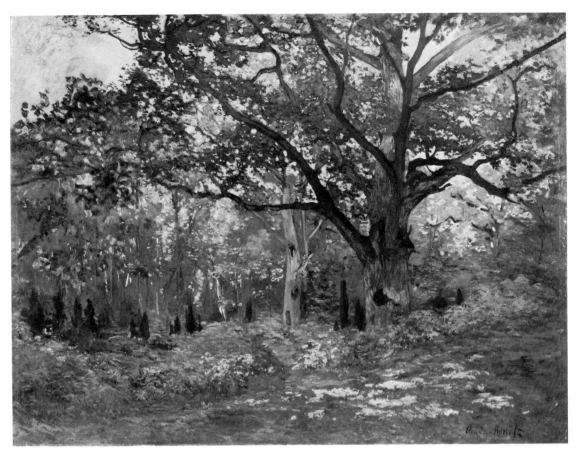

FIG. 9. Monet, *Forest Interior, Fontainebleau*, signed Claude Monet, $37\frac{1}{2}'' \times 50\frac{7}{8}''$, The Metropolitan Museum of Art, New York. Bequest of Julia W. Emmons and gift of Sam Salz, 1964.

FIG. 10. Bazille, *Improvised Ambulance*, unsigned but dated 1866, $18\frac{1}{2}'' \times 24\frac{3}{8}''$, Private Collection, France, (D. 14). Photo: Courtesy Fondation Wildenstein, Paris.

FIG. 11. Monet, *Bazille and Camille—Study for le Déjeuner sur l'herbe*, signed Claude Monet, 20″ × 32½″, Estate of Ailsa Mellon Bruce.

FIG. 12. Monet, *Déjeuner sur l'herbe* (fragment from center of large version), signed Claude Monet, 97¼″ × 85¼″, Private Collection, Paris.

FIG. 14. Bazille, *Nude Boy on the Grass*, unsigned, $61\frac{1}{2}'' \times 58''$, Private Collection, France (D. 43). Photo: Courtesy Fondation Wildenstein, Paris.

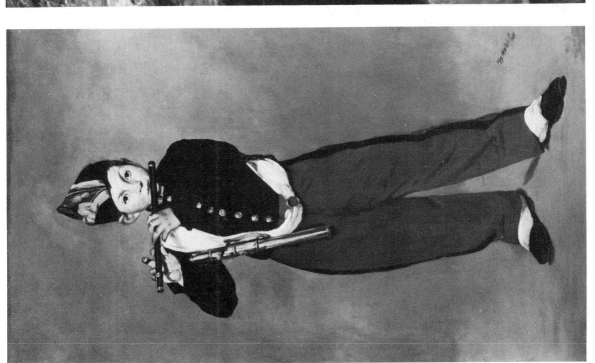

FIG. 13. Manet, *The Fifer*, signed Manet, $63'' \times 38\frac{1}{2}''$, Louvre, Paris. Photo: Cliché des Musées Nationaux.

FIG. 15. Monet, *Street in Fécamp*, signed Claude Monet, 30½″ × 22″, Sterling and Francine Clark Art Institute, Williamstown, Massachusetts.

FIG. 16. Monet, *Chapel of Notre Dame de Grâce, Honfleur*, signed Claude Monet (later), $20\frac{1}{2}'' \times 26\frac{3}{4}''$. Photo: Courtesy Durand-Ruel.

FIG. 17. Monet, *Route de la Ferme St.-Simeon, Honfleur*, signed Claude Monet, $21\frac{1}{2}'' \times 31\frac{1}{4}''$, The Fogg Art Museum, Harvard University, Cambridge, Massachusetts. Bequest of Grenville L. Winthrop.

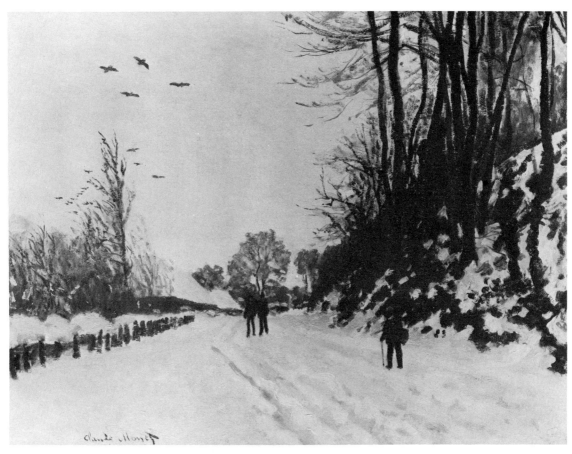

FIG. 18. Monet, *Route de St.-Simeon*, signed Claude Monet, 19″ × 25″, Mr. and Mrs. Alexander M. Lewyt Collection, New York.

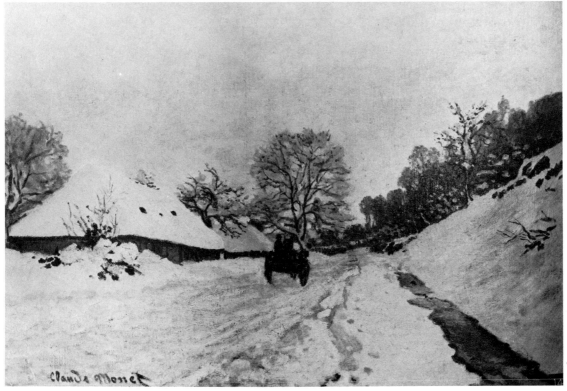

FIG. 19. Monet, *Snowscape, Honfleur*, signed Claude Monet, 27″ × 28⅓″, Louvre, Paris. Photo: Cliché des Musées Nationaux.

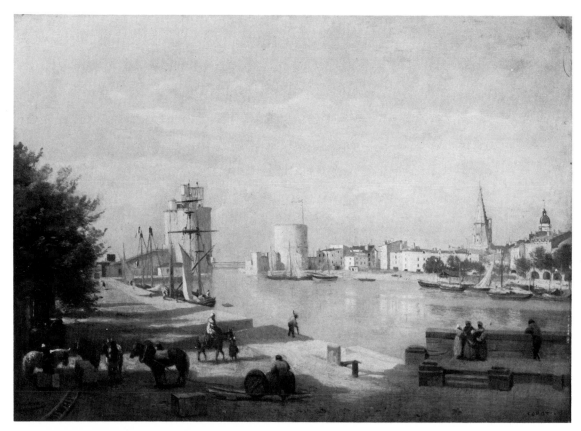

FIG. 20. Corot, *The Harbour of La Rochelle*, signed Corot, 19½″ × 28″, Yale University Art Gallery, New Haven, Connecticut. Bequest of Stephen Carleton Clark, B.A. 1903.

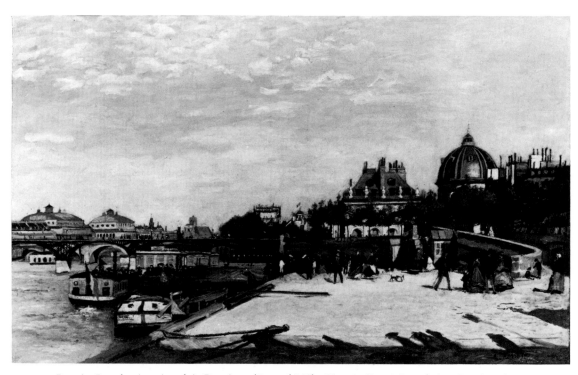

FIG. 21. Renoir, *Pont des Arts*, signed A. Renoir, 24½″ × 40¼″, The Norton Simon Foundation, Los Angeles.

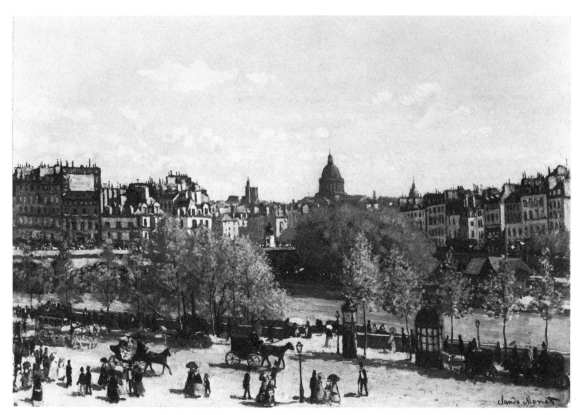

FIG. 22. Monet, *The Quay of the Louvre*, signed Claude Monet, 25½″ × 36¼″, Municipal Museum, The Hague. Photo: Courtesy Municipal Museum, The Hague.

FIG. 23. Monet, *Saint-Germain l'Auxerrois*, signed 66 Claude Monet, 32″ × 39⅜″, Staatliche Museen Preussischer Kulturbesitz Nationalgalerie, Berlin.

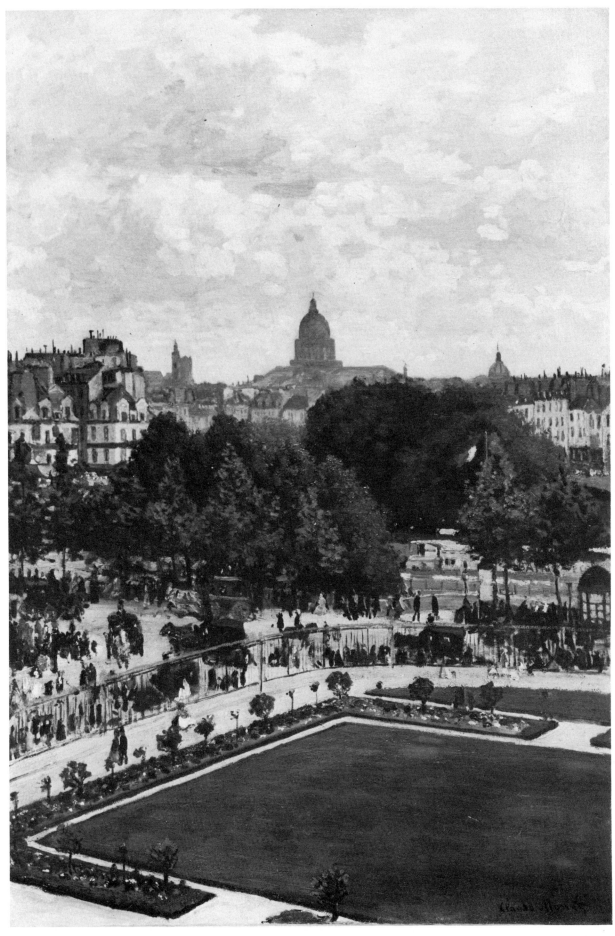

FIG. 24. Monet, *The Princess Garden, Louvre*, signed Claude Monet, $36\frac{1}{8}'' \times 24\frac{3}{8}''$, Allen Memorial Art Museum, Oberlin College, Oberlin, Ohio.

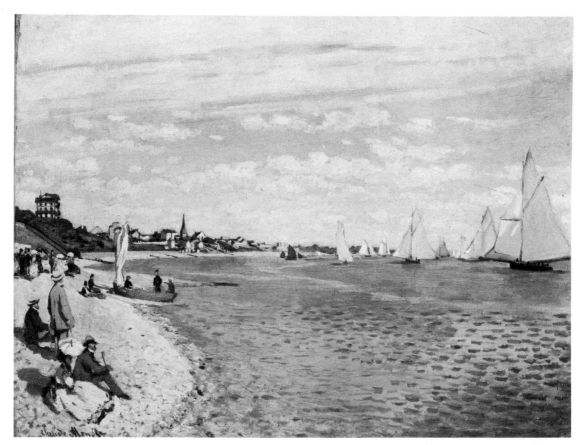

FIG. 25. Monet, *The Beach at Ste.-Adresse*, signed Claude Monet, 29⅝″ × 40″, The Metropolitan Museum of Art, New York. Bequest of William Church Osborn, 1951.

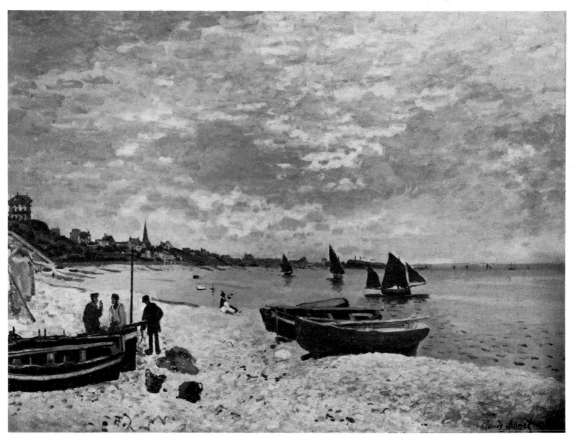

FIG. 26. Monet, *The Beach at Ste.-Adresse*, signed Claude Monet 67, 28½″ × 41¼″. The Art Institute of Chicago, Photo: Courtesy Art Institute of Chicago.

FIG. 27. Monet, *Jetty at Le Havre*, signed Claude Monet, 58″ × 89″, Private Collection, Switzerland.

FIG. 28. Monet, *Fisherman's Hut, Ste.-Adresse*, signed Claude Monet, 17″ × 25¾″, Private Collection, London.

FIG. 29. Monet, *The Sea at Le Havre*, signed Claude Monet, 23½″ × 31½″, Museum of Art, Carnegie Institute, Pittsburgh.

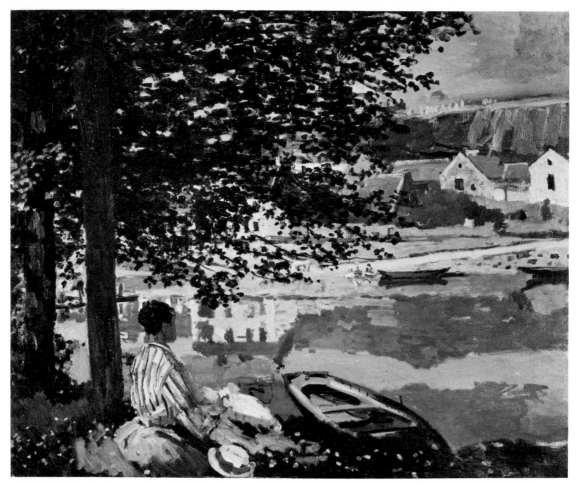

FIG. 30. Monet, *The River*, signed Cl. Monet, 1868, $31\frac{7}{8}'' \times 39\frac{1}{2}''$, The Art Institute of Chicago. Photo: Courtesy Art Institute of Chicago.

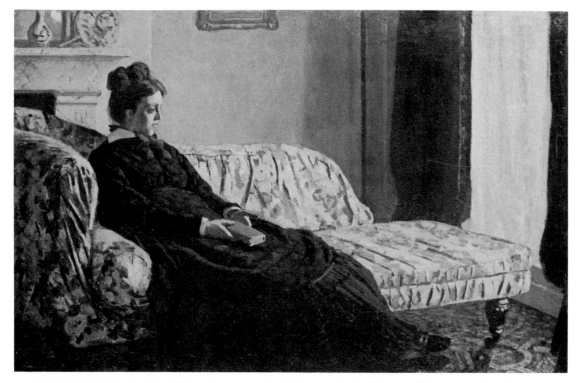

FIG. 31. Monet, *Portrait of Camille*, unsigned, $20'' \times 31\frac{1}{3}''$, Louvre, Paris. Photo: Cliché des Musées Nationaux.

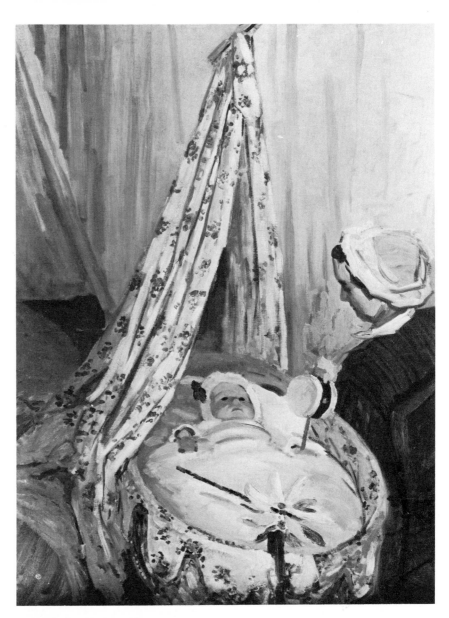

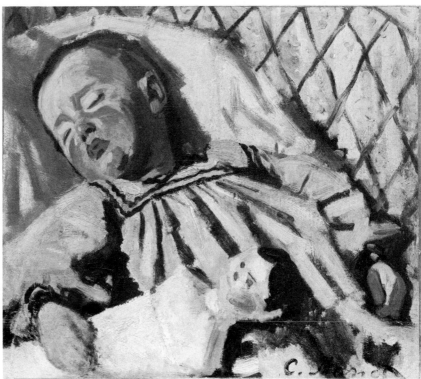

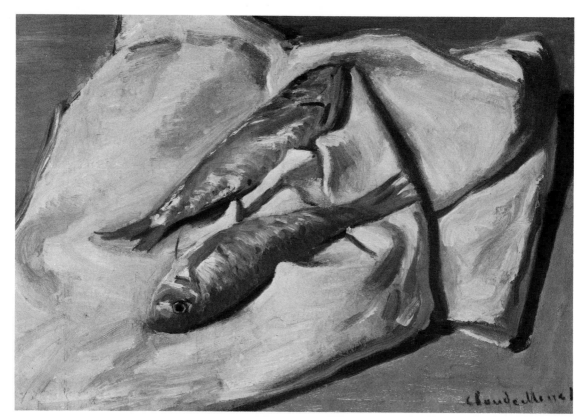

FIG. 34. Monet, *Still Life with Fish*, signed Claude Monet, 14″ × 19¾″ (sight), Fogg Art Museum, Harvard University, Cambridge, Massachusetts. Gift of the Friends of the Fogg.

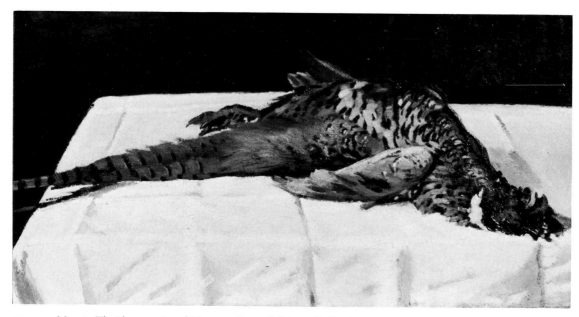

FIG. 35. Monet, *The Pheasant*, signed Monet, 16″ × 31″, Private Collection.

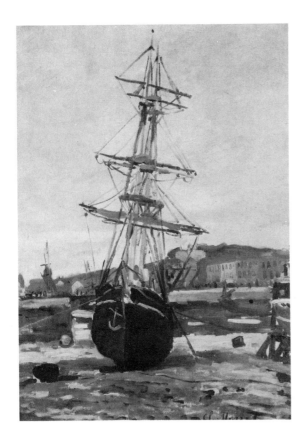

Fig. 36. Monet, *Boat at Fécamp* signed Cl. Monet, $13\frac{1}{2}'' \times 20''$, present whereabouts unknown. Photo: Courtesy Thannhauser Foundation Inc.

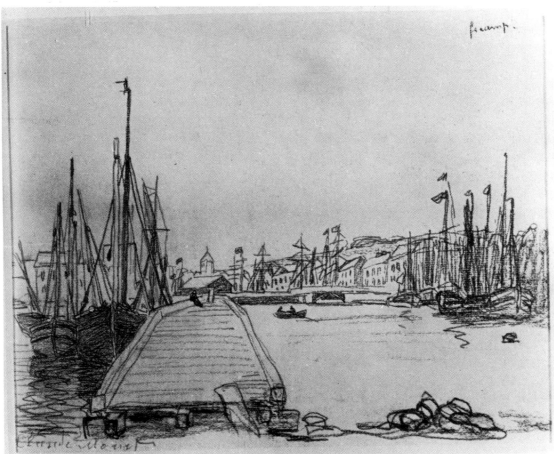

FIG. 37. Monet, *View of Fécamp* (drawing), signed Fécamp, Claude Monet, $8\frac{1}{2}'' \times 12''$, whereabouts unknown.

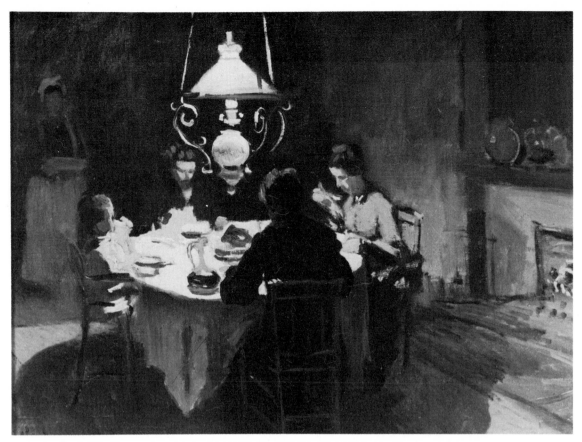

FIG. 38. Monet, *The Sisley Family at Dinner*, signed Claude Monet, 20⅛″ × 26″, E. G. Bührle Collection, Zürich.

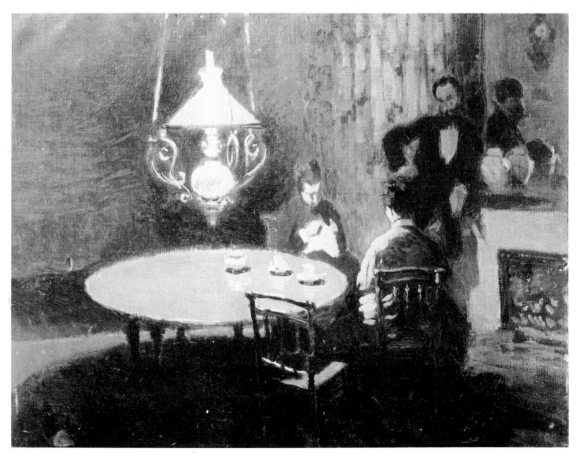

FIG. 39. Monet, *The Sisley Family at Dinner*, signed Claude Monet, 20⅛″ × 26″, Private Collection, Norway. Photo: Courtesy Durand-Ruel.

FIG. 40. Monet, *Mme. Monet in a Red Cape*, unsigned, $39\frac{1}{2}''\times 31\frac{1}{2}''$, The Cleveland Museum of Art, Leonard C. Hanna, Jr., Collection.

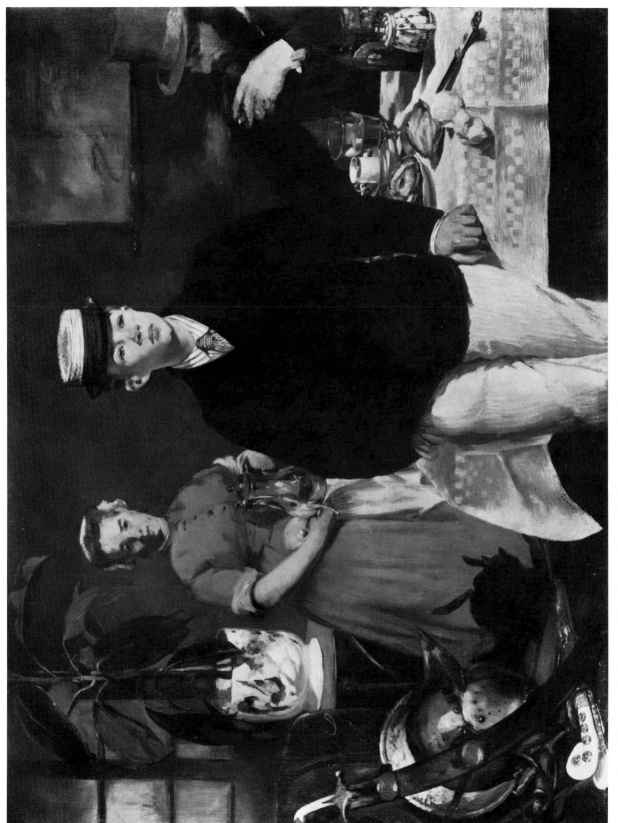

FIG. 41. Manet, *Déjeuner à l'atelier*, signed Ed. Manet, $47\frac{1}{4}'' \times 60\frac{5}{8}''$, Bavarian State Collection, Munich.

FIG. 42. Renoir, *Portrait of a Woman*, unsigned, 16″ × 21″, whereabouts unknown.

FIG. 43. Ricard, *Portrait of Mme. Sabatier*, signed G.R., 18″ × 14½″, Musée Fabre, Montpellier. Photo: Claude O'Sughrue.

FIG. 44. Renoir, *Portrait of William Sisley*, signed A. Renoir 1864, 32″ × 26″, Louvre, Paris. Photo: Cliché des Musées Nationaux.

FIG. 45. Ingres, *M. Bertin*, signed J. Ingres pinxit 1832, 45¾″ × 78⅜″, Louvre, Paris. Photo: Cliché des Musées Nationaux.

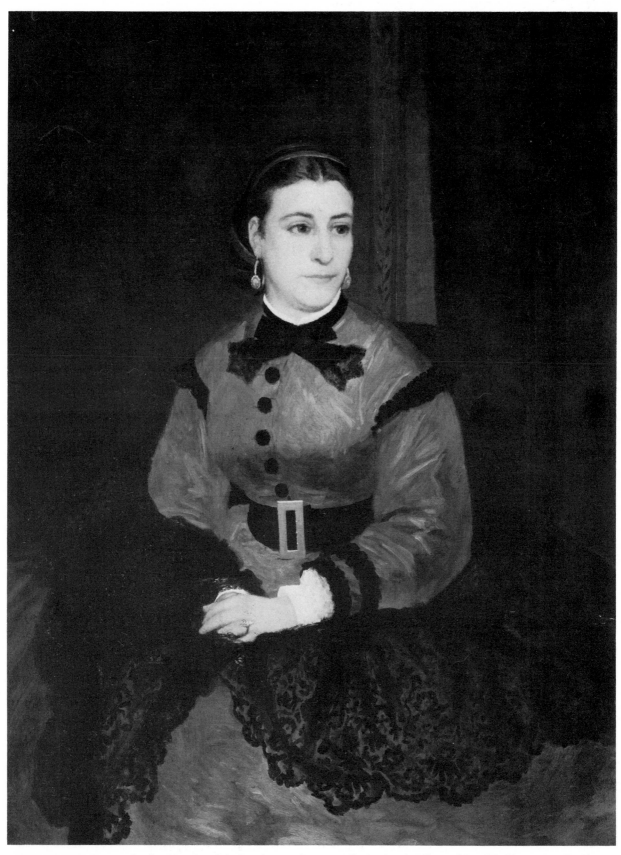

FIG. 46. Renoir, *Portrait of Mlle. Sicot*, signed A. Renoir 65, 40½″ × 31″, The National Gallery of Art, Washington, D.C., Chester Dale Collection.

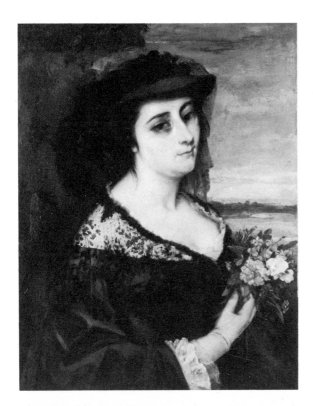

FIG. 47. Courbet, *Portrait of Mme. Boreau*, signed G. Courbet, $24\frac{3}{8}'' \times 31\frac{7}{8}''$, The Cleveland Museum of Art, Purchase. Leonard C. Hanna, Jr., Bequest.

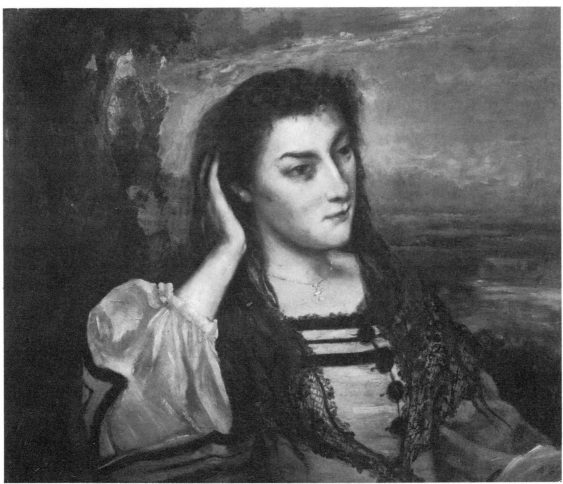

FIG. 48. Courbet, *Portrait of Mme. Boreau*, signed G. Courbet, 62, $25'' \times 30\frac{1}{4}''$, Collection Alfred Daber, Paris.

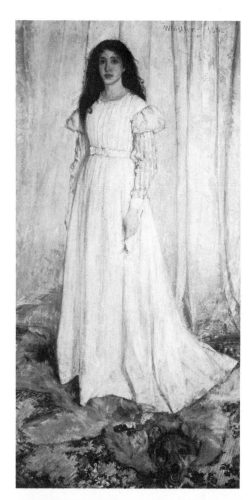

FIG. 49. Whistler, *The White Girl*, signed Whistler 62, 85½″ × 43″, The National Gallery of Art, Washington, D.C., Harris Whitemore Collection.

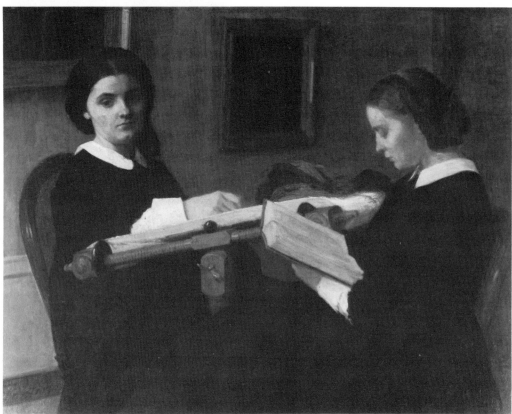

FIG. 50. Fantin-Latour, *The Artist's Two Sisters*, signed Fantin 59, 39¼″ × 52″, City Art Museum of St. Louis.

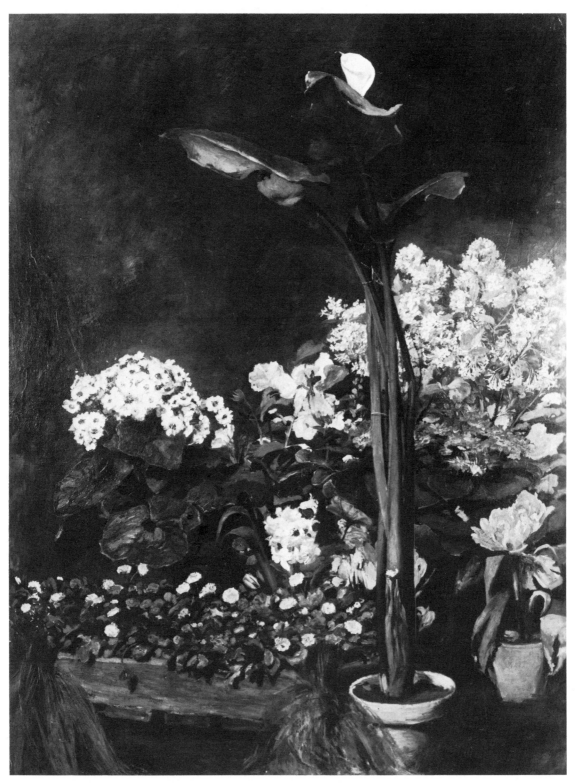

FIG. 51. Renoir, *Flower Still-Life*, signed A. Renoir 1864, $51\frac{1}{2}'' \times 37\frac{3}{4}''$, Collection Oskar Reinhart am Römerholz, Winterthur.

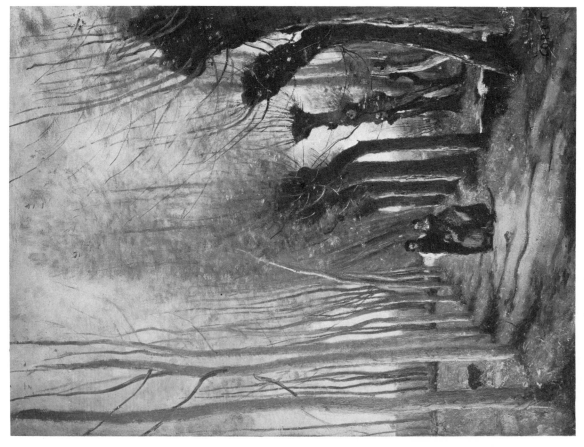

FIG. 53. Corot, *Very Early Spring*, signed Corot, 21⅝″ × 15⅝″, Walters Art Gallery, Baltimore.

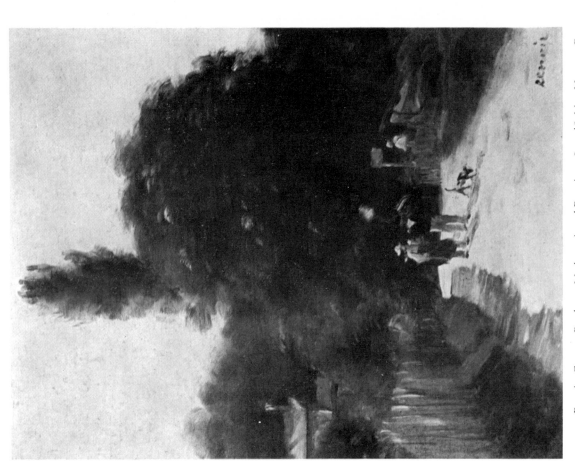

FIG. 52. Renoir, *Country Road near Marlotte*, signed Renoir, 13″ × 9½″, Mrs. Norman B. Woolworth.

FIG. 54. Renoir, *Clearing in the Woods*, unsigned, 21½″ × 32″, Private Collection, New York. Photo: Courtesy Acquavella Galleries.

FIG. 55. Courbet, *The Valley of Ornans*, signed G. Courbet, 23^{11}/$_{16}$″ × 33^{9}/$_{16}$″, City Art Museum of St. Louis.

FIG. 57. Renoir, *Portrait of Jules LeCoeur at Fontainebleau*, signed A. Renoir 1866, $41\frac{3}{4}$" × $31\frac{1}{4}$", Museu de Arte de São Paulo, Brazil.

FIG. 56. Renoir, *Interior of the Forest*, unsigned, $33\frac{3}{4}$" × 27", present whereabouts unknown.

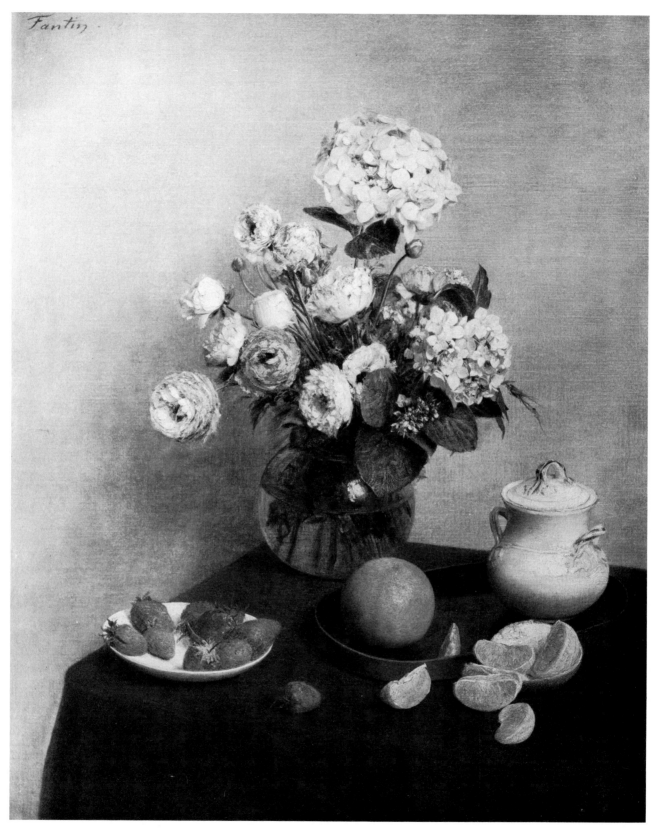

FIG. 58. Fantin-Latour, *Flowers and Fruit*, signed Fantin, 28¾″ × 23½″, The Toledo Museum of Art, Toledo, Ohio. Gift of Edward Drummond Libbey, 1951.

FIG. 59. Courbet, *After Dinner at Ornans*, signed Courbet, 39⅔″ × 107″, Palais de Beaux-Arts, Lille.

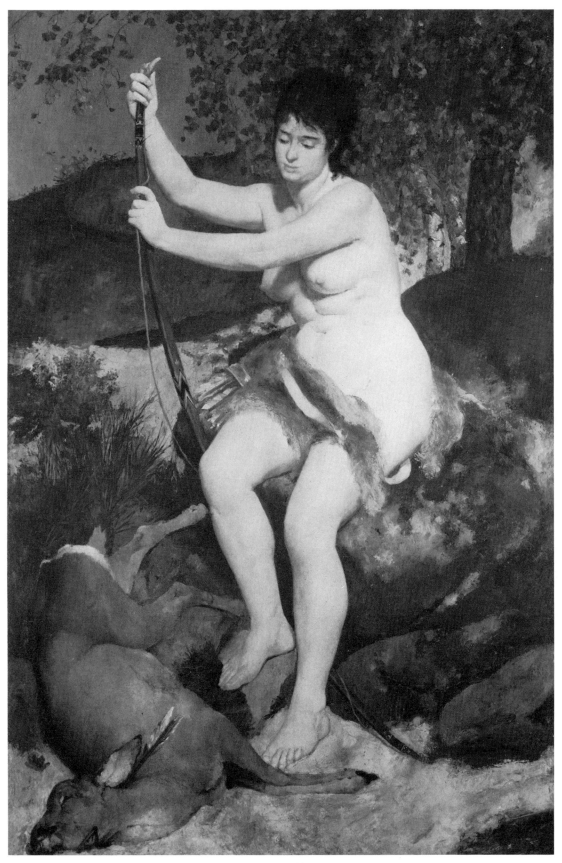

FIG. 60. Renoir, *Diana*, signed A. Renoir 1867, $76\frac{1}{2}'' \times 51\frac{1}{8}''$, National Gallery of Art, Washington, D.C., Chester Dale Collection.

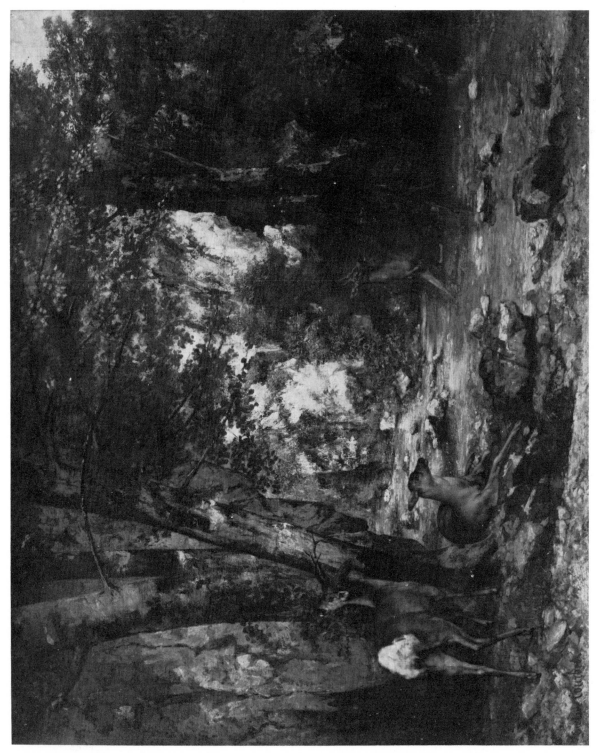

FIG. 61. Courbet, *Deer Haven at Plaisir-Fontaine*, signed Gustave Courbet, 30½" × 86¼", Louvre, Paris. Photo: Cliché des Musées Nationaux.

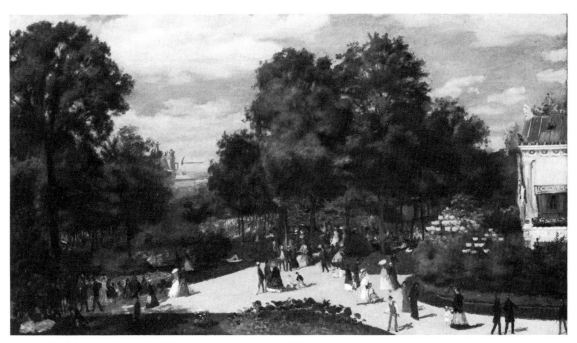

FIG. 62. Renoir, *Les Champs-Elysées pendant l'Exposition Universelle de 1867*, signed Renoir 67, 30″ × 51″. Photo: Courtesy Drs. Fritz and Peter Nathan.

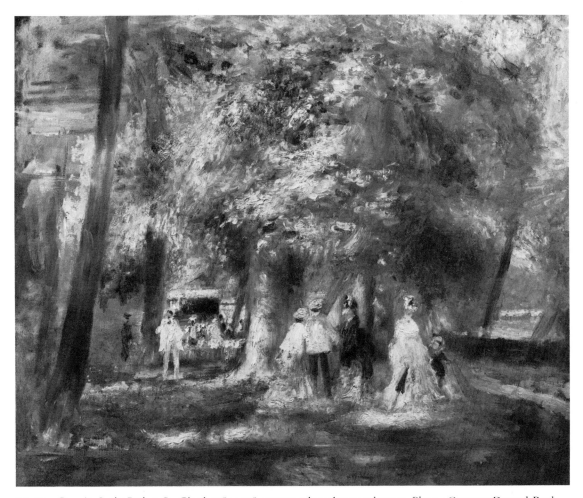

FIG. 63. Renoir, *In the Park at St.-Cloud*, 20″ × 24″, present whereabouts unknown. Photo: Courtesy Durand-Ruel.

FIG. 65. Renoir, *Lise Sewing*, signed A. Renoir, 22″ × 18½″, Collection Mr. and Mrs. Emery Reves.

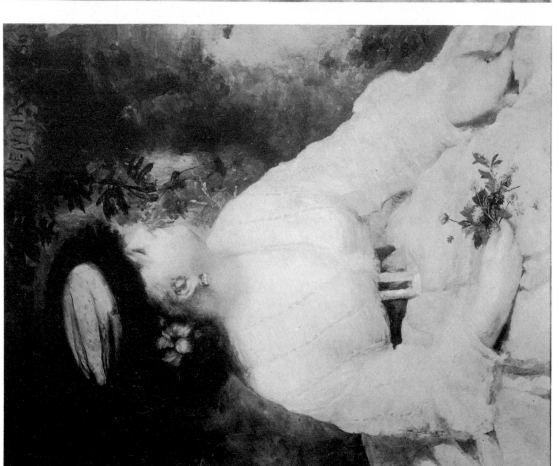

FIG. 64. Renoir, *Woman with a Bird (Lise)*, signed Renoir, 27⅓″ × 34⅛″. Photo: Courtesy Durand-Ruel.

FIG. 66. Renoir, *Lise* (sketch),
signed Renoir, $11\frac{1}{4}'' \times 13\frac{3}{4}''$, present
whereabouts unknown.

FIG. 67. Renoir, *Woman in the Grass*, signed A.R., $12\frac{1}{8}'' \times 14\frac{3}{8}''$, Ordrupgaard Museum, Copenhagen.

FIG. 68. Renoir, *Lise Holding Flowers*, signed Renoir, 26⅛″ × 20⅞″, present whereabouts unknown.

FIG. 69. Renoir, *Lise (Woman Seated with a Parasol)*, signed Renoir, 27″ × 30″, present whereabouts unknown.

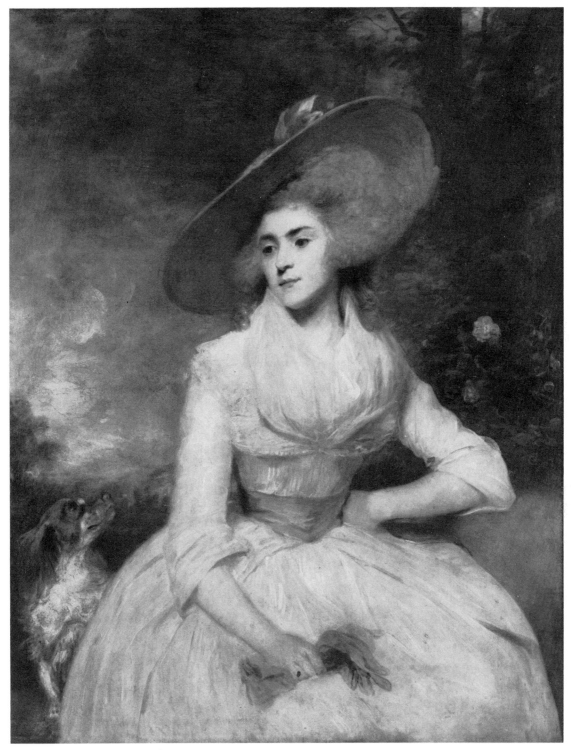

FIG. 70. Reynolds, *Mrs. Scott of Danesfield*, unsigned, 50″ × 40″, The National Trust, Waddesdon Manor, Aylesbury, England.

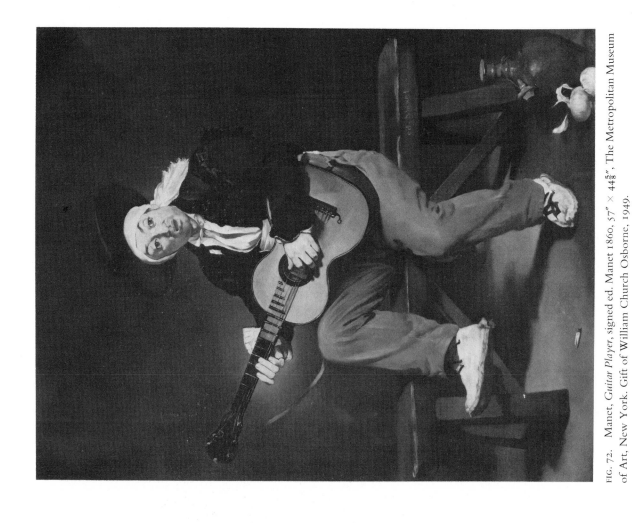

FIG. 72. Manet, *Guitar Player*, signed ed. Manet 1860, 57″ × 44⅝″, The Metropolitan Museum of Art, New York. Gift of William Church Osborne, 1949.

FIG. 71. Renoir, *The Cloum*, signed A. Renoir 68, 53½″ × 80″, Rijksmuseum Kröller-Müller, Otterlo.

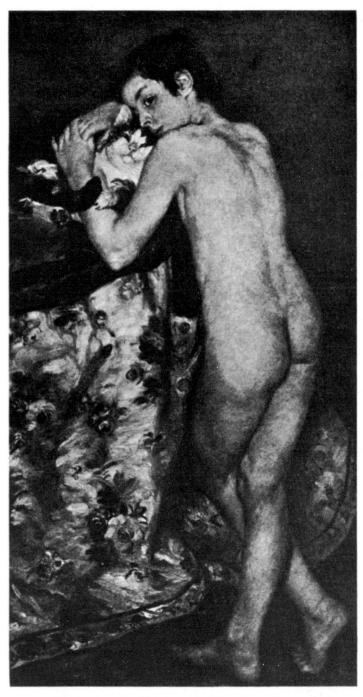

FIG. 73. Renoir, *Boy with a Cat*, signed Renoir, 30″ × 47″, present where-abouts unknown.

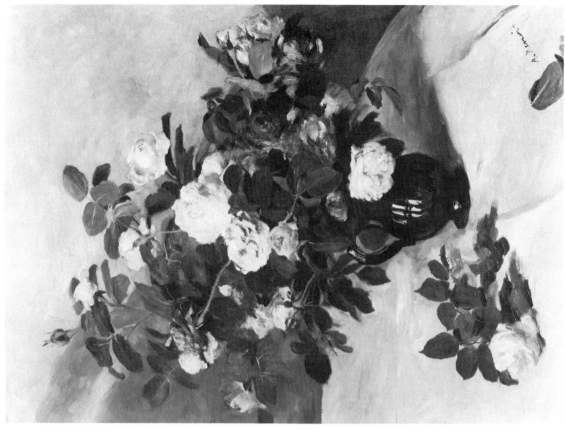

FIG. 75. Renoir, *Still Life of Roses*, signed A. Renoir, 28¼″ × 30¾″, Fogg Art Museum, Harvard University, Cambridge, Massachusetts. Bequest of Grenville L. Winthrop.

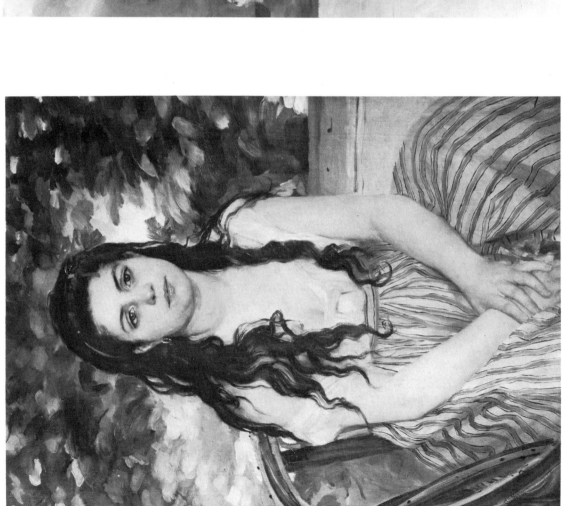

FIG. 74. Renoir, *Lise (Summer)*, signed Renoir, 35⅓″ × 24⅔″, Staatliche Museen Preussischer Kulturbesitz Nationalgalerie, Berlin.

FIG. 77. Lawrence, *Mr. and Mrs. James Dunlop*, unsigned, $106\frac{1}{2}'' \times 70\frac{7}{8}''$. Worcester Art Museum, Worcester, Massachusetts. Gift of Mr. and Mrs. Albert W. Rice.

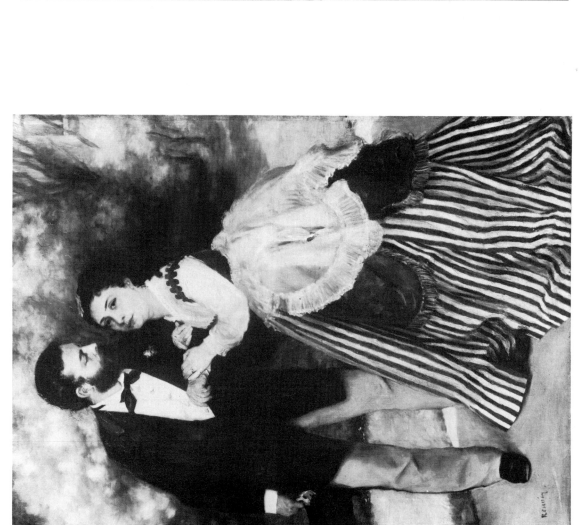

FIG. 76. Renoir, *Alfred Sisley and His Wife*, signed Renoir, $41\frac{1}{4}'' \times 30''$. Wallraf-Richartz Museum, Cologne. Photo: Courtesy Rhenisches Bildarchiv.

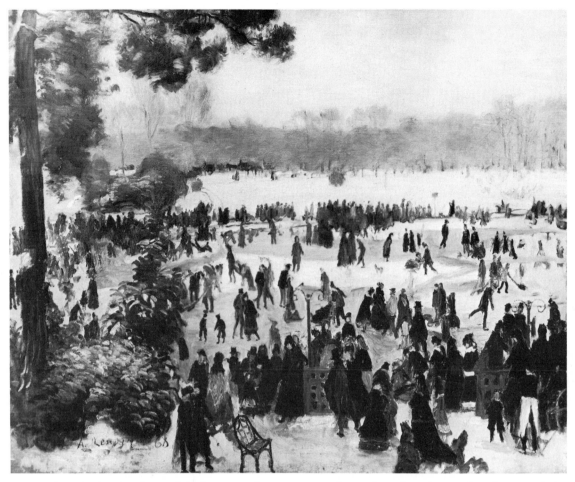

FIG. 78. Renoir, *Skating in the Bois de Boulogne*, signed A. Renoir 68, 28⅞″ × 36⅛″, Robert von Hirsch Collection, Basel.

FIG. 79. Renoir, *Winter Landscape*, signed A. Renoir, 19⅝″ × 25⅝″, Private Collection.

FIG. 80. Monet, *Cliff at Etretat*, signed Claude Monet, 32″ × 39½″, Fogg Art Museum, Harvard University, Cambridge, Massachusetts. Anonymous gift.

FIG. 81. Monet, *The Seine at Bougival*, signed Cl. Monet, $23\frac{1}{2}'' \times 28\frac{1}{2}''$, Smith College Museum of Art, Northampton, Massachusetts.

FIG. 82. Daubigny, *Sunset on the Oise*, signed Daubigny 1865, $16\frac{1}{4}'' \times 27\frac{7}{8}''$, Louvre, Paris. Photo: Cliché des Musées Nationaux.

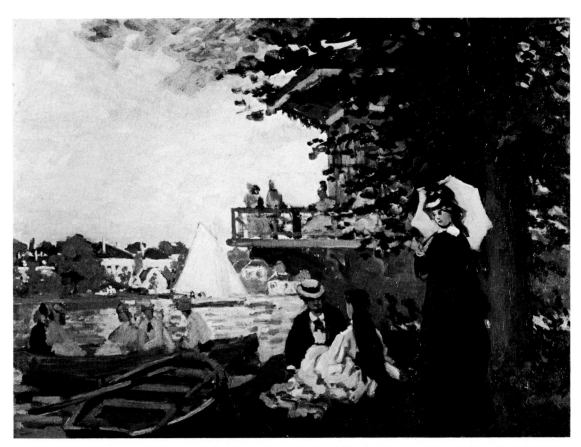

FIG. 83.　Monet, *La Grenouillère* (Argenteuil: River and Trees), signed Claude Monet, $23\frac{1}{2}'' \times 34''$, Mrs. Hugh N. Kirkland. Photo: Courtesy Santa Barbara Museum of Art.

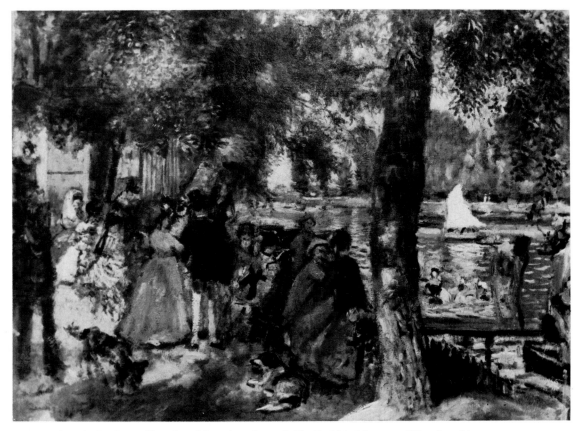

FIG. 84.　Renoir, *La Grenouillère*, signed Renoir, $26'' \times 31''$, The Pushkin Museum of Fine Arts, Moscow.

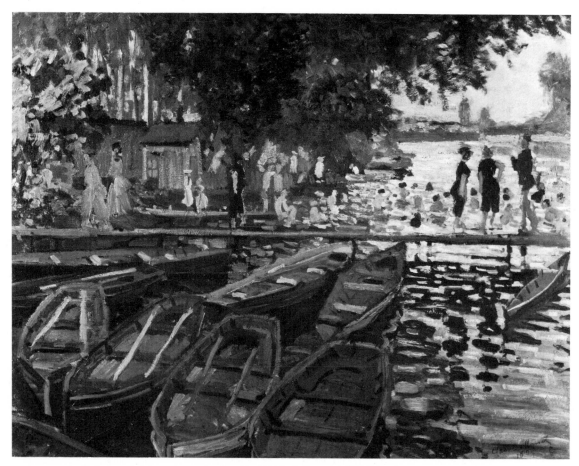

FIG. 85.　Monet, *La Grenouillère*, signed Claude Monet 1869, $28\frac{3}{4}'' \times 36\frac{1}{4}''$, Private Collection, England.

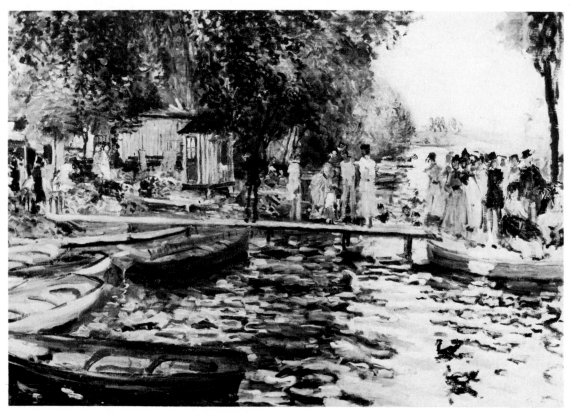

FIG. 86.　Renoir, *La Grenouillère*, signed Renoir, $26'' \times 36\frac{1}{4}''$, Collection Oskar Reinhart am Römerholz, Winterthur.

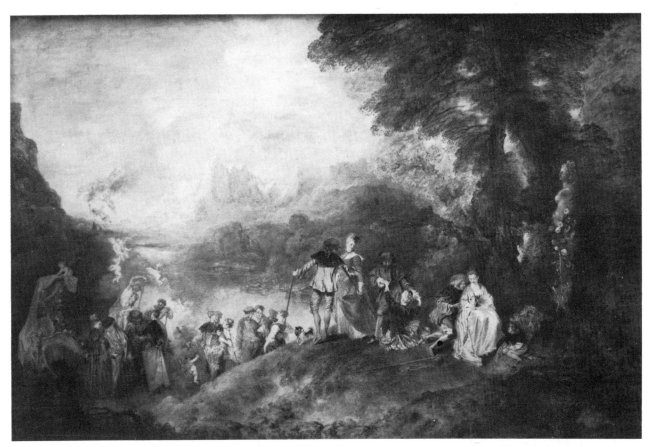

FIG. 87. Watteau, *Embarkation from Cythera*, unsigned, 50¾″ × 76⅜″, Louvre, Paris. Photo: Cliché des Musées Nationaux.

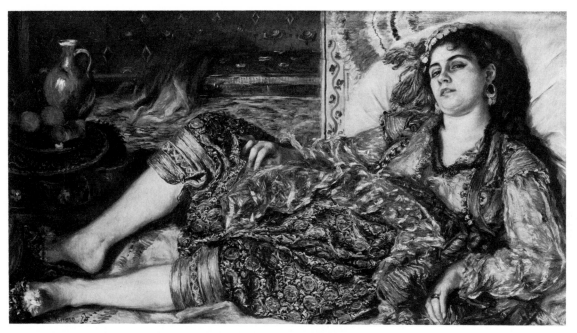

FIG. 88. Renoir, *Odalisque*, signed A. Renoir, 27″ × 48½″, National Gallery, Washington D.C., Chester Dale Collection.

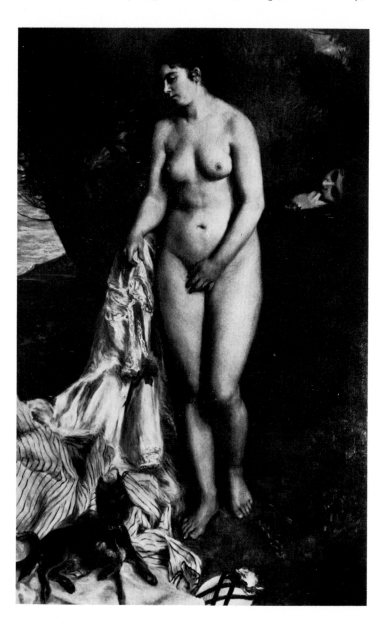

FIG. 89. Renoir, *Bather with a Griffon*, signed A. Renoir 1870, 73½″ × 46⅛″, Museu de Arte de São Paulo, Brazil.

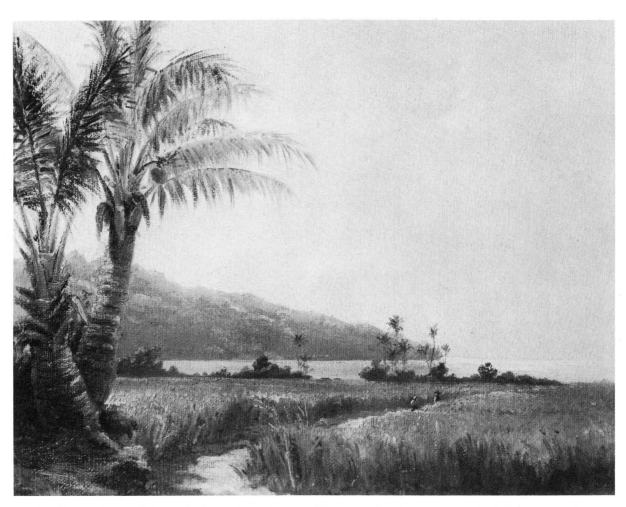

FIG. 90. Pissarro, *Coconut Palms by the Sea*, unsigned, $10\frac{5}{8}''\times13\frac{3}{4}''$, present whereabouts unknown (P. & V. 8). Photo: Courtesy Durand-Ruel.

FIG. 91. Pissarro, *The Hay Wagon*, signed Camille Pizarro, 1858, $8\frac{1}{2}'' \times 12''$, Mrs. Rosemary Peto Collection, London.

FIG. 92. Pissarro, *Prairies at La Roche-Cuyon*, signed C. Pissarro, 59, $8\frac{1}{8}'' \times 10\frac{5}{8}''$, Marlborough Fine Art (London) Ltd. (P. & V. 13).

FIG. 93. Rousseau, *Landscape*, unsigned, 13″ × 20″, Corcoran Gallery of Art, Washington, D.C. Bequest of Amelia B. Lazarus.

FIG. 94. Pissarro, *The Telegraph Tower, Montmartre*, signed C. Pissarro, 1863, $16\frac{5}{8}'' \times 13\frac{1}{4}''$, present whereabouts unknown (P. & V. 24). Photo: Courtesy Durand-Ruel.

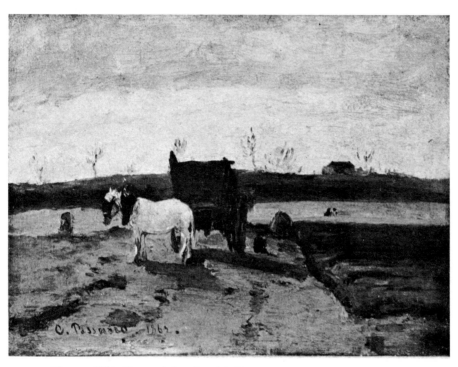

FIG. 95. Pissarro, *White Horse and Cart*, signed C. Pissarro, 1862, $10'' \times 13\frac{3}{4}''$, present whereabouts unknown (P. & V. 21).

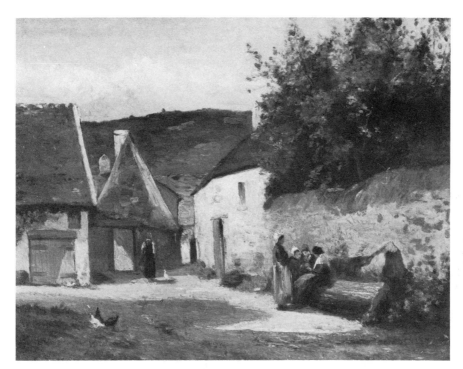

FIG. 96. Pissarro, *Corner of a Village*, signed C. Pissarro, 1863, $16\frac{5}{8}'' \times 21\frac{2}{3}''$, present whereabouts unknown. (P. & V. 27).

FIG. 97. Monet, *Farmyard, Normandy*, signed C. Monet, $25\frac{5}{8}'' \times 31\frac{1}{2}''$, Louvre, Paris. Photo: Cliché des Musées Nationaux.

FIG. 98. Daubigny, *La Frette*, signed Daubigny 1869, $14\frac{7}{8}'' \times 26\frac{1}{8}''$, National Gallery of Scotland, Edinburgh.

FIG. 99. Pissarro, *Tow Path*, signed C. Pissarro 1864, 33″ × 43″, Glasgow Art Gallery and Museum.

FIG. 100. Pissarro, *Tow Path* (sketch), signed C. Pissarro, 9″ × 12¾″, present whereabouts unknown. Photo: Courtesy Marlborough Fine Arts (London) Ltd.

FIG. 101. Pissarro, *The Ferry at La Varenne-Saint-Hilaire*, signed C. Pissarro 64, 11⅔″ × 14⅔″, Louvre, Paris (P. & V. 40). Photo: Cliché des Musées Nationaux.

FIG. 102. Daubigny, *River Scene near Bonnières*, signed Daubigny 1857, 11¾″ × 21⅛″, California Palace of the Legion of Honor, San Francisco, Mildred Anna Williams Collection.

FIG. 103. Pissarro, *Promenade with Donkeys at La Roche-Guyon*, signed C. Pissarro, $15\frac{1}{3}'' \times 22''$, Robert von Hirsch Collection, Basel (P. & V. 45).

FIG. 104. Courbet, *Young Women of the Village*, signed G. Courbet, $76\frac{3}{4}'' \times 102\frac{3}{4}''$, The Metropolitan Museum, New York. Gift of Harry Payne Bingham, 1940.

FIG. 105. Pissarro, *Square at La Roche-Guyon*, signed C.P., $20\frac{7}{8}'' \times 25\frac{1}{2}''$, Staatliche Museen Preussischer Kulturbesitz Nationalgalerie, Berlin (P. & V. 49).

FIG. 106. Daubigny, *The Hermitage at Pontoise*, signed Daubigny 1866, 44⅛″ × 63½″, Kunsthalle, Bremen.

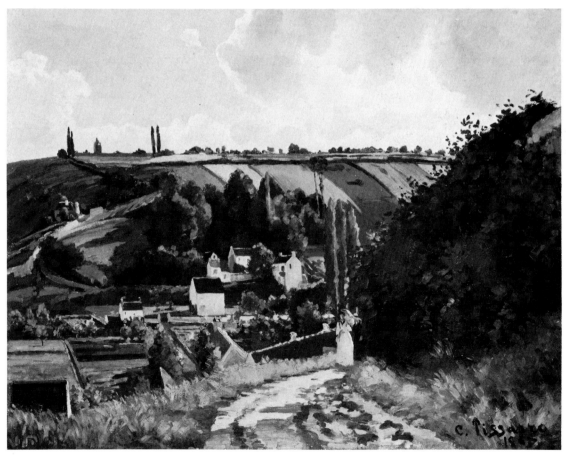

FIG. 107. Pissarro, *Jallais Hill, Pontoise*, signed C. Pissarro 1867, 34¼″ × 45¼″, The Metropolitan Museum of Art, New York. Bequest of William Church Osborne, 1951 (P. & V. 55).

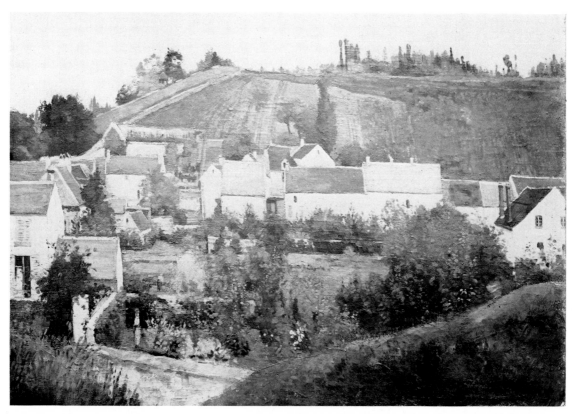

FIG. 108. Pissarro, *View of the Hermitage*, signed C. Pissarro, 29¼″ × 41⅔″. Photo: Courtesy Durand-Ruel (P. & V. 57).

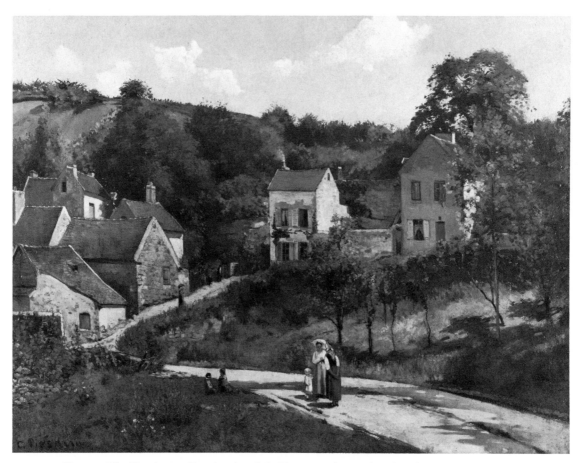

FIG. 109. Pissarro, *The Hermitage at Pontoise*, signed C. Pissarro, 59⅛″ × 78¾″, Thannhauser Collection, New York. Courtesy Thannhauser Foundation Inc. and The Solomon R. Guggenheim Museum, New York (P. & V. 58).

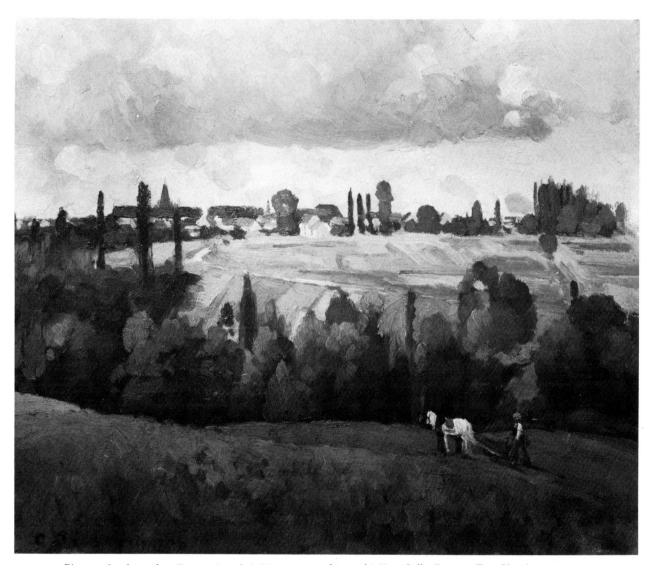

FIG. 110. Pissarro, *Landscape from Ennery*, signed C. Pissarro 68, $15\frac{3}{4}'' \times 19\frac{1}{3}''$, Kunsthalle, Bremen (P. & V. 67).

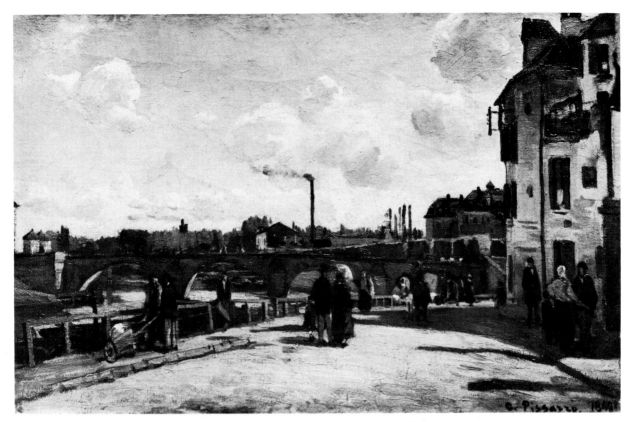

FIG. 111. Pissarro, *Quai du Pothuis, Pontoise*, signed C. Pissarro 1868, 20¾″ × 32½″, Kunsthalle, Mannheim, West Germany (P. & V. 60).

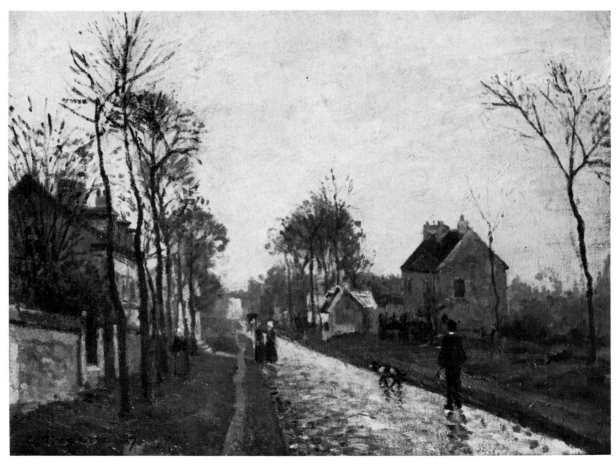

FIG. 112. Pissarro, *The Road to Versailles at Louveciennes—Rain Effect*, signed C. Pissarro 1870, 15¾″ × 22¼″, Sterling and Francine Clark Art Institute, Williamstown, Massachusetts (P. & V. 76).

FIG. 113. Bazille, *Reclining Nude*, signed F.B. 64, 18″ × 12¾″, Musée Fabre, Montpellier (D. 3). Photo: Claude O'Sughrue.

FIG. 114. Bazille, *Farmyard at Saint-Simeon*, *Honfleur*, signed F.B., $14\frac{1}{8}'' \times 10\frac{1}{4}''$, Private Collection, France (D. 6). Photo: Courtesy Fondation Wildenstein, Paris.

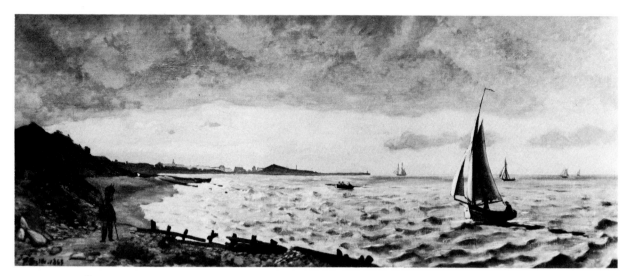

FIG. 115. Bazille, *Coast near Le Havre*, signed F. Bazille 1865, 23⅝″ × 55⅛″, Private Collection, France (D. 15/1). Photo: Courtesy Fondation Wildenstein, Paris.

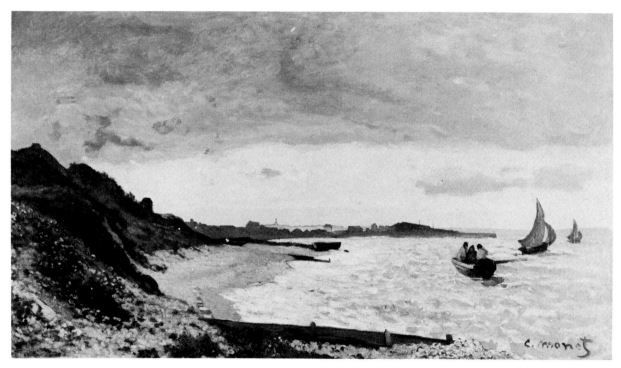

FIG. 116. Monet, *View of the Coast near Le Havre*, signed C. Monet, 15″ × 28″, Minneapolis Institute of Art. Gift of Mr. and Mrs. Theodore W. Bennett.

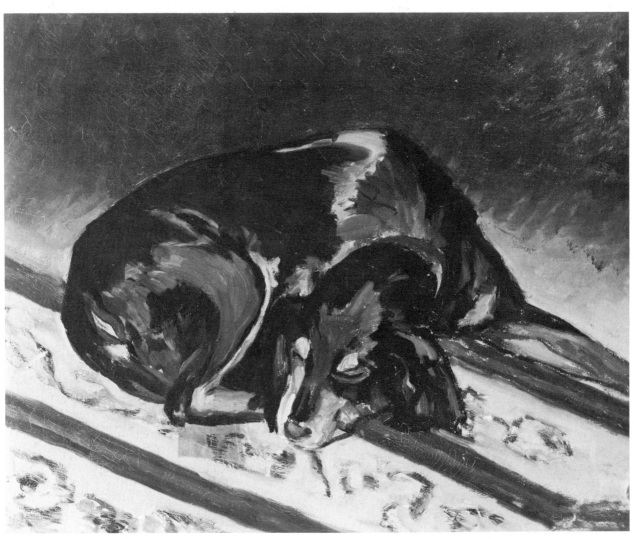

FIG. 117.　Bazille, *Rita, Sleeping Dog*, unsigned, 15⅝″ × 18⅔″, Private Collection, France (D. 5). Photo: Courtesy Fondation Wildenstein, Paris.

FIG. 118. Bazille, *The Red Dress*, signed F. Bazille 65, 58⅛″ × 44″, Louvre, Paris (D. 9). Photo: Cliché des Musées Nationaux.

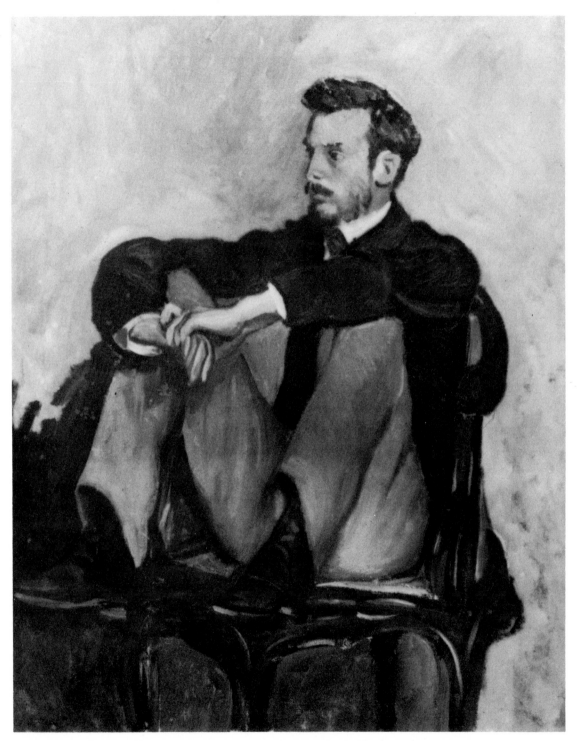

FIG. 119. Bazille, *Portrait of Renoir*, unsigned, 24½″ × 20⅛″, National Museum of Fine Arts, Algiers (D. 22).

FIG. 120. Bazille, *Ramparts at Aiguesmortes from the West*, signed F. Bazille, 24½″ × 43″, Private Collection, France (D. 24). Photo: Courtesy Fondation Wildenstein, Paris.

FIG. 121. Bazille, *The Gate of the Queen at Aiguesmortes*, signed F. Bazille 1867, 32″ × 41″, Private Collection, France (D. 23). Photo: Courtesy Fondation Wildenstein, Paris.

FIG. 122. Bazille, *Ramparts at Aiguesmortes from the South*, signed a M. Fioupou, son ami Bazille, $18\frac{1}{8}''$ × $21\frac{3}{4}''$, Private Collection, France (D. 25). Photo: Courtesy Fondation Wildenstein, Paris.

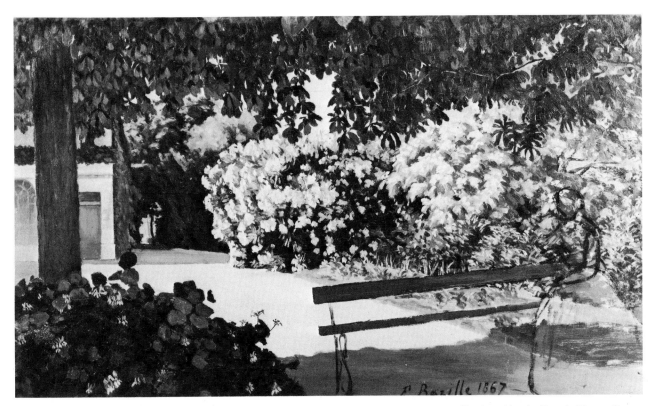

FIG. 123. Bazille, *Terrace at Méric, the Rose-Laurels*, signed F. Bazille 1867, 22″ × 38″, Private Collection, Algeria (D. 26). Photo: Courtesy Fondation Wildenstein, Paris.

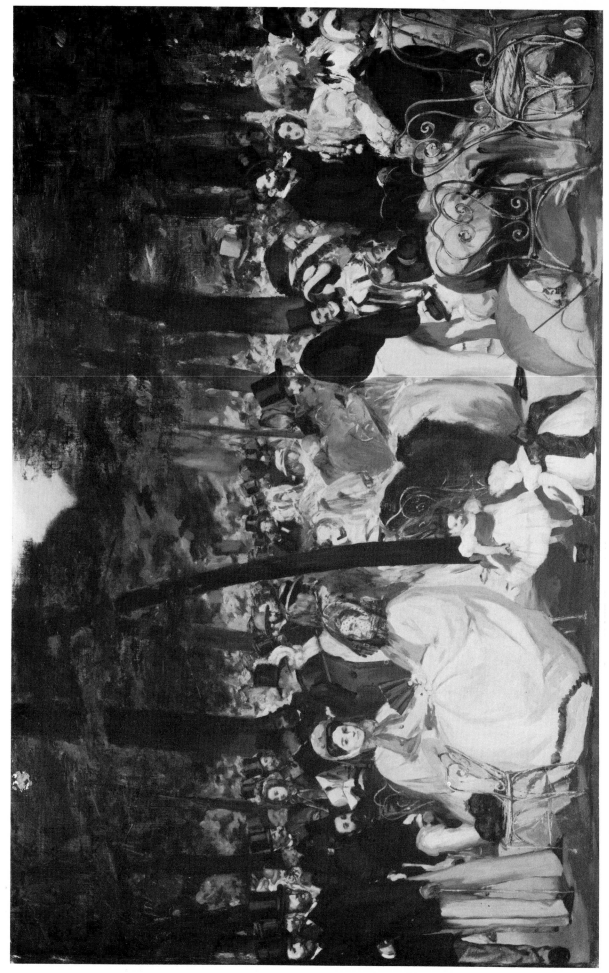

FIG. 124. Manet, *Music in the Tuileries Gardens*, signed éd Manet 1862, 30″ × 46½″, National Gallery, London.

FIG. 125. Bazille, *View of the Village*, signed F. Bazille 1868, $52\frac{1}{8} \times 35\frac{5}{8}''$, Musée Fabre, Montpellier (D. 36).
Photo: Claude O'Sughrue.

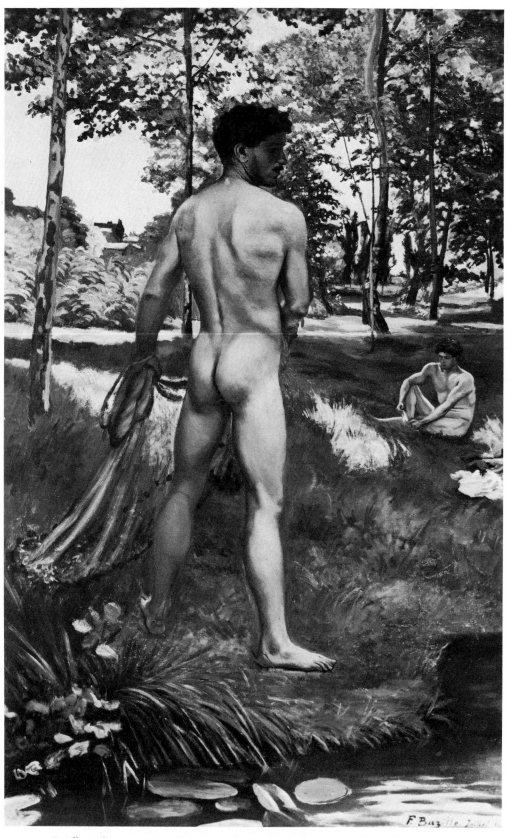

FIG. 126. Bazille, *Fisherman Casting His Net*, signed F. Bazille, juillet, 1868, 53¾″ × 34⅔″, present whereabouts unknown (D. 35). Photo: Courtesy Fondation Wildenstein, Paris.

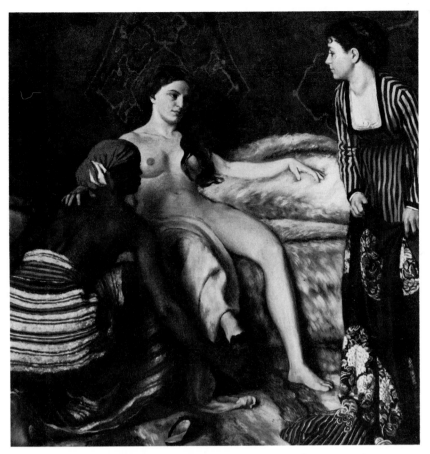

FIG. 127. Bazille, *La Toilette*, signed F. Bazille 70, 52⅞″ × 50⅞″, Musée Fabre, Mont-
pellier (D. 50). Photo: Claude O'Sughrue.

FIG. 128. Bazille, *Ruth and Boaz*, unsigned, 55″ × 80″, Private Collection, France (D. 57). Photo: Courtesy
Fondation Wildenstein, Paris.

FIG. 129. Sisley, *Forest Road*, signed A. Sisley, 19″ × 15⅔″, present whereabouts unknown.

FIG. 130. Sisley, *Chestnut Grove at St.-Cloud*, signed Sisley 65, 49½″ × 80¾″, Musée du Petit Palais, Paris (D. 1). Photo: Courtesy Photographie Bulloz.

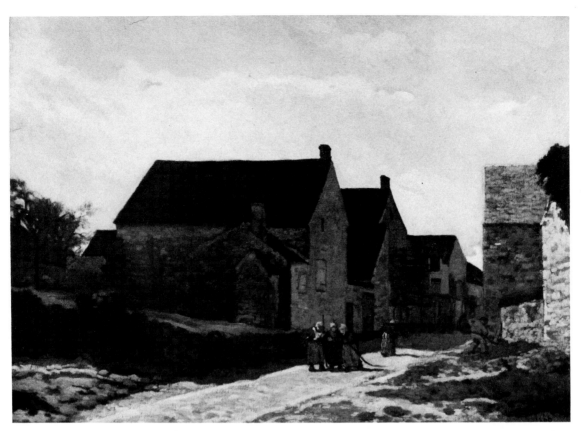

FIG. 131. Sisley, *Village Road, Marlotte*, signed Sisley 1866, 27″ × 38⅓″, Bridgestone Museum of Art, Ishibashi Foundation, Tokyo, Japan D. 4).

FIG. 132. Daubigny, *Gobelle's Mill at Optevoz*, signed Daubigny, 22¾″ × 36½″, The Metropolitan Museum of Art, New York. Bequest of Robert Graham Dun, 1911.

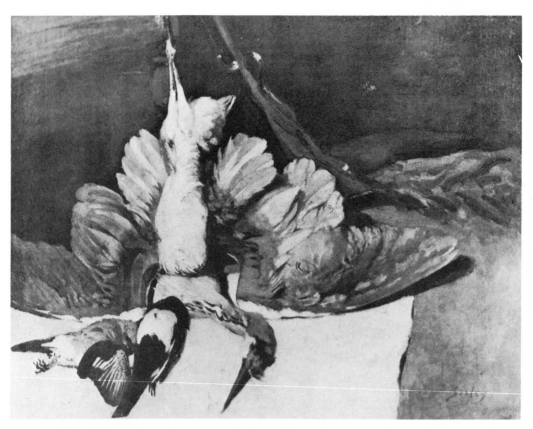

FIG. 133. Sisley, *Still Life of a Dead Heron*, signed Sisley, $31\frac{7}{8}'' \times 39\frac{3}{8}''$, Private Collection, Paris (D. 5). Photo: Courtesy Durand-Ruel.

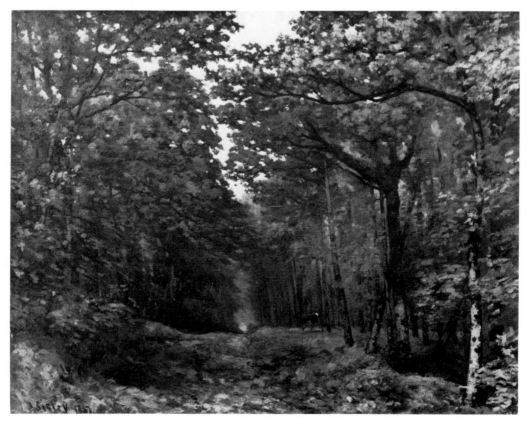

FIG. 134. Sisley, *Chestnut Trees at St.-Cloud*, signed A. Sisley 1867, $37\frac{1}{2}'' \times 48''$, Southampton Art Gallery, England (D. 9).

FIG. 135. Sisley, *Park at the Château of Courances*, signed A. Sisley, $15\frac{3}{4}'' \times 25\frac{1}{2}''$, François de Ganay Collection, Paris (D. 10).

FIG. 136. Corot, *The Road at Sèvres*, signed Corot, $13\frac{1}{2}'' \times 7\frac{1}{2}''$, Louvre, Paris. Photo: Cliché des Musées Nationaux.

FIG. 137. Sisley, *View of Montmartre*, signed Sisley 1869, $27\frac{1}{2}'' \times 46''$, Musée de Peinture et de Sculpture, Grenoble, France (D. 12).